TURNER AS DRAUGHTSMAN

'Good drawing must necessarily be the first principle of education.' –
J. M. W. Turner (annotation in his copy of John Opie's *Lectures on Painting delivered at the Royal Academy of Arts*, 1809)

'Such evidently was the practice of the greater masters of antiquity . . . in not allowing a day to pass without a line and proportions, according to Pliny.' –
J. M. W. Turner (lecture manuscripts, British Library Add. MS. 46151 A f. 19 v)

'No person can colour perfectly who is not a draughtsman. For brilliancy of colour depends, first of all, on gradation; and gradation in its subtleties cannot be given but by a good draughtsman.' – John Ruskin ('Catalogue of Turner's Sketches and Drawings', 1858)

Turner as Draughtsman

Andrew Wilton

ASHGATE

Published by
Ashgate Publishing Limited
Gower House
Croft Road ca—
Aldershot
Hants GU11 3HR
England

Ashgate Publishing Company
Suite 420
101 Cherry Street
Burlington, VT 05401-4405 USA

Ashgate website: http://www.ashgate.com

British Library Cataloguing in Publication Data
Wilton, Andrew
 Turner as draughtsman
 1. Turner, J. M. W. (Joseph Mallord William), 1775–1851
 I. Title II. Turner, J. M. W. (Joseph Mallord William),
 1775–1851
 741'.092

Library of Congress Cataloging-in-Publication Data
Wilton, Andrew.
 Turner as draughtsman / Andrew Wilton.
 p. cm.
 Includes bibliographical references and index.
 ISBN 0-7546-0026-2 (alk. paper)
 1. Turner, J. M. W. (Joseph Mallord William), 1775–1851--Criticism and interpretation.
 2. Artists' preparatory studies--Great Britain. 3. Turner, J. M. W. (Joseph Mallord William),
 1775–1851--Aesthetics. I. Turner, J. M. W. (Joseph Mallord William), 1775–1851. II. Title.

NC242. T9W55 2005
741'.092--dc22

2004062793

ISBN 0 7546 0026 2

Typeset by Bournemouth Colour Press, Parkstone, Poole.

Printed and bound in Great Britain by MPG Books Ltd, Bodmin, Cornwall.

Contents

Figures

(All works are by J. M. W. Turner unless otherwise specified.)

1 Introduction: Could Turner draw?

1.1 *Study for 'The Sack of a Great House'* (formerly called *Interior at Petworth*), c. 1830, oil on canvas, 91 × 122 cm (BJ 449; Tate Gallery N01988)

1.2 *The Burning of the Houses of Lords and Commons, 1834*, 1835, oil on canvas, 92 × 123 cm (BJ 359; Philadelphia Museum of Art)

1.3 *Petworth, the North Gallery at night, with Flaxman's 'St Michael'*, 1827, gouache on blue paper, 14.1 × 19.2 cm (Turner Bequest CCXLIV 25; Tate Gallery D22687)

1.4 *Little Devil's Bridge*, etching by Turner, mezzotint by C. Turner for *Liber Studiorum*, 17.8 × 25.7 cm (R 19; Tate Gallery A00948)

2 Turner's history of drawing

2.1 'Reformation (Luther's Bible)', historical vignette from the *Fairfaxiana* album), c. 1815–25, pencil and watercolour, 32.6 × 20.2 cm (private collection)

3 The rudiments of draughtsmanship

3.1 *Westminster, with Henry VII's Chapel*, c. 1790, pencil and watercolour, 30.8 × 45 cm (private collection)

3.2 *A Study of Boats*, c. 1828–30, pen and brown ink and wash heightened with white on blue paper, signed,

13 × 18.2 cm (D.92 1892; Whitworth Art Gallery, Manchester)

3.3 Annotated copy drawing, with letter from Revd Robert Nixon, c. 1798 (Tate Archive)

3.4 *The Diskobolus (Study from the Antique)*, c. 1792, black and white chalks on grey paper, 44.5 × 28 cm (Turner Bequest V O; Tate Gallery D00067)

3.5 Study of a seated male nude, c. 1800, pencil and gouache on buff prepared ground, 25 × 20.2 cm (private collection)

3.6 Academy study of a male nude stooping, c. 1798, black chalk and charcoal, 21.7 × 25.8 cm (The Art Institute of Chicago)

4 Early influences

4.1 *Landscape with a Man watering his Horse* (drawing in the style of De Loutherbourg, signed: W. Turner Delint.), c. 1792, pencil and watercolour, 15 × 19.7 cm (private collection, Australia)

4.2 *Ely Cathedral: the Interior of the Octagon*, 1794, pencil drawing, 78.2 × 59.3 (Turner Bequest XXII P; Tate Gallery D00369)

4.3 *The Ruins of Valle Crucis Abbey, with Dinas Brân*, 1794–95, pencil and watercolour with some scraping-out, 46 × 37.5 cm (Turner Bequest XXVIII R; Tate Gallery D08703)

5 A mature shorthand

5.1 *Distant view of Rochester*, c. 1793, pencil, 21 × 27.2 cm (Turner Bequest XV B; Tate Gallery D00158)

5.2 *Ely Cathedral, South Trancept*, 1797, watercolour, 62.9 × 48.9 cm (W 195; Aberdeen Art Gallery 54.2)

5.3 *Burg Eltz*, 1839, pencil and scraping-out on a grey-washed ground, 17.5 × 23 cm (courtesy of Sotheby's)

5.4 *Killin and the Falls of Dochert* ('Scottish Pencil'), 1801, pencil and white gouache on prepared grey ground, 34 × 49 cm (Turner Bequest LVIII 42; Tate Gallery D03421)

5.5 *Yorkshire 1* sketchbook, ff. 10 verso – 11 recto, study of Cowthorpe Oak, 1816, pencil drawing, page size 15.4 × 9.4 cm (Turner Bequest CXLIV; Tate Gallery)

5.6 *Waterloo and Rhine* sketchbook, ff. 41 verso – 42 recto, sketches at St Goar and Coblenz, 1817, pencil, page size 15 × 9.4 cm (Turner Bequest CLX 41a–42; Tate Gallery)

5.7 *Holland* sketchbook, f. 88 recto, 1825, pencil, page size 13.7 × 8.7 cm (Turner Bequest CCXIV; Tate Gallery)

5.8 *Studies for Pictures: Isleworth* sketchbook, f. 16 recto, study for a classical harbour subject, c. 1805–06, pen and ink on white paper washed with grey, page size 14.7 × 25.6 cm (Turner Bequest XC; Tate Gallery D05512)

5.9 *Calais Pier* sketchbook, pp. 74–75, c. 1802, black and white chalks on blue paper, page size 43.6 × 26.7 cm (Turner Bequest LXXXI; Tate Gallery)

6 Line and colour

6.1 *Llanberis Lake*, colour beginning, c. 1799, watercolour, 54.7 × 76.5 cm (Turner Bequest LXX d; Tate Gallery D04181)

6.2 *Grenoble*, colour beginning, c. 1824, watercolour, 55.5 × 75 cm (Turner Bequest CCLXIII 346; Tate Gallery D25469)

6.3 *Moselle Bridge at Coblenz*, 1817, watercolour and gouache on white paper prepared with a grey wash, 199 × 311 cm

(Makepeace Investments, courtesy of the Art Gallery of Ontario)

6.4 'The Field of Waterloo from Hougoumont' (vignette illustration from *The Works of Lord Byron*), c. 1832, watercolour, 19 × 26 cm (Makepeace Investments, courtesy of the Art Gallery of Ontario)

7 Drawing and painting

7.1 *Venice, from the porch of Madonna della Salute* (detail), 1835, oil on canvas, 91.4 × 122 cm (BJ 362; Metropolitan Museum, New York)

7.2 *Sunrise with a Boat between Headlands*, c. 1845, oil on canvas, 91.5 × 122 cm (BJ 516; Tate Gallery N02002)

7.3 *An Alpine Pass, with Cascade and Rainbow*, c. 1842, black chalk and watercolour with pen, 22.1 × 28.8 cm (Turner Bequest CCCLXIV 278; Tate Gallery D36126)

8 Turner's humanity

8.1 J. S. Copley, *The Siege of Gibraltar*, 1792, oil on canvas, 543.6 × 754.4 cm (Guildhall Art Gallery, Corporation of London)

8.2 *A country blacksmith disputing upon the price of iron, and the price charged to the butcher for shoeing his poney (The Blacksmith's Shop)*, 1807, oil on pine panel, 55 × 78 cm (BJ 68; Turner Bequest, Tate Gallery N00478)

8.3 *The unpaid bill, or the Dentist reproving his son's prodigality*, 1808, oil on panel, 59.4 × 80 cm (BJ 81; private collection, photo courtesy of Christie's)

8.4 *Calais Pier* sketchbook, pp. 120–21, c. 1800–05, black and white chalks on blue paper, page size 43.6 × 26.7 cm (Turner Bequest LXXXI; Tate Gallery)

8.5 George Jones, *Samson destroying the Temple of Baal*, 1832, grey, brown and blue washes with gouache and gum arabic, 49.5 × 40 cm (private collection, photo courtesy of Sotheby's)

8.6 *Venice, from the porch of Madonna della Salute*, 1835, oil on canvas, 91.4 × 122 cm (BJ 362; Metropolitan Museum, New York)

Preface

I think it probable that when Pamela Edwardes of Ashgate Publishing commissioned a book from me on 'Turner's drawings' she had in mind an eminently saleable commodity involving beautiful watercolours. It was forbearing of her in the highest degree when, having glanced at my typescript, she stalwartly went ahead with the project. For I had chosen to interpret her suggested subject quite literally: rather than going over ground that, however attractive, had been traversed innumerable times in the last three or four decades, I would concentrate on a subject – Turner's draughtsmanship pure and simple – that seems relatively uninteresting, and that has not been a subject of detailed study for a hundred years.

One might argue that, in Turner's art, drawing and the use of watercolour are inextricably linked. That is true, and I have found myself inevitably incorporating some discussion of his procedures in watercolour; – but it seemed to me that there is a strong case for attempting to evaluate his use of line (and its technical and stylistic adjuncts) for its own sake, to draw attention to its intrinsic beauty and fitness for purpose.

I hope to show that Turner was, indeed, a virtuoso draughtsman, as he was a watercolourist, and that the sketchbooks which, more by accident than design, came into the possession of the British nation are worthy of a place beside his paintings in both watercolour and oil as the products of an astonishing alliance of bravura skill and poetic imagination. In addition, they are testimony to a highly evolved professional and creative discipline, and give evidence of the innermost working of one of the most original minds of Western art.

His true worth as a draughtsman has been obscured by a longstanding perception that when it came to the representation of the human figure Turner was almost laughably incompetent. Ruskin, among a very few, wrote in justification of his figure drawing, but from Turner's own time till now most people have enjoyed taking pot-shots at this aspect of his work, and for many it has prevented them from allowing him the supremacy he deserves. I have written before on this subject in various places, but it seemed appropriate to bring the threads together here and to argue for an assessment of what his figures achieve in the context not of some universal

preconception of how the human figure should function in landscape painting, but of how he conceived his landscapes – and other types of picture.

For I argue here that, at certain moments in his career, Turner had different agendas, that landscape for a time took second place to a type of subject matter more in tune with the middle-class art economy that arose in the decades after 1815. A corollary to this is the recognition that he was a human being with physical and psychological capacities that varied over a long career, and that these temperamental variations can be detected in his response to the fluctuations of the market, on which he always kept a close eye.

Such considerations have entailed proposing that he undertook a number of works that were outside his range, and acknowledging – as he too did, if only to himself – that this was so. Many of my colleagues in the world of Turner studies have proved reluctant to consider the possibility that their hero might have at least a toe or two of clay, and my suggestions have fallen on almost totally deaf ears over two decades: with few exceptions they have not been incorporated, even tentatively, into the received interpretation of the canvases in question. I, for my part, am now more certain than I was originally that my hypothesis is correct, and so I have no compunction in rehearsing it again here.

Writing a book of this kind is an essentially solitary assignment: one is alone with the works themselves, and with a host of predecessors in the field, whose writings nourish and inspire in a multitude of ways. But I have also been encouraged and greatly helped both in discussion of ideas and in practical matters by a number of friends and colleagues both at the Tate and elsewhere, and accordingly I would like heartily to thank Clive Adams, Peter Bower, David Blayney Brown, Sarah Hobrough, Hattie Drummond, Judy Egerton, Jane Farrington, Sue Graves, James Hamilton, Angeline Collings, Juliet Cook, Nicholas Horton-Fawkes, Vivien Knight, Sandra de Laszlo, Lowell Libson, Katharine Lochnan, Anne Lyles, Nicola Moorby, Joe Rishel, Nick Savage, Eric Shanes, MaryAnne Stevens, Sarah Taft, Martha Tedeschi, Joyce Townsend, Piers Townshend, Rosalind Mallord Turner, Ian Warrell, Henry Wemyss and Laura Whitton, and members of my family, especially Christina and Henry Wilton. To Sam Smiles I owe a special debt of thanks for a considered reading of the text and many helpful suggestions.

Abbreviations

The principal works of reference in the Turner literature are listed in full in the Bibliography. They are referred to in the text by standard abbreviations, as follows:

BJ Martin Butlin and Evelyn Joll, *The Paintings of J. M. W. Turner*, 2 vols, 2nd edn, London, 1984.

R W. G. Rawlinson, *Turner's Liber Studiorum: A Description and Catalogue*, 2nd edn, London, 1906, and W. G. Rawlinson, *The Engraved Work of J. M. W. Turner, R.A.*, 2 vols, London, 1913. (Note that Rawlinson's two publications catalogue different parts of Turner's output of prints, and his initial is used to refer to either; the context always makes clear which is meant.)

TB A. J. Finberg, *A Complete Inventory of the Drawings in the Turner Bequest: with which are included the twenty-three drawings bequeathed by Mr Henry Vaughan. Arranged chronologically*, 2 vols, London, 1909.

W Catalogue of the finished watercolours in Andrew Wilton, *The Life and Work of J. M. W. Turner*, London, 1979.

Works in the Turner Bequest are in the Tate Gallery, London, unless otherwise indicated.

Other abbreviations used in the notes are:

Farington, *Diary*: Farington, Joseph, *The Diary of Joseph Farington 1793–1821*, ed. Kenneth Garlick, Angus Mackintyre and Kathryn Cave, 16 vols, with index by Evelyn Newby, 1978–98.

Ruskin, *Works: The Works of John Ruskin* (Library Edition), edited by Sir E. T. Cooke and Alexander Wedderburn, 39 vols, 1903–12.

Introduction: Could Turner draw?

There have been few books devoted to the subject of Turner's draughtsmanship – to his use of pen, pencil or chalks, and to his skills as a deployer of line – as opposed to his perennially interesting achievements as painter in both oils and watercolour. Apart from a series of illustrations of the contents of sketchbooks in the Turner Bequest, selected with a commentary by Gerald Wilkinson, and some valuable recent work on his materials and technical procedures,[1] the only serious discussion of the subject in a century fertile in literature about Turner has been A. J. Finberg's *Turner's Sketches and Drawings*, published in 1910. The book was a direct result of Finberg's work on his *Complete Inventory of the Drawings in the Turner Bequest*, which had appeared in two volumes in 1909. Arising as it did from such a detailed investigation into a vast topic – the Bequest comprised, in addition to some 300 oil paintings, over 30,000 drawings on loose leaves or in sketchbooks – *Turner's Sketches and Drawings* embodied a highly specialized approach to Turner's art; it was not reprinted until a paperback edition appeared in 1968.[2] Since then, other studies of different aspects of his output have touched on the subject of his drawings; some, like A. G. H. Bachrach's *Turner and Rotterdam* (1974), have published *in extenso* the sketchbooks used in a particular place. This book attempts to engage with the topics that fascinated Finberg, and to examine Turner's protean draughtsmanship for its own sake, while relating it to his equally various work as painter in both watercolour and oil, which has almost invariably dominated discussions of his achievement to the exclusion of any consideration of the style, technique or function of his drawings.

The reasons for this preoccupation are not far to seek. During most of the twentieth century Turner's art was consistently interpreted as an exploration of pure colour and light, that is, of the abstract elements that constitute the media by virtue of which we perceive nature. Kenneth Clark summed up Turner's evolution as an artist with the observation that 'the idea that the world is made up of solid objects with lines round them ceased to trouble him'. His art 'consisted of transforming everything into pure colour, light rendered as colour, feelings about life rendered as colour'.[3] But Clark, typically for his time, accounted only the latest of Turner's works important,

and of those only the colour sketches fully successful.[4] There grew up in the twentieth century a response to Turner that evaluated his achievement against the developments of subsequent decades – indeed, of subsequent epochs: Impressionism, Expressionism, Abstraction. In that context, the sketches and unfinished works, in which the Bequest abounded, took on a salient role, which seemed to warrant their segregation in a category of their own, as works of independent value, unconnected with their original function.[5] Many thought, as Clark did, that Turner 'must be judged by the pictures which he did not exhibit'.[6]

Clark's estimate of the sketches was based partly on their generally satisfactory state of preservation, as opposed to the often damaged condition of the finished pictures, but it was also founded on a perennial misunderstanding of what the sketches actually are, in terms of function and purpose. For instance, the enigmatic unfinished oil once known as *Interior at Petworth* (see Figure 1.1) was described by Clark as 'the first attempt to make light and colour alone the basis of a design'.[7] A comment from the 1960s echoes this: 'light and colour ... are themselves the chief subject of the picture'.[8] This assessment overlooks the specific details that crowd the foreground, and indeed much of the background, of the composition, and it assumes that what we see is a finished work, a complete statement, which all the visual evidence seems to deny. On the contrary, this suggests that the picture is an *ébauche*, or the abandoned beginning of an elaborate genre subject of a type popular in the decades after Waterloo. Clark himself refers to the 'monks, maidens, troubadours, balconies, guitars and other properties of the Keepsake style' in Turner's finished Italian landscapes,[9] and there can be little doubt that the mature Turner was influenced by the prevailing aesthetic of the 1820s and 1830s – that of the sentimental portraits and genre scenes engraved as illustrations in the popular 'Annuals', which were given such names as *The Keepsake* and *Friendship's Offering*. I shall discuss this phase of his career in Chapter 8.

In Clark's view there are two Turners: one the perpetrator of 'preposterous' pictures of 'storms and avalanches' that are 'too artificial for modern taste', the other a secret Turner who, in the privacy of his studio (or perhaps in one of his hideaways along the Thames?) was forging a new art – 'perfecting, for his own private satisfaction, an entirely new approach to painting which was only recognised in our own day'.[10] This interpretation isolates certain aspects of his work that speak directly to a twentieth-century sensibility, and accuses him of gross incompetence and vulgarity in other respects, so that although he was, as Clark admits, 'a genius of the first order' his genius did not manifest itself at all consistently, or indeed sometimes at all, in so far as his own contemporary public was concerned. Another commentator of the 1960s, Adrian Stokes, could refer to the inchoate watercolour studies that are thought to relate to the two oil paintings of *The Burning of the Houses of Lords and Commons*, exhibited in 1835, as 'among his great masterpieces' without according any special status to the paintings themselves (see Figure 1.2).[11]

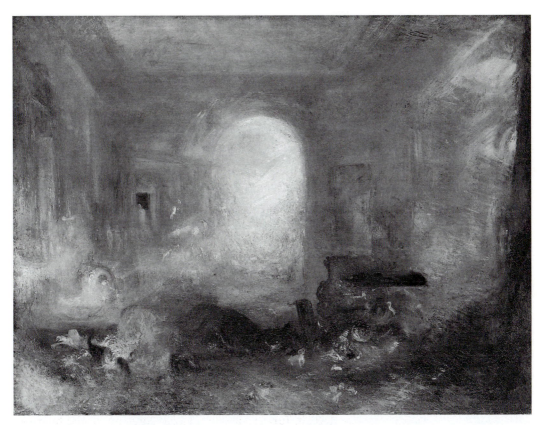

Part of Turner's appeal to twentieth-century taste was precisely that his preoccupation with natural abstractions had enabled commentators to argue that his work is actually 'abstract', that it isolates the general from the particular, preferring to represent qualities, as it were, rather than essences. It is possible that his single most important contribution to a 'progressive' history of painting was his mastery of the depiction of light in nature. Indeed, Turner's most ardent champion in his lifetime, John Ruskin, laid the foundations for the modern view of him by stressing that it was precisely his fidelity to the truth that 'WE NEVER SEE ANYTHING CLEARLY' that constituted his claim to greatness.[12] But 'progressive' histories are less authoritative now than they once were.

In the last few decades this fundamental anomaly in the understanding of Turner has been redressed to a great degree in the work of a generation of scholars much younger than Clark. One of the most thoughtful of the current generation of Turner's commentators, John Gage, has argued circumspectly that his 'vocabulary of form and colour, as it developed in the latter half of his career, may be related to an experimental art on the borderline of twentieth-century abstraction'. He advances several instances of early modern painters admiring Turner – notably Signac, who was struck by two views of Norham Castle, one from the first half of Turner's career, the other from near its end. Signac himself was not, of course, a crucial formative

1.1 *Study for 'The Sack of a Great House'* (formerly called *Interior at Petworth*), c. 1830, oil on canvas, 91 × 122 cm (BJ 449; Tate Gallery N01988)

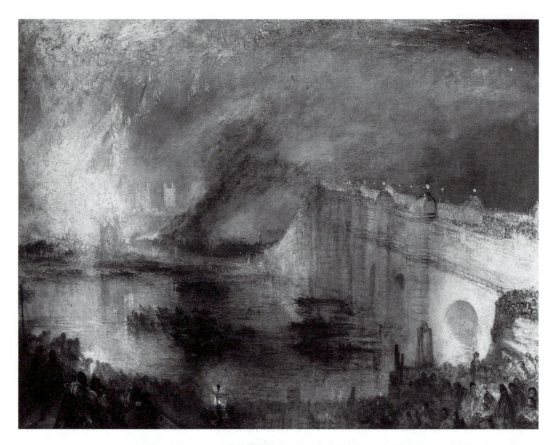

1.2 *The Burning of the Houses of Lords and Commons, 1834,* 1835, oil on canvas, 92 × 123 cm (BJ 359; Philadelphia Museum of Art)

influence on the development of modernist painting; and, as Gage points out, he was 'treating the late work in a way that was far from Turner's intention'.[13]

The two pictures of *The Burning of the Houses of Lords and Commons* are acknowledged as among his most impressive achievements, and their relation to the politics of the time is frequently discussed.[14] Critics have stressed the consistency of his vision, and the indissoluble connection between his finished and unfinished work. But the perception of the general public, and indeed of many specialists outside the immediate field of British Romantic painting, remains similar to Clark's. The problem with this view lies in the indisputable fact that Turner remained committed, to the end of his career, to the public exhibition and purchase of his works, and that the 'modernist' case rests very largely on examples that he did not intend for exhibition or sale. It cannot be argued that he was inhibited by conditions imposed by the Royal Academy, since he flouted the Academy's conventions from an early period and was accustomed to the brickbats of the critics; he was wounded by them, but they did not prevent him from going his own way. To argue his modernity from his unfinished work is equivalent to claiming the progressive nature of Beethoven's music on the basis of his notebooks. Indeed, it is quite possible to argue that case from the self-evidently finished pictures he sent to the Academy in the 1830s and 1840s,

which may perhaps be likened to Beethoven's late masterpieces: the parallel with Beethoven (whose output is, like Turner's, often divided into an early, a middle and a late period) is a fruitful one on the level of the imagination, though it would be fallacious to attempt to spell out any exact correspondences.[15]

There has long existed a view of Turner's work that is less committed to either the modernist or the anecdotal interpretation, a view that would emphasize the purely visual nature of his art without denying its descriptive character. It takes the form of a rejection of what is seen as the essentially literary interpretation brought to bear by Ruskin, while reaffirming the 'truth' of what Turner's pictures show us of the world. In 1903, two years after Ruskin's death, Walter Shaw Sparrow forcibly enunciated this argument. Had Ruskin, he wrote, 'felt Turner's art as art – felt it, that is to say, with all the intensity he laid claim to – he would not have written about it with such a flood of words. For the strongest emotions of an aesthetic kind incline men to be silent rather than eloquent.' Sparrow averred that 'Turner was not a moralist nor a man of letters: He was a great master of the brush . . .'.[16] We now regard him as a moralist, if at all, by virtue of his standing as a great artist; by the same token we take seriously the idiosyncratic scraps of poetry that he jotted in his sketchbooks and appended to the catalogue entries for his pictures at the Academy exhibitions. We also, most significantly, accord him greater weight as a thinker about aesthetics and the role of the arts in society. The notes and drafts he made for the series of lectures that he delivered as Professor of Perspective at the Royal Academy,[17] together with the annotations he made in various theoretical works by other artists and writers, are scanned for every last gleaning of evidence of the 'wonderful range of mind' that John Constable famously commented on.[18]

These changes of approach are characteristic of the point in time from which we assess him. We are no longer able to see him simply as either 'a great master of the brush' or a virtuoso recorder of nature. The 'modernist' interpretation has not gone away and, while that is one valid response to a portion of his achievement, there persists a wish to understand him solely and simply as a precursor of modernism.[19] It is the intention of this book to return to Turner his credentials as an artist working within the disciplines of his time. He was capable of transcending them, and he affirmed the need for the artist to 'dare to think for himself';[20] equally he was clear that practical experience in the art of painting was the only sure way to success: 'it is the art attained by Practice only which can be truly call'd art'.[21] His achievement was always dependent on his holding the traditional disciplines in the highest regard. As he told his audience at the start of his course of lectures on perspective, 'however arduous, however depressing the subject may prove; however trite, complex or indefinite . . . however trammelled with the turgid and too often repelling recourance of mechanical rules, yet those duties must be pursued . . .'.[22] A profound respect for the technical foundations of painting underlay his life's work.

If we are to approach Turner as receptively as possible, we must

understand his subject matter as comprehending a mass of individually observed and recorded facts about the world, as well as a broader conceptual context within which those facts are deployed. The phenomena of light and colour are themselves facts subject to observation, analysis and careful recording. Turner's output is comprehensively concerned with the way specific aspects of the world appear. What is perhaps surprising at first is that the vast majority of his attempts to grapple with the effective presentation of those aspects are made with the aid not of colour but of line.

The dominant aesthetic theory of Turner's early career, and indeed until much later in modified form, was one in which line, and specifically outline, played a central role. The influence of Johann Joachim Winckelmann, whose *Geschichte der Kunst des Alterthums* (1764) had been translated into English by Henry Fuseli (1741–1825) in 1765,[23] was profound. The culture of the ancient Mediterranean civilizations was in the process of being rediscovered during the course of the eighteenth century, partly owing to the stimulation of the increasingly fashionable Grand Tour and its associated industries, partly because important sites were being excavated: Herculaneum and Pompeii outside Naples, the Golden House of Nero in Rome and many others. Winckelmann argued that the art of antiquity was qualitatively superior to all modern productions, and isolated certain central characteristics as contributing to its superiority: its salient qualities were purity, grace and simplicity.

He identified one element in particular as a quintessential feature of classical art: outline, or contour. 'Precision of contours' Winckelmann declared to be 'that characteristic distinction of the Ancients'.[24] The idea that the greatest art was expressed by means of pure, clear outline permeated all aspects of design, and was as important in 'grand manner' history painting as in sculpture or sculpture-inspired drawing, as famously exemplified in the outline drawings that John Flaxman (1755–1826) executed to illustrate Homer, Hesiod and Dante.[25] These designs were known all over Europe, and Flaxman enjoyed an international reputation as a sculptor. Turner was very much aware of him, as his drawing of the great 'St Michael' at Petworth (Figure 1.3) shows. The primacy of sculpture in Winckelmann's account of aesthetics was, of course, the result of the historical accident that very little painting had survived from antiquity, whereas the art of the Greeks was well documented in innumerable works of sculpture. 'In sculpture remain almost all the excellent specimens of ancient art', Sir Joshua Reynolds (1723–92) confirmed.[26] At the same time, 'the distinct, sharp and wiry ... bounding line', as William Blake (1757–1827) called it,[27] was enjoying an almost unique status in the visual arts; it had been established as the touchstone of Neo-classical expression, and played a defining role in the creation of works of art in many different media. Fuseli himself insisted that correct drawing underlay the greatest works of art, and had a moral force too: 'Design, in its most extensive as in its strictest sense, is their basis; when they stoop to be the mere playthings, or debase themselves to be the debauchers of the senses, they make *Colour* their insidious foundation ...'.[28]

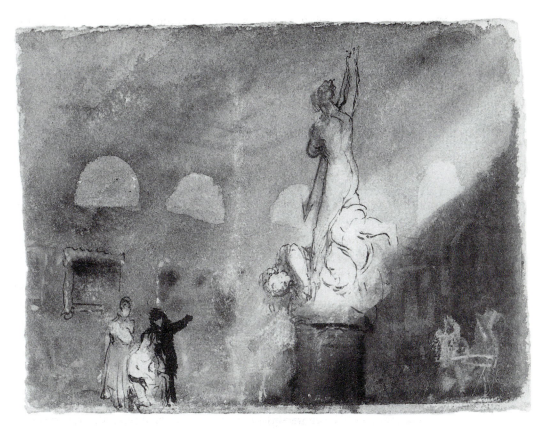

Linking sculpture and outline in so intimate a way may seem contradictory, but it was a connection clear to connoisseurs of the period. Winckelmann had pointed out that 'the middle parts of a full face are the outline of its profile, and so on'.[29] The idea was summarized forcibly by George Cumberland in his *Thoughts on Outline Sculpture, and the System that guided the Antient Artists in composing their Figures and Groupes*, published in 1796. 'A statue is all outline', Cumberland asserted. 'A fine simple Outline may possess grace, action, expression, character, and proportion. A fine statue is only better, as it contains all these qualities when varied in a thousand ways ... There are statues in the world which, if turned round on a pivot before a lamp, would produce, on a wall, some hundreds of Outlines.'[30] Following the practice in other such institutions on the Continent of Europe, the London Royal Academy Schools, in which Turner enrolled himself in 1789 at the age of fourteen, began its courses with a 'Plaister Academy' where he and his young colleagues drew from casts of classical sculpture as a regular discipline. This aspect of his training will be examined in Chapter 3.

When the Royal Academy was established in London in 1768, Reynolds, its first President, enjoined simplification of form as a necessary element in the generalization required for the expression of sublime character or drama.

1.3 *Petworth, the North Gallery at night, with Flaxman's 'St Michael'*, 1827, gouache on blue paper, 14.1 x 19.2 cm (Turner Bequest CCXLIV 25; Tate Gallery D22687)

He pointed to one of the greatest of the Renaissance masters, Raphael, as a supreme model 'who possessed a greater combination of the higher qualities of the art than any other man' for his 'correctness of Drawing' and 'purity of Taste'.[31] Raphael was to be the subject of one of Turner's most important acts of art-historical homage, the large canvas *Rome, from the Vatican* that was his first public response to his experience of Italy, exhibited in 1820. This picture is in itself a kind of demonstration of the importance of drawing, with its complex perspective and intricately interrelated forms.[32]

The process of simplification that Reynolds advocated can be found even in watercolour landscape painting of the first decade of the nineteenth century. This is a subject to which we shall have to return. For Turner was inevitably caught up in the taste for classic simplicity, a taste that found one of its supreme exponents in his close colleague Thomas Girtin (1775–1802). A comparison of these two artists is a crucial step in the process of defining Turner's draughtsmanly style in the years in which he reached his first maturity as a painter; it will be undertaken in Chapter 4.

There were other reasons, perhaps more pressing, why landscape painters needed to understand outline, since most were view-makers with little direct interest in the creation of Sublime art. As late as 1841, a leading topographical watercolourist of Turner's time, David Cox (1783–1859), made the point emphatically to the readers of a manual for amateurs published in that year – at a time when his own style both in drawing and painting was moving towards an unparalleled atmospheric breadth: 'A clear and decided Outline possesses a manifest superiority over the imperfect or undecided one . . . He who devotes his time to the completion of a perfect Outline, when he has gained this point, has more than half finished his piece.'[33] The details of Turner's early training as an architectural draughtsman confirm the principle repeatedly, and his methods of gathering information all his life continually demonstrate that the medium on which he primarily relied for recording and transmitting essential information was line. For the travelling draughtsman, moreover, picking up new topographical information on tour, a *porte-crayon* or chalks would be more convenient to carry and manipulate in the open than a box of colours. So for purely practical reasons Turner's watercolours, like his paintings in oil, rely on a discipline of drawing that is essentially linear, in so far as it is founded on the practice of the topographical artist whose chief responsibility was to record clearly and accurately the physical facts of specific places.

Despite the evidence of many able artists' work, it was popularly thought that landscape did not require such rigorously accurate draughtsmanship as other forms of delineation:

Landscape has many advantages over historical painting, its subjects being more familiar to the spectator; consequently more impressive, and more immediately understood by him, and its errors less apparent . . . branches of trees, or projections of buildings, are not in conformity to any certain regulations, neither are they of such importance (generally) as that a failure in expressing them perfectly, should ruin the piece.[34]

But as antiquarianism became more sophisticated, its demands on the topographer were intensified. It became important that the artist should understand what he saw, distinguish periods of building and recognize technical features. These were to be conveyed in drawings that suggested not only bald facts but character, period and the incidental qualities stemming from age, erosion, alteration and so on.

The skills of the late-eighteenth-century topographical draughtsman, then, were not necessarily those of the academically trained artist. They placed a relatively low premium on tonal modelling, and although many of the great topographers – Paul Sandby (1730–1809), for instance – were accomplished figure draughtsmen, the drawing of the human figure was for them secondary to that of architecture. Turner was brought up as a topographer, and his most thorough early training was in architectural drawing. Few people have denied his capacity in this respect, though Finberg sometimes accuses him, even in detailed architectural studies that would serve as bases for highly finished watercolours, of perfunctory finish.[35] At an early stage he had trained himself to use a kind of shorthand when recording architecture, simplifying and omitting repetitive detail. This seems less a matter of their being 'done with as little effort as possible', as Finberg suggests, than of their being professionally economical of means. Even as a landscape draughtsman Turner has been thought to be less than wholly felicitous. Kenneth Clark observed that 'Many of his forms are remarkably ugly in themselves, so that the old accusation that his pictures look like poached eggs and sausages is not without foundation.'[36] Nevertheless, the use of line underpins even his most atmospheric work. Ruskin pointed out in a lecture that the *Liber Studiorum* plate of the Devil's Bridge (Figure 1.4) was a subject for which 'if ever outline could be dispensed with, you would think it might be so, in this confusion of cloud, foam, and darkness. But [he went on] here is Turner's etching on the plate, made under the mezzotint; and of all the studies of rock outline made by his hand, it is the most decisive and quietly complete.'[37]

The criticisms of Turner as a purveyor of 'vulgarisation in the bad sense' – Clark again[38] – focus on an aspect of his work that was surely, if realism was the objective, an essential element: drawing. Clark's comment about 'poached eggs and sausages' seems more specifically appropriate to Turner's treatment of the human form. It is often said that he could not draw figures. This is a stricture that has been levelled against other landscape painters, including Turner's hero, Claude Lorrain himself. There does indeed appear to be a tendency on the part of landscape artists to give figures short shrift in their work. Richard Wilson (1714–82), Turner's great predecessor and early model, attracted similar objections. Yet the human figure is an essential part of landscape painting. It is 'the measure of all things' – the point of reference by means of which we enter into the artist's imaginative world and identify with the reality of what is presented to us. In the words of a contemporary of Turner's, 'The landscape, however dignified, however picturesque, is, unless animated by human figures, far from complete.'[39] Both Wilson and Claude

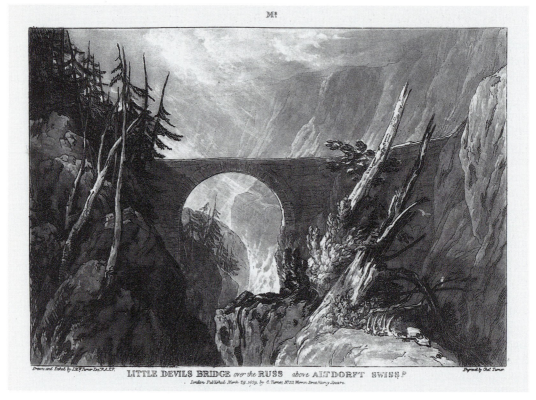

M?

LITTLE DEVILS BRIDGE *over the* RUSS *above* AITDORFT SWISS ?

London, Published March 29. 1809, by C. Turner, N°.50, Warren Street Fitzroy Square.

Drawn and Etched by J.M.W.Turner Esq.r R.A.EP. *Engraved by Chat. Turner.*

1.4 *Little Devil's Bridge*, etching by Turner, mezzotint by C. Turner for *Liber Studiorum*, 17.8 x 25.7 cm (R 19; Tate Gallery A00948)

made a point of giving their landscapes a human subject, sometimes consisting of local figures in the manner of the topographers, but generally taken from the Bible, mythology or history.

On the other hand, it will be argued that a large number of Turner's sketches have no figures. The relationship between sketch and finished work is something that will concern us a lot, but, as I have already suggested, the sketches, however fine, were a means to an end, and that end was the work he intended to show in public.[40] He did not finish his pictures to satisfy a tiresome bourgeois demand for 'detail'. He finished them because they would otherwise have been incomplete – his purpose in painting them would not have been accomplished.

Ruskin made a point which goes to support this argument, when discussing the treatment of architecture in Turner's work: 'Turner, though he was professor of perspective to the Royal Academy, did not know what he professed, and never, as far as I remember, drew a single building in true perspective in his life; he drew them only with as much perspective as suited him.'[41] Buildings, like people, are part of the larger context of the observed world; constructed by men, they carry with them their own connotations of age and decay, and rarely conform to the appearance they would have on an architect's drawing-board. The principle of the Picturesque, under whose influence Turner grew up,[42] laid great stress on the ways in which pictorial

truth favours all manner of deviation from regularity, and it would have been counter-intuitive for him to seek mathematical exactness in drawing architecture. His occasional exercises as a young man in colouring and adding backgrounds to professionally produced architectural elevations show the discrepancy that inevitably exists between the art of the landscape painter and that of the architect.[43] By the same token, academic exactness in drawing the human body according to the rules of the anatomist or the classical sculptor would have introduced absurdities into attempts to present the reality of the world.

None of this would exonerate incompetence on Turner's part, and it will be one of the aims of this book to show, while acknowledging his occasional shortcomings (which it is important to admit can sometimes be wilfully unsightly), that he was a highly competent draughtsman at every level. The materials he used, the supports he selected and other technical matters must necessarily be taken into account, but that aspect of Turner's practice has been extensively investigated in the last decade or so, and my purpose is not to add to that field of research. Rather, in order to understand how he drew, one must understand what he intended to convey, and why he drew as he did in particular creative contexts. Accordingly, Turner's draughtsmanship will be discussed here as an essential element in the grand strategy by which he achieved his formidable results.

Turner's history of drawing

Turner was born into an age in which the collecting of Old Master drawings and prints was an established part of civilized life. By the beginning of the eighteenth century the habit, common on the Continent since the sixteenth century, had become widespread among British connoisseurs and artists. The great collections of the seventeenth-century painters and virtuosi, among which that of Charles II's court portrait painter, Sir Peter Lely, was especially distinguished, had come on the market and been dispersed among many new aficionados. The cabinet of the gentleman connoisseur was an increasingly common phenomenon, and the growing professional self-consciousness of London artists ensured that they too studied and collected the work of their predecessors. Early Royal Academicians as diverse in their practice as the topographer Paul Sandby and the President, Sir Joshua Reynolds himself, were large-scale collectors. There were sound reasons for this professional interest: drawings and prints provided a readily accessible library of images by the great masters for reference and inspiration. The 'print cabinet', moreover, was the mark of a sophisticated and cultured mind and helped to propel aspirant artists of the new, upwardly mobile breed into the ranks of the gentry.

Turner, the son of a Covent Garden barber, had little wish to be taken for a member of a class other than his own somewhat lowly one, or, at any rate, he acknowledged that he lacked the social graces to imitate Reynolds or his own near-contemporary, Thomas Lawrence (1769–1830), in bridging a wide social chasm. He did not collect drawings and prints in order to shine socially, and he never achieved an assemblage of works on paper even remotely to rival that of Lawrence, a collection 'unequalled in Europe', as Lawrence himself justifiably thought.[1] Rather Turner acquired drawings piecemeal as examples of the output and style of artists he felt some personal association with, either from direct acquaintance or from admiration for their work. The assorted drawings by other hands that have come down to us from his house and studio do not comprise a survey of the finest draughtsmanship of the past and present; they were acquired at odd times, usually (it seems) from the saleroom, and they reflect many of his interests, connections and influences. It seems fitting to begin a study of his draughtsmanship and its

place in his output by glancing at these evidences of his interest in other men's drawings. They can be amplified by reference to his observations on the history of European art, in his letters and other writings, notably the course of lectures he delivered in his capacity of Professor of Perspective at the Academy, from 1811 and on intermittently for nearly two decades.[2]

The broad pattern of Turner's interests was set by the prevalent taste of his time. The masters of the high Renaissance, especially Raphael, Michelangelo and Titian, were models of unquestioned authority. Turner owned more than one history of the art of this period: William Aglionby's *Painting Illustrated in Three Dialogues*, published in 1685, included 'the Lives of the most eminent Painters from Cimabue to the time of Raphael and Michelangelo'. Aglionby was precocious in drawing attention to so early a master as Cimabue: in Turner's own day the Italian 'primitives' were only just beginning to be understood. A few of his contemporaries – John Flaxman, William Young Ottley and, a little later, William Roscoe of Liverpool – were opening the way to a proper appreciation of Giotto, Sassetta, Fra Angelico, Signorelli and others who did not figure in the Reynoldsian account of European painting.[3] Turner himself was alive to non-mainstream works of art. Among his designs for 'Historical Vignettes' illustrating the history of parliamentary government for his patron Walter Fawkes, there is a representation of 'Reformation' that includes a drawing of a Latin Bible, open at its title page, with the words 'Biblia Sacra' surrounded by an elaborate sixteenth-century German woodcut border, its linear patterns interlocking in a complicated jigsaw of forms (see Figure 2.1).[4]

The work of the great artists of the Renaissance was disseminated primarily through the medium of engravings, though paintings, often of very dubious authenticity, found their way into many collections. The most distinguished of such collections might also claim to include examples of Raphael as a draughtsman, or at any rate early prints after his drawings by Marc Antonio Raimondi and others. Engraved reproductions were widely copied: for instance Turner, as a student, made a drawing from a print after Michelangelo's *Last Judgement*.[5]

Chalk was a medium specifically associated with the practice of the Old Masters; the studio drawings of Venetian and Roman painters of the late sixteenth and seventeenth centuries were typically done in that medium, often on buff or blue paper. Turner owned a figure study of this type, perhaps Venetian and dating from the late sixteenth century.[6] The studies from plaster casts and from the nude model that he made at the Royal Academy Schools were executed according to the Italian practice, using black and white chalks on blue paper, and when he was developing his ideas for his first large Academy pictures he adopted these media as the appropriate vehicle for such important ideas, whether they involved figures or not (see Figure 5.9, p. 80).

The tradition of drawing from the model can be traced to the Italian quattrocento. The great artists' studios of the high Renaissance were in effect academies in which much drawing went on. Assistants, colour-grinders and

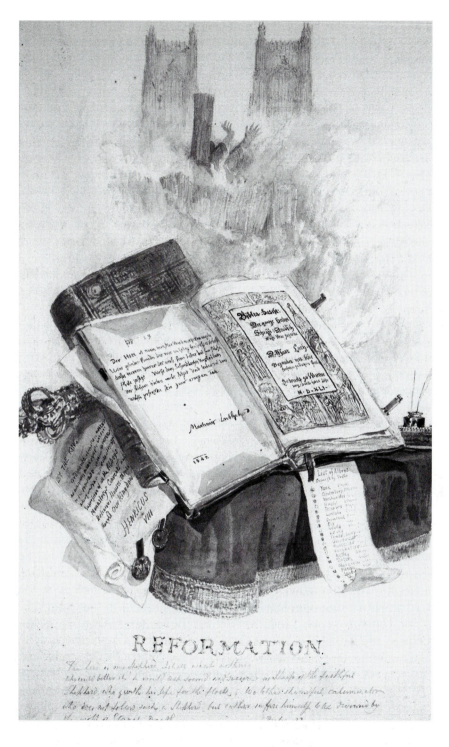

2.1
'Reformation
(Luther's Bible)',
historical
vignette from
the *Fairfaxiana*
album),
c. 1815–25,
pencil and
watercolour,
32.6 x 20.2 cm
(private
collection)

apprentices might all be roped in as models, for a whole figure, for a limb or to carry drapery for study. Each element in the group that made up an altarpiece would be studied from life, in pen and ink or in red or black chalk. To make a crude generalization, the Florentines tended to prefer pen or metalpoint, as favouring their emphasis on 'disegno' or drawing; in Venice, as the value of plastic form expressed through colour became the great preoccupation, chalks were used as more evocative of the three-dimensionality, the plasticity of things.[7] The artists of the Roman Baroque favoured chalks on blue paper, and this bias was inherited by the French, whose characteristic media they became. Antoine Watteau (1684–1721) was especially associated with delicate drawings in red, white and black chalks on white paper, his 'trois crayons' manner, which continued to be used by his successors in France. Turner owned a drawing in black and white chalks on blue paper which is probably French: a study of a pumpkin plant, which may be by the painter of animals and still life Jean-Baptiste Oudry (1686–1755).[8]

The first school of draughtsmen by whom originals could be readily collected in eighteenth-century England were the Dutch, prolific draughtsmen in many media throughout the seventeenth century. Turner owned an even earlier example of Netherlandish art, a small sheet depicting the *Nunc Dimittis*, in pen and brown ink and wash, which bears an attribution to Hans van Aachen (1552–1615).[9] The work of the greatest of the Dutch masters, Rembrandt, was in demand, his pen and ink drawings (often confused, as they are to this day, with the work of his assistants and pupils) eagerly collected. Two were acquired by Turner at the sale of Dr Thomas Monro's collection in 1833; one is known today, a *Flight into Egypt* which is of high quality, if not by the master himself.[10] Rembrandt's large canon of etchings was equally valued, and represented his capacities as draughtsman in more accessible form, since the images were not usually unique, and indeed during the eighteenth century they were reissued in considerable numbers, often heavily doctored by Captain William Baillie, who got hold of several of the copper plates.[11] Turner is certain to have known many of Rembrandt's etchings, and seems to have been particularly interested in the famous plates *The Three Crosses* and *The Three Trees*, both of which he discussed in his lectures.[12] He gave quite conscious practical demonstrations of his lifelong admiration for Rembrandt in works he exhibited at the Academy in almost every decade of his career.

The Dutch were also, and crucially for Turner, the mainspring of the tradition of marine painting, which was transported from Holland to England in the later seventeenth century by the Van de Veldes, father and son. It is not surprising that he should have owned drawings by marine artists, given his early and abiding commitment to the depiction of the sea, and his reminiscence that a print after Willem Van de Velde the younger (1633–1707) by Elisha Kirkall 'made me a painter'.[13] In fact, he came to possess at least two drawings by Van de Velde himself, one a substantial pencil study of an English ship, the other an offset from a drawing of a sail in black chalk. They must have attracted him as examples of an artist who had

been of signal importance in shaping the direction his own art would take. Neither makes use of the characteristic grey wash of Van de Velde's most typical work, though Turner acquired two other marine drawings by unidentified Dutch artists which incorporate wash. He also owned some Dutch landscape drawings in pen or black chalk and watercolours. All these works seem to have been bought from Paul Sandby's sale of 3 May 1811,[14] and may be said to symbolize Sandby's role as an important link between the Dutch and English topographical and marine traditions.

But Sandby himself was not an exponent of maritime painting. One of the most notable of the eighteenth-century practitioners in this field was Samuel Scott (1702–72), who was the author of a group of eight studies of boats that Turner had acquired a decade earlier than the Sandby sale: they are in pencil with some wash, and are annotated 'West Country Barges'. They were picked up at the sale of effects of another topographical watercolourist, Sandby's pupil Michael 'Angelo' Rooker, on 1 May 1801.[15] On the previous day of the same sale he bought nine sketches by Rooker himself.[16] These were typical specimens of the draughtsmanship of the topographers: plain, functional pencil outlines recording buildings with no deviation into sentiment.

The more serious or 'academic' face of the landscape coin was represented by the idealizing compositions of masters who derived their conception of nature painting from Claude. One of Turner's early patrons, Richard Payne Knight, built up an unparalleled group of Claude's pen and ink drawings, both composition studies and sketches direct from nature.[17] Turner will have been even more familiar with a famous set of facsimiles from Claude's *Liber Veritatis*, the series of drawings recording his finished paintings which was then in the collection of the Duke of Devonshire. The facsimiles took the form of mezzotints with etched outlines, imitating Claude's pen and wash technique. They were engraved by Richard Earlom for the publisher Boydell and issued in the 1770s; they would prove an important stimulus to one of Turner's most personal projects, the *Liber Studiorum*, which will be discussed in Chapter 6.[18]

The most important of Claude's British imitators was Richard Wilson, whom Turner hugely admired. Wilson had given the English a Claudean language of their own, consonant with the theories of Jonathan Richardson[19] and the teachings of Reynolds. His more developed drawings reflect the broad, generalizing character demanded of 'high art' in the period, and are executed not in simple pencil but in the more evocative medium of black chalk, with its ability to create areas of warm tone and to suggest, in its indistinctness, the haze of atmosphere over a wide landscape. Wilson's work in Rome in the 1750s had redefined landscape painting for the British, and the best of his drawings occupied almost as honoured a place as his pictures. A series of 68 highly finished chalk drawings done for the Earl of Dartmouth were especially prized: in John Hoppner's opinion they were 'such as the Greeks would have made, & put all others at a distance'. Another Academician, Joseph Farington, remarked that 'they have all the quality of his pictures except the colour'.[20] Turner's own specimen was a large sheet

with a highly developed ideal landscape subject, representative of Wilson's work in chalk. When he acquired it we do not know, but such drawings as this must have had a considerable influence on his ideas about tone and monochrome in the depiction of landscape, matters that were to concern him a great deal at different periods of his career.

Thomas Gainsborough (1727–88) was another prominent practitioner of the chalk drawing in late eighteenth-century London. His approach to generalization was, if anything, more uncompromising than Wilson's, a single-minded pursuit of purely pictorial effects using elementary landscape forms to construct imaginary scenes whose internal logic is dictated simply by the Picturesque principle of 'that . . . which makes objects chiefly pleasing in painting'.[21] He experimented widely, with pen and wash, watercolour and even monotypes, using oil paint probably transferred from glass plates. But his most usual medium was chalk: black and white for the most part, often on buff or blue paper, the stick sometimes treated as a drawing tool, sometimes as a means of building up rich tone. Some of Gainsborough's most developed landscape drawings have the velvety density of mezzotint. Turner must have seen examples in the collections of his early patrons, notably that of Dr Monro. One of his early oil paintings is partly copied from an early oil of Gainsborough's (or a print after it),[22] and another print supplied the source for a small drawing in a very early sketchbook,[23] but he never directly imitated Gainsborough's later style of drawing. He did not adopt the 'abstract' aspects of Picturesque theory, but it seems likely that some of his experiments with tone, and particularly the 'Scottish Pencils' done in the Highlands of Scotland in 1801, were executed as much with Gainsborough's chalk drawings in mind as those of Wilson.[24]

Turner's copies after Gainsborough betoken the interested student; the Wilson drawing in his collection represents a special relationship. While the 'Old Master' drawings that have survived in the Bequest are of uncertain authorship and it is not clear how Turner came to own them, or why, there are much plainer reasons for his ownership of contemporary works. For the most part he seems to have acquired them relatively late in his career, out of nostalgia for past associations, or respect for the achievements of departed friends. Thus he bought large groups of drawings by Philippe Jacques de Loutherbourg, Edward Dayes and Thomas Girtin at the sales of Dr Thomas Monro's collection in 1833, not because they were representative masterpieces of those artists, but, more probably, because they were minor items that cost little but reminded him of his former colleagues. The fact that all these works were topographical views underlines how strong a thread the topographical idea remained for him throughout his career.

But he also collected modern drawings that were not landscapes. The leading star in his Academic galaxy was Reynolds, and it is not surprising that, when many of Reynolds's effects came on the market in 1821, he attended the sale in order to acquire mementoes of the man he saw as 'the greatest ornament of British art'.[25] He bought three pictures and one of Reynolds's sketchbooks, which included notes on paintings by Old Masters.

It was both a memory of Reynolds and a reminder of his most strenuous precept: to honour and study the masters of the past. He also owned a drawing showing a lady adorning a classical statue which has been attributed to Angelica Kauffmann (1741–1807). Another, more obscure Neo-classical figure painter, Charles Reuben Ryley (c. 1752–98), was represented surprisingly fully in his collection. Ryley worked as an illustrator and decorator, painting mural schemes for the Duke of Richmond at Goodwood and for members of the Duke's family. Turner owned a sketchbook of Ryley's, as well as two individual sheets with large single figures. He seems to have bought these at Ryley's sale at Christie's on 15 November 1798, which confirms a lively interest in figure drawing in the first decade of his career. He probably knew the artist, since he singled Ryley out as 'the strongest instance I know' of assiduous application in an aside scribbled in one of his books: 'A man . . . devoted to his Art and the innumerable sketches left at his death prove how oft he correct[ed] his design / Nor past an idle day without a line.'[26] The brief quotation (translating the Latin 'Nulla dies sine linea') has been a motto for many artists, and it was evidently one that Turner knew and applied to himself.

The rudiments of draughtsmanship

The gradual advance in *technique* which culminated in the days of Turner's maturity will be found to have been regulated, step after step, by the nature of the demands made upon professional talent. Their methods of work, and the materials they used, were enough for the purpose in hand at the time being. As culture advanced and taste improved, other and higher tasks were set before them, and then they employed new methods and needed and obtained new materials. Thus the history of technical progress, fascinating as it may be to the artist and connoisseur, and valuable to the collector as a means of assigning its true period to a work of art, derives a wider interest and a higher value from the indication it affords of the progress of national taste.[1]

In his account of the founding and progress of the Royal, or 'Old', Watercolour Society, John Lewis Roget places the institution and its members in the context of the world, local and national, from which they emerged, and of which, he emphasized, they were an important expression. No artist, however great or original, can be divorced from his times, and from the human groups to which he belongs. The Watercolour Society, founded in 1804, was the culmination of a steady progress in the arts that had continued throughout most of the eighteenth century. That progress had been marked by the establishment in the 1760s of artists' exhibiting bodies like the Society of Artists and the Free Society of Artists, leading to the founding of the Royal Academy in 1768. The vastly increased exposure of works of modern art to the public generated new audiences at the same time that social patterns were being modified by the accumulation of wealth from industry and the expanding Empire. All branches of the visual arts flourished, though the higher and more cerebral forms of painting – the historical and the allegorical – enjoyed prestige rather than popularity. Watercolour, although an apparently modest art form, was particularly well suited to the needs of amateurs since it was less messy than oil painting, and its disciplines were more readily inculcated in the context of polite society. A large leisured class, made up of the families of industrial magnates and Indian nabobs, sought stimulation, diversion and indeed improvement at art exhibitions, where their taste could be sharpened by looking and acquiring, and at the hands of drawing-masters, who themselves formed a group that grew rapidly in this period.[2]

Many artists supplemented their incomes by teaching drawing, and by publishing manuals of instruction; Turner himself had a number of pupils during the 1790s, but with the exception of a few friends he rarely gave lessons after his election to full membership of the Royal Academy in 1802. In the course of his teaching duties, like other drawing-masters he made many 'copy drawings', watercolours with simplified compositions and technical procedures that his pupils could readily imitate.[3] But he does not appear to have taught draughtsmanship as such – the use of the pen or pencil to produce line drawings, as opposed to watercolour views. He was to become, however, a conscientious Visitor of the Academy's Schools, and several accounts exist of the help he gave the students there when his own apprentice days were long over.

His history- and portrait-painting colleagues often made drawings that were intended to be seen as works of art in their own right. Lawrence, for instance, was a superb draughtsman who had begun his career making chalk or pastel portraits, and throughout his life he issued prints after his drawings; the latter sometimes fetched as much as his paintings on the market.[4] James Barry (1741–1806), like John Hamilton Mortimer (1740–79), made extensive use of the etching medium as a means of disseminating his work. In the first years of the nineteenth century the newly invented medium of lithography inspired several artists, Benjamin West (1738–1820) among them, to make designs directly on the lithographic stone, to be issued as prints that reproduced exactly the quality of the original drawing. Sometimes these designs contained landscape elements, but for the most part they were figure subjects.

There were plenty of precedents for the reproduction of landscape drawings, from the etched facsimiles of Guercino's work by Arthur Pond in the 1730s to Richard Earlom's set of plates after Claude's *Liber Veritatis* in the 1770s, already mentioned. The popularity of aquatint as a reproductive medium in the late eighteenth century was largely due to its suitability for rendering tonal effects like those integral to landscape views enhanced by wash or watercolour. (Paul Sandby was a pioneer of the medium.) Turner came to develop a significant relationship with the Earlom *Liber Veritatis* when he planned his *Liber Studiorum* in the first decade of the new century; he experimented with aquatint for one of the plates in that work, but he very rarely designed for that medium,[5] and with one or two slight exceptions[6] he never envisaged his work being reproduced as drawing *per se*. Lithography occurs even more rarely among the prints after him: only one plate was published in his lifetime.[7] The vast majority of reproductions from his designs that were issued under his supervision are either line engravings or mezzotints, and for the most part they record watercolour compositions.

If he never produced finished works in pencil or pen alone, what purpose did drawings in those media serve in the production of his vast body of work? Did he employ them only to jot down records of what he saw? Did he regard them as possessing any special qualities that he valued for particular purposes? In answering these and other questions I shall not confine myself

to pencil and pen: chalks, too – at least when only black, or black and white, are used – can be classified as a comparable medium. Even watercolour must sometimes be taken into account as a vehicle for drawing rather than painting. But the whole question of how watercolour is used must be dealt with in proper detail in due course (see Chapter 6).

The artist's materials

Whereas chalks – black, white, and red or sanguine – had been the most common material used by artists for working drawings since the sixteenth century, their monopoly began to be usurped during the eighteenth century by the lead, or plumbago, point. This was a much finer point than was generally available with chalk or charcoal, having some of the qualities of the old metalpoint, favoured by artists of the late medieval period and the early Renaissance, which incised a dark line on a prepared ground containing lead or Chinese white. Plumbago required no ground, for it imparted its own greyish colour to any sheet of paper. It was used extensively by miniaturists in the seventeenth century, who exploited the delicacy of line achievable with its hard point, and the precision with which features such as hair could be rendered strand by strand.

By Turner's lifetime, the pencil had begun to assume a character that we would recognize. It was not made of lead, of course, but of 'black lead', christened 'graphite' because it was used for drawing. This was prized because it produced a firm black line when drawn across a smooth surface. It was mined in very few places on earth, the most important of them being, as it happened, in England. The black-lead mine at Borrowdale in Cumberland had been exploited since the sixteenth century, excavation being carefully controlled so that supplies did not run out. After enough black lead had been brought out to sustain the market for a given period, the mine was closed, not to be reopened until demand required. Several manufacturers of pencils set up in business at Keswick nearby, but in due course the bulk of the precious mineral was transported to London to be exported all over the world. In the mid-nineteenth century over-exploitation brought about the closure of the mine, but by that time industrial technology had made it possible to produce a composition substitute for graphite.[8]

For a long time, the thin strips of black lead were held in iron pincers, tightened with a screw: the same device as the traditional *porte-crayon*. Often these pincers were double-ended, so that two different colours of chalk could be employed together. When graphite was used, a stick of chalk or charcoal might be mounted in the other end so that the artist had the two media to hand at once. The idea of encasing the graphite in a cylinder of wood had been around since the seventeenth century, and by the end of the eighteenth it was beginning to be common practice to sell graphite pencils embedded in tubes of American cedar wood, very much as they are today. It was usual to market pencils in graded sets of varying hardness, and by the early

nineteenth century pencils often bore the code letters 'H', 'VH', 'S', 'VS' or
something similar. In the eighteenth century the word 'pencil' itself had a
rather different meaning – it might denote the drawing implement, but was
more commonly used to signify the artist's paint-brush. Addressing Turner's
contemporary, the history painter Benjamin Robert Haydon (1786–1846),
Wordsworth wrote of his 'pencil pregnant with ethereal hues'. But by the
early nineteenth century this usage was becoming obsolete with decidedly
poetic overtones; except in quotations, I shall always use 'pencil' here to
mean what it signifies today.

Turner adopted the pencil as a standard tool from his earliest years. He
began life as a draughtsman of views, and was already an earnest self-
appointed trainee topographer in his early teens, copying views from prints.
The techniques he employed in these self-imposed tasks were the standard
procedures of the time. He would draw an outline in pencil that might be
very slight, but could equally be a substantial rendering of the whole subject
in all its detail. There was then from the outset considerable potential for
choice and variety as to how the pencil contributed to the whole drawing. As
a rule, it existed simply to guide the artist when he applied washes on top of
it. These washes served two separate functions: a first layer established the
tonal layout of the whole design. All darker areas were filled in with an even
wash of grey or brown. Sometimes this was simply made with Indian ink and
water, but there were proprietary greys like Payne's grey, and a suitable
dead-colour could be achieved by mixing, say, indigo and lake. Little attempt
was made to differentiate degrees of shadow at this stage. Over the grey
underpainting local colour would be added as required: sap green, or a blend
of, say, Prussian blue and gamboge for grass and trees, indigo for the sky and
umber or lake for brick buildings. Greys could also be enlisted at this stage to
describe bare rocks or stone masonry. Hues were modified usually towards
paler tones, or tints. An increase in the amount of water in the pigment
solution produced a lighter tint, permitting more of the white paper support
to be seen through the increased transparency of the wash. Highlights were
achieved by leaving blank, or 'reserving', the paper, so that its natural
whiteness became the highest tone in the design. We can see this system in
operation in Turner's early unfinished watercolour of *Westminster, with Henry
VII's Chapel*, where only the grey shadows have been put in, together with
some blue sky (Figure 3.1).

This establishment of a gamut of tones along the single string of the paper
colour is the fundamental principle of watercolour in the eighteenth century,
analogous to the musical tonal system of the diatonic scale. The finished
work in this medium was universally referred to as a 'drawing', not a
painting or even a watercolour, though the term 'stained drawing' was
common. In the Romantic period, just as composers increased the expressive
possibility of the musical scale by extending the repertory of tones,
modulations and key-relationships, so painters extended the expressive
power of colour and tone by moving away from the strict gamut of
transparent pigment taking its value from the luminosity of its paper

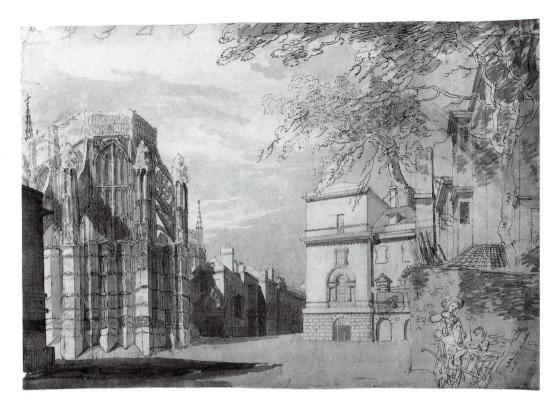

support. The 'drawing' was replaced by the watercolour 'painting', which was already by the turn of the century a new art form, consciously rivalling oil painting in its significance. The transformation was dramatic, and relatively sudden. Turner was to play a crucial role in it. But it was of the essence of the revolution that it proceeded by individual experiment and discovery, step by step. Not all the stages were accomplished in England, but it was in England that the transformation was integrated most completely into professional practice and aesthetic theory. And it was certainly in England that the revolution achieved its culmination and climax.

3.1 *Westminster, with Henry VII's Chapel*, c. 1790, pencil and watercolour, 30.8 x 45 cm (private collection)

The scientific and industrial advances that were under way at the time ensured that this aesthetic development was reflected in the physical nature of paints. Hitherto, artists had often prepared their own pigments by grinding them on a glass or stone surface, forming them into cakes by mixing them with a solution of water and gum arabic or some other binding agent. In 1781 Thomas and William Reeves were awarded the Greater Silver Palette of the Royal Society of Arts for their contributions to the arts, notably the introduction of ready-made cakes of watercolour, which required only the application of a water-loaded brush to be used directly on the paper. At first the colours available were Indian red, lake, indigo, yellow ochre, burnt umber, burnt sienna and black, but the impetus of experiment and commercial exploitation, prompted largely by the explosion in the number of amateur artists, ensured that within a few years this gamut had considerably

increased in both quality and quantity.[9] By the end of the century few artists were still making their own colours; William Blake (1757–1827) was a rare survival from the old order.

A necessary corollary of these developments in the medium of watercolour was the radical improvement in paper manufacture at the same period. As Peter Bower has demonstrated, Turner was an enthusiastic experimenter with papers of all types.[10] He bought new papers as the mills produced them, and tried out foreign papers when he came across them. There was an immense variety of type and texture to choose from, production being far less standardized than it subsequently became. There was a considerable range of colour, too: the wrapping papers that constituted an important part of the makers' output were available in various blues, greys and buffs. No papers were manufactured specifically for the use of artists until much later in the nineteenth century but, however coarse (as some wrapping papers were), they were sold ready-sized, generally with glue size, which reinforced the paper and made it a durable support for Turner's often physically demanding processes.[11]

But his lifelong preference as a support for finished watercolours was the 'wove' paper that had been developed by James Whatman and others in the second half of the eighteenth century. Previously, sheets of paper had been made by laying pulp formed from soaked and beaten rags or wood-bark in trays constructed in a wooden frame of wires laid close together, parallel to one another. These were held in place by longitudinal wires, about an inch apart. Paper made in this way had the disadvantage of carrying the impression of the 'laid lines' in tiny corrugations which collected or, sometimes, escaped the pigment brushed onto it, making a perfectly even wash difficult to achieve. Whatman redesigned the tray so that its wire base was composed of tightly meshed wires that created a smooth, even texture of paper much more friendly to the pen or brush. Thomas Gainsborough, presented with the contrast between the two types, declared that he 'could cry my Eyes out to see those furrows' in the old laid paper; 'Upon my honour, I would give a guinea a quire for a dozen quires of [wove paper].'[12] Gainsborough's enthusiasm was fired in the late 1760s; by the 1780s wove paper was becoming standard as a drawing support. Other mills quickly followed where Whatman had led. In the 1790s Turner bought large quantities of Whatman paper, which he continued to use for many years afterwards. He replenished his stocks when necessary, and was still making his finished watercolours on Whatman wove at the end of his life.

The equipment of the artist was obtainable from various sources in London, notably the emporia of artists' colourmen and stationers. Their task was modified during the late eighteenth century by the introduction of new technologies. In the middle decades, as a contemporary explained, 'The Colour-Man buys all manner of Colours uncompounded. He is, in some Shape, the Apothecary to the Painter; as he buys the simple Colours and compounds some of them. He grinds such as require grinding, and adds that Expence to the prime Cost.' He was, of course, a specialist in his own right:

'He ought to be a thorough Judge of Colours, to know all their Properties, and the common Tricks that are used in sophisticating Dyes of all Sorts, not with an Intention of cheating his Customers, but to guard against the Imposition of those who would impose upon him in the Sale of Goods.' His stock might vary, and include 'Oils, Pickles, and several Things that are sold in what are properly call'd Oil Shops: But the Colour-Man properly confines himself to what relates to Painting.' This writer admits that 'Of this sort [he knows] but one in *London, viz.* Mr *Kateing,* at the *White-Hart* in Long-Acre' – a street close to Maiden Lane where Turner spent his childhood and youth:

This gentleman deals in all Colours for the House-Painter; but his chief Business consists in furnishing the Liberal Painters with their fine Colours. A Painter may go into his Shop and be furnish'd with any article he uses, such as Pencils, Brushes, Cloths ready for drawing on, and all manner of Colours ready prepar'd, with which he cannot be supplied either in such Quality or Quantity in any or all the Shops in London. He is himself an excellent Judge of Colours, and has no mean Taste in Painting.[13]

There were other shops 'call'd Dry-Salters, who deal in Colours; but they chiefly deal with Dyers and Stainers'.[14] However, the artist would also make use of the stationers, a name 'originally applied to Booksellers, who had their Stations or Stalls near the *Temples.* The Stationer buys the Paper from the Manufacturer' – firms such as Whatman – 'and sells it out to Printers and other Dealers in this Commodity.' More important for the artist,

There are another Sort of Men that are called Stationers, who generally join some other Trade to it, such as Bookseller and Stationer, Bookbinder and Stationer, and Printer and Stationer; some of all these Trades deal in Stationery Ware, which in these Shops consist of Paper, Pens, Ink, Sand, Sand-boxes, Wafers, and Sealing-Wax, Ink Glasses, Ink-Standishes, Pounce-Books, Pocket and Memorandum Books, Copy-Books, Books of Accounts, drawn and undrawn, with all the other Apparatus belonging to Writing.[15]

Reynolds's preferred supplier was the artists' colourman Middleton's in St Martin's Lane; another Middleton, Nicholas, in Shoe Lane was listed in *Kent's Directory* as 'pencil-maker to the Prince of Wales'.[16] Other firms included Louis Berger & Sons, 'Colour Manufacturer' in Well Court off Cheapside; Reeves & Woodyer, 'Colourmen to Artists' at Holborn Bridge; and Yallop, Grace and Yallop, 'Colour Manufacturers' in Old Street. Turner is likely to have availed himself too of the services of dealers like A. Arrowsmith, 'Geographer', in Rathbone Place, from whom he may have bought maps and guide books for his journeys.[17] The famous John Boydell conducted his printselling business for much of the late eighteenth century and, under the name of his son Josiah, into the early nineteenth at his premises in Cheapside; in 1785 he appeared splendidly in *Kent's Directory* as 'Alderman & Printseller'. Many of the principal suppliers were based in the City, but by the end of the century they were beginning to populate the West End too. The most famous art store in London in the early 1800s was the Repository of Arts set up by Rudolph Ackermann in premises at 101 Strand. It was a business deliberately aimed at the amateur artist rather than the professional, and its

huge range of stock and facilities is itself an index of the colossal increase in social importance of the artist's supplier.[18] The number of such emporia steadily increased, and the range of commodities sold became likewise larger. Turner presumably preferred the professional artists' suppliers; he made use of them all his life.

He supplemented what the shops could not provide with home-made items. His first surviving sketchbook, for instance, looks as if it had been bound and sewn together by him, and a little travelling watercolour wallet has come down to us that seems to have been put together to his own specifications. A watercolour box that he was using in the later decades of his career contains cakes of pigment stamped by the colourman J. Sherborn of 121 Oxford Street, who had set up business in 1780.[19]

Although his training was very largely practical, Turner acquired books on the subject of how to draw and paint, manuals for professionals of the kind that were published in large numbers from the mid-seventeenth century on. He owned, for instance, William Salmon's famous *Polygraphice, or the art of drawing, engraving ... &c*, published in 1675. Du Fresnoy's *The Art of Painting* was also in his library: written in verse, even more than *Polygraphice* it had become a classic. It was translated into English pentameters by William Mason in 1783 and Turner used a quotation from it as a gloss to one of his exhibited pictures, the little genre subject titled *Watteau study by Fresnoy's rules* of 1831.[20] Using quotations from literature was allowed by Academy regulations from 1798 onwards, and Turner frequently availed himself of the permission, famously composing his own verses to accompany the catalogue entries for exhibited works in both oil and watercolour. He acquired many works on the theory and practice of perspective in the process of researching his own lectures on perspective in the years around 1810.

Starting a career

There was, then, a vast and expanding armoury of materials available to the draughtsman, a battery of technical resources to be drawn on. Each artist evolved his own system, and as the later eighteenth-century decades passed, some of these systems became elaborately self-conscious. We have already noticed that, with an expanding new market, artists found employment as teachers, and it was inevitable that they should compete with one another for memorable and effective short cuts to achieving atmospheric effect. The spirit of competition and of invention was in the air of the period, and the modest topographical watercolour became a focus for some of the most original thinking of any of the art forms of Romanticism. It was into this apparently innocuous but potentially thrilling world that Turner precipitated himself in 1790, when he showed his first work at the Royal Academy, a watercolour that was unashamedly and unambiguously topographical: a view of the Archbishop of Canterbury's Palace at Lambeth.[21]

There survive watercolour views by him from well before that date. Some

are copies from prints, which constituted a universal source of information about the art of topography, and on which Turner probably relied much more than on manuals and other published guides to the practice of drawing and colouring. Other early watercolours seem to be his own original work. Technically, however, they are much the same, and observe the procedures just outlined. The pencil plays no part in the finished view, but he relied on it for more than the bare outline on which he built up his washes. A view of Nuneham Courtenay in Oxfordshire, which he signed with the date 1787,[22] was completed with the aid of a small pencil drawing that he jotted in the first of his sketchbooks to have come down to us, the *Oxford* book.[23] Whether this sketch records his own observation of Nuneham Courtenay, or paraphrases a print, is not clear. Another watercolour of a couple of years later, a panoramic view of Oxford from the Abingdon road,[24] can also be linked to a pencil sketch in the *Oxford* book. This time there seems to be every reason to believe that the sketch constitutes an original observation on his part, unaided by another artist's work.

The same sketchbook contains drawings that illustrate a range of technical procedures with which he was experimenting. He used pencil to make drawings of buildings, and to construct ruled grids that enabled him to transfer these drawings to larger sheets of paper. There are quick sketches of animals and allegorical figures; sometimes the outline is made in pen and ink, sometimes the pencil is amplified with monochrome or coloured washes. One page is given over to a relatively elaborate watercolour showing a waterfall plunging beneath a bridge. There is little likelihood that this is a study made out of doors, since the view looks Italian: it must be copied from another watercolour, or from a print. But the colour that Turner has added to the other studies might in some cases have been included on the spot, as part of the business of jotting down what he saw. Much more commonly, though, he would add colour afterwards from memory. This was to remain true throughout his life.

The ruled grids, or squaring, are especially revealing. Careful pencil views of Radley Hall[25] are squared with a ruler, the divisions numbered, just as the Old Masters would square a preparatory composition study for transfer to the much larger support on which the finished painting was to be executed. It was not common for topographers to proceed like this, and Turner didn't himself make much use of the method afterwards. There is nothing exceptionally complicated about the Radley Hall compositions that might have made the squaring particularly helpful. He was simply emulating a grand practical and professional tradition, getting a useful trick under his belt.

This diversity of method and intention in one early sketchbook is itself indicative of the young artist's wide-ranging ambitions, modest though they still are at this stage. The *Oxford* book is interesting for another reason: it was apparently manufactured by Turner himself, sewing folded sheets of paper together within thin boards covered with paper. He was beginning to establish his working procedures, and the use of sketchbooks was itself to be an important methodological item. Between the covers of sketchbooks much

of his thinking would be carried on. The point is reinforced by another early book, one of the very few to have escaped from the Turner Bequest, now in the University Art Gallery of Princeton, New Jersey. Although it is smaller in size than the *Oxford* book, it betrays even more wide-ranging and ambitious interests, including a copy after Gainsborough and ideas for a literary subject, Ophelia.[26] A concern to broaden his range is an undercurrent of many of these early studies.

The roles of drawing and painting in England have frequently existed in a symbiotic relationship with printmaking. The connection was often, as in the case of both Turner and Reynolds, a frankly commercial one. Reynolds had cultivated close relations with a group of mezzotinters who had been responsible for a steady output of plates reproducing his most important portraits, which were disseminated to a wide public through the print-shops that, like the arts emporia, were increasingly numerous in late-eighteenth-century London. Turner, with a sound business head on his shoulders, seems to have sensed the value of the print market from an early stage. His first tour away from the relative familiarity of the Thames Valley and the home counties was to Bristol in 1791, and while there he formed the idea of making a series of 'Views of the River Avon' which might be published as prints. A few of these 'Views' were completed, in sharp, bright watercolour. They show the Avon flowing beneath the cliffs of the gorge at Clifton, and include scenes at Malmesbury, where Turner was captivated by the monumental ruins of the Norman abbey. He seems to have entertained the idea that he could etch the plates himself, and jotted down a brief résumé of the etching process on a sheet of paper that he had been using at the Academy Schools. He even began to design a cover. But that was as far as the scheme got. It was an ambitious plan to widen his audience, one whose time had not quite arrived.[27]

The scheme had clearly been inspired by the popularity at this date of engraved or aquatinted topographical views, which fed the fashionable market for Picturesque scenery. It was entirely typical of Turner to wish to tap that market. Equally characteristic was his decision to try to make the prints himself. He wanted to be in control of the production process, and at the same time had a natural urge to master a new medium which was in a sense intrinsic to the art form – topographical view-making – that he aspired to command. He saw the form in its social and economic setting, no abstract creative activity but a commercial business related to a real audience, a real market. This lively perception of how things were at an economic level gave him his insight into landscape, and prompted his urgent review of the status of landscape painting. It was a branch of art that deserved greater esteem, a more exalted status than its generally accepted position in the hierarchy, below history and portraiture. He aimed to attract royal patronage for landscape. Portrait painting had it; why not its sister art? These motives underlie much of what he set himself to achieve, and his work cannot be understood without understanding them.

The dominant aesthetic theory of the time asserted that the importance of

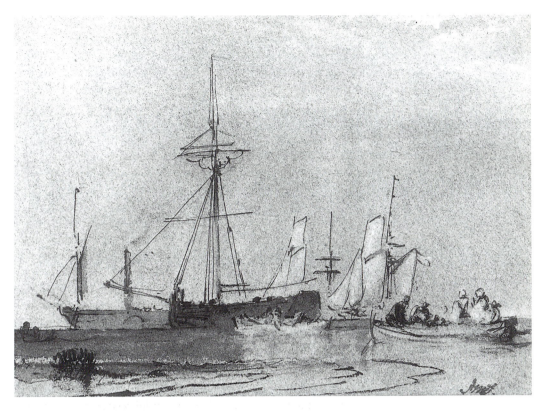

a work of art was to be assessed by its subject matter. By definition, a painting of still life could not aspire to the same status as a painting depicting the actions and passions of heroes. The more exalted the sentiment, the more exalted the art. The idea that the created object itself possessed an intrinsic value was not much considered, although notions of craftsmanship and mastery of execution were certainly current. We might draw a parallel with present-day views on the importance of certain kinds of art object which, regardless of any technical accomplishment they may exhibit, express, or purport to express, serious ideas about subjects – 'issues' – of topical concern. In Turner's youth the artist was not necessarily expected to address ideas thrown up by contemporary events, but he was asked to engage with the highest activities of the human mind and spirit. The doctrine of the Sublime had been thoroughly aired by a succession of philosophers and aestheticians in the course of the century, and had been underwritten firmly by Reynolds in his Presidential discourses to the Academy students.

3.2 *A Study of Boats*, c. 1828–30, pen and brown ink and wash heightened with white on blue paper, 13 x 18.2 cm (D.92 1892; Whitworth Art Gallery, Manchester)

Turner knew very well that Reynolds's priorities were correct. He had no wish to overturn the framework of values on which the Academy was built. (That objective was to be Constable's shortly afterwards.) But he did, as we have seen, aspire to bring landscape painting within the bounds of 'Sublime' subject matter. That involved tackling subjects more substantial than views in the Thames Valley. It more or less obliged the young landscape painter to visit grander scenery. If he was to paint buildings, then they should be noble

remnants of a glorious past, redolent of heroic deeds and high ideas. Cathedrals, ruined monasteries and castles furnished suitable matter. But to serve their ambitious purpose these things needed to be drawn with more than perfunctory accuracy. The very act of recording them must embody their solemn and venerable antiquity, the texture and patina that bore longstanding witness to the passage of time. Even a pencil outline must capture these subtle things.

The economics of art, then as now, were more ruthless than Academic theory would have liked to allow. Reynolds's own adherence to portraiture, despite his advocacy of history painting, was a perpetual demonstration that artists must live, and that the most intellectually respectable activities are not necessarily the most remunerative. History painters rarely did well for themselves; Benjamin West, the American who succeeded Reynolds to the Presidency in 1792, was a rare exception, having found royal favour. It was more usual for the painter with noble ideas to live and die in penury, like James Barry. (Barry's zealous pursuit of history was of a piece with the ideological intransigence that underlay his contentious personality; he was ultimately expelled from the Academy.) Turner's achievement was to unite history and landscape, and to do so from an early age within the framework of an Academic career.

But even precocious success as a painter and the quick public awareness of his exceptional gifts were not in themselves enough to guarantee wealth and security. In the years when he was setting his sights on the Academy's honours, he was at least part of the time a drawing-master in the well-established English tradition. Like everything else he undertook, he approached this job with acute professionalism. As we have seen, he followed the common practice of the time in making 'copy drawings' for pupils to imitate, and these were still in his house when he died.[28] An early record of his activity as a teacher is a note jotted down in the spring of, probably, 1794, in a little sketchbook known as the *Marford Mill* book: 'Major Frazer / April 6 1 Hour & Half / 8 Lessons'.[29] A few years later, in 1798, we find him in correspondence with a friend, the Rev. Robert Nixon of Foot's Cray in Kent, whose drawing, on the back of a letter, he has carefully annotated with suggestions and corrected with washes (see Figure 3.3).[30] This practice of supervising other people's work, assessing and amending it, often by means of mailed correspondence, must have proved useful experience when he came to forge working relations with the engravers who were to translate so many of his designs into black and white.

For the real money lay, as Hogarth and Reynolds well knew, not in an original work, but in the reproduction that could be sold in bulk to a wide public. But Turner would never confine his creativity to high-minded 'historical landscapes' in oil or watercolour, and had no wish either to discontinue the topographical view-making he had been trained to do. That remained a staple of his output for the rest of his career – so much so that in his last decade he insisted on continuing the lifelong habit of creating series of topographical views, even though print publishers were no longer

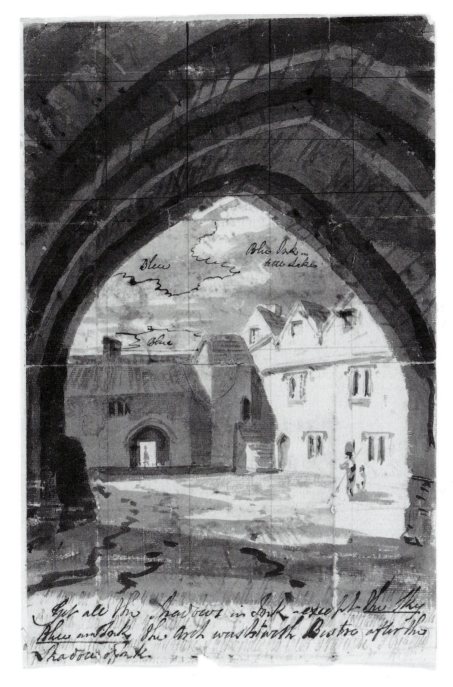

3.3 Annotated copy drawing, with letter from Revd Robert Nixon, c. 1798 (Tate Archive)

commissioning them. Furthermore, during most of his life the engravings made from his views, often issued in the form of books of plates with commentaries, were a primary source of his income. Later, he expanded this practice to include vignette illustrations to volumes of poetry. Turner believed in the virtues of what would nowadays be termed 'diversification'.

Yet another option lay open to him, and it is astonishing to realize that at the very moment when he was within sight of his goal at the Academy, and had actually been elected A.R.A., he could contemplate taking up a position as travelling artist to an archaeological tour. In 1799 the Earl of Elgin invited him to join his expedition to Greece, and Turner seriously considered going. It was only the Earl's insistence that he should retain all the drawings that resulted from the trip that decided Turner against the venture. Turner naturally wanted to maximize his own investment in such a tour by keeping and referring to his drawings for further use, as he was to do throughout his life. He was the type of the independent artist, that new invention of the Romantic period, when patrons ceased to dictate artistic activity. Elgin's was a very eighteenth-century proposal, something that had been a matter of course for the emissaries to distant places of the Dilettante Society, or for scions of the aristocracy making the Grand Tour: an artist was an accepted member of any enlightened traveller's entourage. But that sort of thing was becoming rarer; the French Wars restricted all foreign travel, and after 1815 the world was a different place. Turner was one of the last painters to be offered such a role, and it is symbolically right that he refused it.

The Academy Schools

If Turner was fully aware, from an early age, of the intimate connection between drawing and earning a living, he was equally conscious of the need to submit to a discipline that had as its ulterior goal the production of superior works of art. Ruskin, moralising about Turner's youth rather in the manner of Samuel Smiles, affirmed that in working for

the commonest publications of the day, and for a remuneration altogether contemptible, he never did his work badly because he thought it beneath him, or because he was ill-paid. There does not exist such a thing as a slovenly drawing by Turner. With what people were willing to give him for his work he was content; but he considered that work in its relation to himself, not in its relation to the purchaser. He took a poor price, that he might *live*; but he made noble drawings, that he might *learn* ... he is *never* careless. He never let a drawing leave his hands without having made a step in advance, and having done better in it than he had ever done before ...[31]

We do not have to endorse the idealizing tone of this imaginative snippet of biography to agree that Turner's early drawings exhibit a pertinacious pursuit of steady improvement. It is worth noticing that Ruskin was speaking of those drawings that Turner allowed to 'leave his hands' – that is, finished works in watercolour – but it would follow from his encomium that any drawing, however slight, may be regarded as a demonstration of the artist's conscientiousness. In the face of so many thousands of working sketches, studies and mere scraps produced over a long lifetime, it would perhaps be hard to insist on this point, but we can generalize to the extent of saying that almost every drawing fulfils its function, whether slight or highly sophisticated. Beneath this lifetime's accomplishment lie many layers of

apprenticeship. Turner's enrolment in the Schools of the Royal Academy would have been a necessary stage in the process even if he had not subscribed to the fiercest belief in the professional value of that institution.

We have already noticed that, in the opinion of some, landscape did not entail the disciplines required by figure painting. As late as the 1870s, Hamerton could record that 'Some landscape-painters say the Academic training is of little use to them or that it is certainly not so useful as studies from landscape-nature out of doors', but he countered this observation by saying that 'others believe that the work done in Academies, though it has so little apparent connection with landscape, is a better preparation for the future work of a landscape-painter than the premature study of trees, and hills, and water.'[32] He went on, 'There are reasons in favour of the latter opinion which are not obvious at first sight, but they are of a kind which the most intelligent artists are the most likely to estimate justly.' Turner may evidently be classed with these latter.

He was, besides, determined to bring out the greatest potential of the landscape art that he had espoused. He may have come across an account of landscape painting published just before he began his apprenticeship and Academy training, a *Lecture on Landscape* by the artist and publisher Charles Taylor, writing under the pseudonym Francis Fitzgerald Esq., which appeared in print in 1786 and was reprinted more than once. 'Fitzgerald' summed up the 'branches' of landscape between which the artist might choose: first, 'the sublime and grand ... the HISTORICAL', second, 'that which endeavours to represent a faithful picture of Nature as she is; [which] we denominate the RURAL', and third, 'VIEWS of particular places wherein accuracy is an important principle'. Of these, the historical type of landscape

seeks in unusual subjects situations and forms, what shall rouse, and, if possible, rivet the spectator's regard; but, besides being uncommon, the composition must be beautiful and engaging ... These qualities are sought in commanding situations, and bold projections; in masses of rocks and mountains; or whatever nature presents as solemn and stupendous: in noble fabrics, temples, palaces; in ruins of capital buildings; and the most magnificent exertions of art: the lofty turret, the ivy-mantled tower, the consecrated aisle, the melancholy tomb.[33]

The expressive accessories listed by Taylor carry with them an assumption of narrative content which must in practice often be realized in terms of figures. The Academy was the proper place in which to learn the requisite skills for such work.

Formal academies had been established on the Continent in the sixteenth and seventeenth centuries, to give proper training to artists;[34] no such institution emerged in Britain until much later. In 1757 R. Campbell, the author of the guide to the trades of the capital we have already quoted, lamented that 'we have but one Academy meanly supported by the private Subscription of the Students, in all this great Metropolis', unable to maintain more than 'two Figures', or models, 'one Man and a Woman; and consequently there can be but little Experience gathered, where there are neither Professors nor Figures'. Campbell contrasted this situation with that

in Rome and Venice, 'the two principal Schools for Painting', with 'eminent Professors' and 'as great a variety of Figures ... as the Students require'. In addition, 'the young Painter must remain two or three Years; and afterwards visit the most famous Works of the antient Painters ...'.[35]

The Schools of the Royal Academy had been instituted as an integral part of the original foundation of 1768. The Instrument of Foundation, signed by George III on 10 December 1768, provided for their direction by 'the ablest Artists', stipulating that 'there shall be elected annually from amongst the Academicians nine persons, who shall be called Visitors; they shall be Painters of History, able Sculptors, or other persons properly qualified'. Under the superintendence of these Visitors, drawing classes were to be organized, the students instructed and their work examined. The students would be admitted after samples of their work had been submitted and approved. The Academicians would elect from among themselves Professors of Anatomy, Architecture, Painting and Perspective and Geometry, who would all deliver courses of lectures to the students. Drawing classes were to be 'free to all students qualified to receive advantage from such studies'. There would be 'a Winter Academy of Living Models, men and women of different characters' and 'a Summer Academy of Living Models, to paint after, also of Laymen [i.e. mannequins] with draperies, both Antient and modern, Plaister Figures, Bas-reliefs, models and designs of Fruits, Flowers, Ornaments &c.'[36]

Turner first enrolled at the Schools in 1789, and was for some time a regular attender at the Plaister Academy, making a series of drawings from the collection of casts after the Antique (see Figure 3.4); a couple of studies after an *écorché* figure seem to date from early on in his time there.[37] The records show that he would attend regularly, day after day, for several weeks, then absent himself for a few days, presumably for family reasons, or for some weeks if he was out of London on tour. He progressed to the Life Class in 1791, but was still putting in increasingly irregular appearances at the Plaister Academy for much of that year too. He continued to attend the Life Class intermittently throughout the 1790s, and there are drawings, in the Turner Bequest and elsewhere, which document his progress. The record is one of steady application and of considerable achievement. The studies from casts are, perhaps inevitably as they are among the earliest, somewhat stiff, but with the change to the living model greater animation quite naturally appears. The early efforts are no worse than those of any reasonably talented beginner, and the quality of the work rapidly improves.[38] There are signs, even in some of the most uncompromisingly academic studies, of the energy and humour that pervade the figures in Turner's early watercolours. Each study is on a separate sheet of paper, either white or blue, the figure almost filling the space. Some of the studies from casts are done in pencil, but it was natural for him to adopt the medium of the Old Masters in these exercises, and he mostly worked in black chalk, heightened with some white. He seems to have backed up his practical exercises in the Schools by consulting works like John Tinney's *Compendious Treatise of Anatomy, adapted to the arts of*

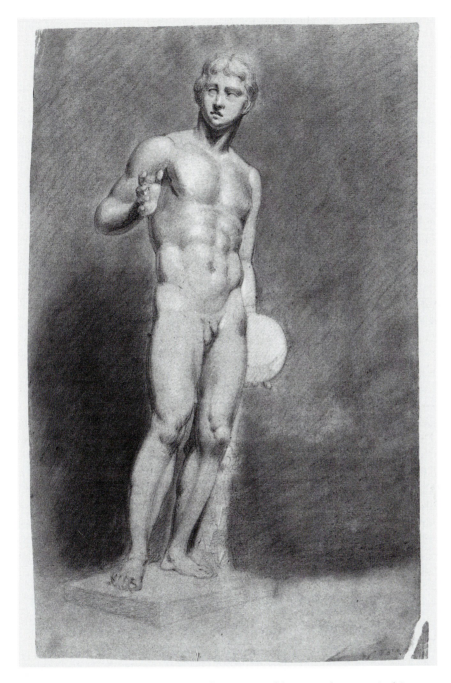

3.4 *The Diskobolus (Study from the Antique)*, c. 1792, black and white chalks on grey paper, 44.5 x 28 cm (Turner Bequest V O; Tate Gallery D00067)

designing, painting, and sculpture, of 1772, a publication that was in his own library.

The poses of the Life Class models were customarily chosen and superintended by the Visitor to the Schools – one of the Academicians. Turner was later to take some interest himself in the job of placing and arranging the model. Poses were often based on figures in works by the Old Masters, and

while he was a student Turner several times drew figures in strenuous positions adapted from Michelangelo or the Carracci. These reflect the current concern to express powerful emotion or human drama through the attitudes of the body, a preoccupation especially notable in the work of Henry Fuseli (1741–1825), a prominent Academician, who was to become Keeper in 1804. The extreme violence of Fuseli's gestural language was admired as exemplifying the grandeur of heroic or Sublime art, and a taste for emphatically energetic poses sometimes made itself apparent in the class-room. In about 1794, Turner made a study of a male nude half-kneeling, with head thrown back onto an upraised arm, an example of this type of pose.[39] He also made a drawing of a nude figure which seems to be a 'five-point' study of the kind that Fuseli enjoyed inventing. In this exercise, head and extremities must fit five randomly scattered points on the sheet, so that the body may be contorted in unpredictable ways (see Figure 3.6).[40] Such essays tended to promote a view of the human body as elastic, almost infinitely mouldable to suit the expressive requirements of the figure painter. In Fuseli's own work the language of the violently contorted body serves a kind of expressionism that conforms perfectly to his exaggeratedly dramatic subject matter. Turner's expressive use of the figure may owe something to this background in Fuselian *Sturm und Drang*.

High Romantic expressiveness apart, the disciplines of the Plaister and Life Academies will have tended to reinforce the emphasis on outline that, as we have noted, was a salient feature of the aesthetic in which Turner was brought up. He duly respected it, and came to admire the French for their skill in this regard: 'Drawing or in other words the outline is the predominant character of the French School.' But having experienced the London Academy's newly established teaching methods, he came to the conclusion after he had visited Paris in 1802 that for the French 'precision of detail is their sole idol', to the detriment of painterly breadth. They had not achieved the 'middle course' that would require the combination of refined draughtsmanship with the expressive use of paint. As he noted in another place, 'The student must distrust the opinions of his preceptors when he views the works of David and the French school, where drawing stands first second and third.' He added three lines of verse to this observation:

> Without the aid of shade or tone
> But indivisible alone
> Seems every figure cut like stone.[41]

He had anticipated these opinions in his own studies from the model as they evolved, in the later 1790s, into explorations of the relationship between figure and ambient space, abandoning the formal pencil or chalk outline for a more painterly method. The little book that he labelled twice – 'Academy' and 'Academical' – in about 1798 contains thirteen drawings from the model in watercolour and coloured chalks on a reddish ground that he had previously washed over the leaves of the book.[42] The sense of effort that suffuses the early Academy studies has gone now (see Figure 3.5). The figure

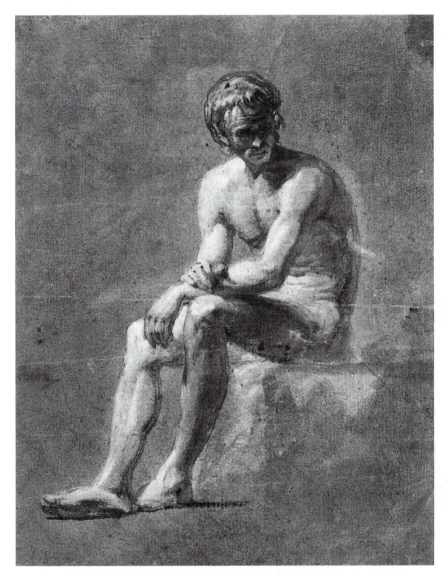

3.5 Study of a
seated male
nude,
c. 1800, pencil
and gouache on
buff prepared
ground, 25 × 20.2
cm (private
collection)

is approached with a new freedom and vitality that proclaims the relevance
of these exercises to the accomplished figure drawing to be found in some of
the early oil paintings. The most notable of these are *Calais Pier* of 1803 and
The Shipwreck of 1805 in which the drama of the sea is expressed largely
through the actions of people. The large *Calais Pier* sketchbook, in use in the
years about 1800, contains many preparatory drawings for these important
paintings (see Figure 5.9, p. 80) and also includes nude studies obviously
made at the Academy Life Class with the responsibilities of the serious figure
painter very much in mind.[43]

 At various times later in his career he undertook the role of Visitor to the
Schools, and took his duties there seriously, as he did all his official relations
with the Academy. In the course of superintending the work of students, he

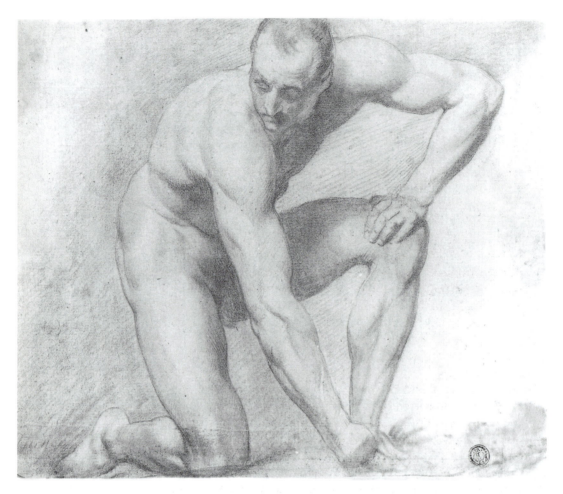

3.6 Academy study of a male nude stooping, c. 1798, black chalk and charcoal, 21.7 × 25.8 cm (The Art Institute of Chicago)

would often take out a small book and make his own drawings. These prefigure a myriad studies of people, usually rapid jottings in pencil, which are to be found scattered through the Turner Bequest: notes of occupations, of costumes and occasionally more elaborate studies of figures for themselves rather than for what they could tell him about their environment.

Turner's relations with the Academy Schools reached a climax, as it were, when, in 1811, he delivered his first lecture in the capacity of Professor of Perspective. He had been elected towards the end of 1807 and it had taken him two years to accomplish the necessary reading and to plan and draft his course. He also made diagrams and watercolours on large sheets of paper to illustrate what he had to say. The purpose of the course was to inculcate the principles of architectural draughtsmanship and of linear perspective into the students. He himself had probably attended lectures given by Edward Edwards (1738–1806), who, though never a full Academician, had been Teacher of Perspective since 1788. His own eagerness to take on the job, despite his lack of skill as a public speaker, was at least in part a desire to contribute to the function of the Academy as a teaching institution. It was a

way in which he could communicate his knowledge to others, which in various often indirect ways he tried to do all his life.[44]

In addition to the mechanical disciplines of linear perspective, he sought to enunciate broader ideas on the function and nature of art, and his lecture notes contain odd snippets of information on his view of drawing in itself.

The functions of drawing

The term 'study' has already appeared several times in this survey, and it will occur frequently hereafter. In the present context of Academic practice it may be as well to define it, and some of the other words used to designate different types of drawing. They are closely associated with the working methods of the artist, and their precise signification will vary according to the character of the individual draughtsman. Turner's own creative personality changed as his long life unfolded, and it is perhaps dangerous to assume that definitions valid for his practice in 1800 are equally accurate when applied to his activities in 1840. But throughout his career, and underlying everything he did, certain basic procedures remained more or less constant, and can be described in terms of the types of objects – whether drawings or paintings – that he produced on the route to any finished work.

The idea of the 'finished work' is central, and particularly difficult to grasp in Turner's almost unique case, on account of the mass of half-finished and unfinished pictures we possess by him and tend to treat as though they were indeed finished. All of this is quite apart from the even larger number of works never intended to be finished, which also fall into categories involving different degrees of 'completeness' in their own terms. Any Academician of Turner's time – and he was, as we know, staunchly committed to that appellation – believed implicitly in the finished work of art, indeed rarely thought in terms of anything else. One of the innovations of the period was the establishment of the 'study' as constituting a legitimate focus of serious attention. This did not mean that studies were now viewed as though they were finished works of art. They remained what studies had always been – preparatory works, in which ideas that would be fully exhibited in finished pictures were plotted and explored. The great difference between the Romantic study and the traditional Academic study was that whereas the latter was usually a studio exercise, assembling details of bodies and drapery, or whole groups of figures, to be placed in a large composition, the Romantic study reflected the new interest in nature as a vehicle of expression, and was more likely to be executed out of doors. It was therefore by way of being an attempt to record facts about the natural world in a spirit of open-minded investigation. This was why Constable referred to the oil sketches he made out of doors as 'scientific experiments'.[45] His *plein-air* paintings, notably those in oil, are the *locus classicus* of the Romantic study.

Finberg argued that 'A study ... points to the object it was made from – it assures us that this particular object was bodily present to the eyes of the artist when he made the study, but it does not tell us in what ideal context we are to take the object.'[46] In other words, it does not have the trappings we assume come with the finished work of art. It was the achievement of Constable, Turner and their contemporaries to undermine that assumption: their informal sketches and studies possess qualities that we are happy to accept as works of art in their own right even though they do not serve a wider conceptual purpose. But whereas Constable was dedicated, in an almost systematic way, to the elevation of the study, and even the sketch, to a point at which it took over the role of a finished work, Turner never abandoned his Academic prejudice. Sketches, studies and finished works occupy distinct places in his working procedure, and despite the variations over time that I have suggested, he never greatly modified his priorities.

How, then, are we to define these terms? The study is a record, as objective as possible, of an external observed fact or set of facts. But it needs to be distinguished from the sketch, which is just as much a staple of Turner's method. The two terms can be used interchangeably, but that is to lose an important nuance. It is best to restrict 'sketch' to refer to rapid note-taking, the sort of drawing, usually in pencil, that the artist would make in his travels, generally in a small book: a 'sketchbook'. There are many hundreds of such drawings in the Turner Bequest, and they are sometimes elaborated with colour, but for Turner the application of colour tended to belong to a different stage in the process. The sketches may note figures, trees, wayside plants, odd objects seen in passing (see Figure 5.5, p. 73) – these are the subject matter of many studies by Turner's contemporaries; but he occupied himself with such things relatively rarely. More usually his sketches record topographical specifics: individual buildings or groups of buildings, a whole town seen in the distance or on the horizon. These drawings are amplified by signs, capital letters, numbers and verbal notes indicating colours and effects. The extreme acuteness of Turner's observation is revealed in some of his memoranda: Gage remarks on a note in the *Edinburgh* 1818 sketchbook which records variations in the width of a rainbow in relation to its background of sky.[47] Significantly often, even at the beginning of his career, these drawings have a tendency to adumbrate a landscape composition: the course of a river is indicated by a few quick lines, with its wooded banks and backdrop of hills. But despite the implied complexity, they are still rudimentary in the manner of their presentation. If climate is included, it will be indicated equally swiftly, and again letters will provide reminders of the colours of clouds or sky.

This kind of shorthand is alien to the study, which develops its content rather more fully. It too may concentrate on a single element of the landscape, but will record every aspect of the subject in detail. It may not approach the minuteness that Ruskin was to promulgate a little later, but it will dwell on the specific rather than the general. Such studies, again, are rare in Turner's output. He would always prefer to encompass a whole landscape at once,

and his oeuvre is replete with full-scale landscape compositions that exist only in the form of studies. Often, though not invariably, they make use of colour. They 'study' the problem of composing a particular subject, and so serve a meditative, introspective function, one that is, as it were, the opposite or complement of the outward-looking sketching process of recording what is seen.

Some of the composition studies are so all-embracing, so 'complete' as statements of their subject matter, that they are generally taken as finished works. An example of this type is the group of views on the Rhine that Turner completed during his tour of 1817, and indeed sold to Walter Fawkes as though they were finished (see Figure 6.3, p. 93).[48] Finberg certainly considered them 'finished drawings'. He objected to Thornbury's assertion that Turner accomplished his set of fifty Rhine views 'at the prodigious rate of three a day'; 'No one who has studied these beautiful drawings at all carefully could believe such a statement.' But he pointed out that the sketchbooks contain between 150 and 200 pencil drawings made during only twelve days; these were consulted when Turner came to make his coloured studies at a later date, either in lodgings on tour or later, when he had returned to England. They are, he thought, 'carefully pondered and perfectly elaborated works of art'.[49] Yet there is a difference between Fawkes's Rhine series and the group of genuinely finished watercolours that Turner developed from some of the same subjects a little later. Sometimes those differences appear small, but they involve completely separate techniques, like hatching, stippling and scraping-out, which need to be appreciated if his range of intentions is to be grasped.

The sketchbooks comprise such a multitude of notes and drawings that it would be misleading to describe their contents as consisting exclusively of 'sketches', even though this class of work is by far the most numerous. Some books, notably early ones like the *Calais Pier* sketchbook of about 1800 or the *Studies for Pictures, Isleworth* book of 1805,[50] were used mainly for composition studies for elaborate paintings. (The latter title, Turner's own, employs the word 'studies' in a usefully definitive way.) The later 'roll' sketchbooks of the 1830s and 40s frequently have sketches in pencil or watercolour, and sometimes both together, and in addition they were used for the development of ideas for finished works in watercolour, the type of studies that have come to be known as 'samples' for the use of his dealer when soliciting commissions. The lack of a hard cover, however, meant that the 'roll' books could not be simply held in the hand, a method of working 'on his feet' shown in a famous likeness.[51] The larger, floppy sheets required support, and this suggests that most of his 'roll' sketchbook drawings were executed indoors, after the day's touring. Occasionally, though very rarely, a sketchbook page was taken to a point of completion at which Turner could remove it from the book and mount it as a genuinely finished work. This happens typically with some of the early drawings, which could be displayed effectively by being stuck down onto another sheet of paper decorated by the artist himself with a washline border. The elimination of the washlined

mount in Turner's watercolour work of the later 1790s signalled the great revolution in the aesthetics of watercolour that was a central achievement of Romanticism.[52]

4

Early influences

Turner's mature drawing style was very much a pragmatic affair, begotten by necessity on innate practical intelligence. In the context of that overall development it is a matter of considerable interest to watch his growing individuality in line drawing subordinated in succession to a range of individual styles absorbed from other artists.

His early copies after prints, and juvenile imitations of the contemporary topographical conventions, hardly admit of being classified under a recognizable 'manner', but it is not long before we find a decided influence emerging – the obvious one, in fact: that of Thomas Malton, junior (1748–1804), in whose office Turner worked as an assistant at the end of the 1780s. Malton senior had published a treatise on perspective which was to instruct Turner when he was researching the subject for his lectures in the 1810s, and the first thing to be said about the style of Malton junior is that, in an important sense, it is style-less. It has in it much of the theory of architectural drawing. It is a way of recording observed facts – usually buildings – with the minimum of intrusive fuss or interpretative personality. The line is fine, even and regular; it does not aspire to the calligraphic; it does not eschew the ruler when a ruled line is evidently needed. In fact, it is commoner to encounter Malton's work in the form of hand-coloured etchings than as original drawings. The delicately bitten, drily inexpressive etched outline suited Malton's requirements very well.

Nevertheless, he was capable of investing his views of buildings with considerable grandeur – he must have digested the lessons of Piranesi's *Vedute di Roma*. His handling of scale is sometimes inspired, with soaring façades rising from the street like vertiginous cliffs, the pedestrians below dwarfed by tall columns or pilasters. Malton's manner – or absence of it – is so suave, his colouring so much the simple pale formulations of topographers' usage, that we may miss this inherent drama. To appreciate how cool and objective Malton's work is we can compare it with the architectural subjects that John Sell Cotman (1782–1842) produced in Normandy in the late 1810s and early 1820s. Many of these, like Malton's, were presented to the public as etched outlines, and although Cotman never coloured his published etchings as Malton did, he was inclined, when

applying washes, to restrict them to modest tones of brown and buff. Despite the austerity of Cotman's style in these works – and he too was not averse to the straight edge when he needed it – there is an idiosyncratic passion in his drawings that is absent from Malton's. (Cotman is a Romantic; Malton belongs in the 'classical' eighteenth century.) Turner made clear his classical lineage when, recalling his early training in perspective drawing, he said that 'my real master was Tom Malton, of Long Acre'.[1] He could not have adopted a more unprejudiced model.

In the 1791 watercolour views of Radley Hall that he worked up from the studies already mentioned he can be seen in full Maltonian vein, using a fine pen line (inked in over pencil) and a schematic tonal arrangement based on a dead-colouring of grey. The symmetrical classical building sits firmly in the middle of the view, which is without incident except for the framing trees. These subjects are almost ruthless in their simple directness. They pursue the Maltonian drawing technique alone, and altogether avoid the dramatic perspectives of Malton's most exciting work. But those were to be explored very shortly, in the Oxford, Worcester and Canterbury views of the early 1790s. For Turner the employment of scale in such a way entailed the appropriate emotional atmosphere, so that a towering cathedral interior must be presented complete with its chiaroscuro, its falling light and shadow. No doubt he too had seen Piranesi by the time he came to develop these ideas, but it is not too far-fetched to attribute his initial sense of the possibilities of architectural scale to what Malton had shown him. Early in 1792 he made a pencil drawing of the façade of the Oxford Street Pantheon, just after it had been gutted by fire. This was a subject close to the canon of London buildings that Malton had made his own, though the recent conflagration and the ruined state of the Pantheon invested it with a romantic glamour alien to Malton's view of things. We might say that Malton's method lies behind this study, since it is 'style-less' in a sense; but it is not a neat, carefully finished drawing, rather a hasty sketch. It nevertheless seeks to record as many details as possible, and its margins are covered with annotations.[2]

Together with a fastidious discipline in using line, a training in the partly mechanical skills of architectural perspective drawing inculcated various short cuts by which the work could be accomplished more speedily. One obvious tool, as we know, was the straight edge or ruler, which Turner employed on various occasions when confronted by a large-scale architectural subject. Another was tracing. This expedient appears less often, but it was a convenient method of transferring the outline of a subject from one sheet to another, and was regularly used by artists then, as now. Examples of Turner's tracing are not straightforward, however. They do not simply replicate an outline for use in making the replica of an image. Two early sheets show him moving isolated sections of the subject about on a larger sheet in order, apparently, to combine the process of transfer with that of enlargement. Thus an outline of about 1793–94, showing Tom Tower, Christ Church, Oxford, seems to have been 'exploded' from a smaller drawing of the scene, leaving spaces between the various elements, as

though they were to have been filled in by invention. The same process lies behind another fragmented image, a view of the porch of Great Malvern Abbey, on a similarly large sheet. Here the final result can be seen in the finished watercolour shown at the Academy in 1794, evidence perhaps that this was Turner's usual intention in making these odd 'exploded' tracings.[3] A further subject that may have been duplicated in this way is another Oxford view, showing the Radcliffe Camera from Oriel Lane; this exists in two finished versions in the Turner Bequest, one small, the other on the scale of the Malvern tracing. The larger version seems to have been executed a year or two after the smaller.[4]

Such experiments indicate the exploratory nature of Turner's activities in the early to mid-1790s. A much later tracing accompanies an exploratory work of a very different kind. It is drawn over a 'colour structure' of the kind that Turner was to use extensively in his maturity,[5] and is taken from a view of the Rialto in Venice, probably an engraving by John Pye after the watercolour that Turner executed in 1817 for James Hakewill's *Picturesque Tour in Italy*.[6] Here the outline tracing is taken directly from Hakewill's own drawing, on which Turner (who had not at this point visited Venice) relied for his information. The broad wedges of complementary colour, blue and ochre, follow the general design of the subject and affirm the basic warm/cool opposition on which a finished subject would be based. The pencil is, like the earlier examples we have looked at, in isolation fragmentary and rather uninformative, but in conjunction with the colour washes it almost suffices to create a vivid image.[7] We shall be examining Turner's use of 'colour structures' in a later chapter.

Another use for tracing was as a means of transferring onto paper the image of a view projected by a lens into a darkened box – a camera obscura. The camera lucida was a similar device which was easily portable and which became popular with tourists who wanted to make picturesque views. Although many respectable artists availed themselves of these gadgets, and sometimes invented their own adaptations of them, and although Turner was an enthusiastic experimenter with anything new in his way of business, he seems to have felt no need to buttress his natural fluency as a draughtsman with such adventitious aids. The partial tracings I have just discussed might have been made with a camera, but this is apparently not the case, partly because they are so fragmentary and do not consistently register the relations of the forms traced and partly because originals exist from which they seem to have been copied. Otherwise, there is no evidence for his ever having tried such devices.

Malton's cool, methodical style might have been the consequence of using a camera, but it does not seem to have been; it epitomizes the discipline of the pure professional, whose intention is simply to transmit facts. Turner quickly enough sought to break away from it. Already in his delineation of trees and their branches he was inclined to introduce a frisky note, a sense of the untrammelled, organic vitality of natural forms. Even the staid Radley Hall drawings show this tendency, and the views on the River Avon have it to a

lively degree, as do other watercolours of 1790–91. This trait might be interpreted as a reminiscence of Rococo design, but it is much more convincingly explained as an inherent ebullience in Turner's character, an innate sympathy with living, growing things. There was something flamboyant in him, despite his famously unprepossessing appearance. His friend Clara Wells described him on one occasion as wearing a 'ridiculously large cravat',[8] which suggests a certain foppish aspiration, and that trait is expressed in the signature that he used in the 1790s. His surname, often preceded by a 'W', is written in an agreeable, unforced copper-plate, with a fluently curling initial 'T'. But when he reaches the 'e', Turner almost invariably makes it a tall Greek letter, breaking the flow yet enhancing the elegance of the word so that it looks distinctively different from any other inscription of his not uncommon name (see Figure 4.1). The Greek E is an excrescence that seems to assert that this Turner is no run-of-the-mill specimen. Perhaps in this tiny calligraphic point lies a signpost to all the eccentricity and potency of imagination that were to characterize his life's work.

So it should not be surprising that Turner put aside Malton's sober manner in favour of more stylish – and stylized – procedures. We can see him searching for models. For example, in 1792 Michael Angelo Rooker exhibited a view of the *Gatehouse of Battle Abbey* at the Royal Academy, and Turner copied details from it.[9] Here he is evidently interested in Rooker's genius for rendering dappled light and shade and the textures of masonry, and the two copies show him homing in on these qualities. They are essentially exercises in watercolour technique. It was also in 1792 that he made the copy after Gainsborough in an early sketchbook now in Princeton, using unemphatic grey washes; about the same time he began to make a series of drawings that frankly imitate the draughtsmanship of Philippe Jacques de Loutherbourg.

Loutherbourg (1740–1812) was not an obvious model for a budding topographer. Born in Alsace and trained in Paris, he had evolved a polished Continental academic style. He attained eminence as a painter of grand imaginary landscapes and historical subjects. In these paintings, the high quality of his draughtsmanship is evident. The brush is often used as a drawing tool, defining objects with crisp precision, presenting foliage with a rhythmic energy that is as much linear as painterly. He produced a similar range of subjects in the form of drawings, sometimes with watercolour, usually simply in pen and India ink with monochrome washes. In the 1770s, soon after his arrival in London from Paris, he frequently essayed caricature, a form he practised with verve, taking his inspiration, as Rudiger Joppien has pointed out, from both Pier Leone Ghezzi and Hogarth, two giants of caricature who exemplify respectively the Continental and the indigenous English approach.[10] The fact that Turner acquired a number of Loutherbourg's drawings, a series of small cards with views in pen and wash of ironworks and other subjects in Wales, suggests a high and sustained regard for Loutherbourg on Turner's part.[11] But there is evidence enough for this in his work.

Loutherbourg's influence is evident in a group of imaginary coastal

scenes, with fierce breakers and craggy rocks, and other subjects which seem to date from about 1792–93 (see Figure 4.1).[12] They adopt the subject matter of Loutherbourg's grand coastal seascapes, but realize it in the more intimate language of his jagged pen and wash drawings. In these small sheets Turner's grasp of the older artist's purposes is remarkably complete. Still more interesting in this respect is an elaborate drawing illustrating a scene from *Don Quixote*. Loutherbourg had made something of a speciality of humorous illustration, which he sometimes executed on a relatively large scale, as finished drawings for engraving or framing as works of art in their own right. Turner's *Don Quixote* derives from these. The subject is Don Quixote falling out of the boat that he believes is an enchanted barque in which he is rescuing his inamorata Dulcinea from brigands. The drawing must date from about 1792–93, and is highly finished in monochrome washes with pen and ink outlines, within an oval border. A detailed preparatory study for it exists, demonstrating the care with which it was conceived and made.[13] The angular formulas with which such details as foliage are treated derive directly from Loutherbourg's characterful, highly professional draughtsmanship. It is probably no coincidence that Turner's first identifable essay in the medium of oil takes the form of an oval study of a watermill which, while it is simply a picturesque scene and in no sense a 'history', is nevertheless close to the *Don Quixote* in both format and subject.[14]

The comic nature of the incident from *Don Quixote* suggests that Turner must also have appreciated the humorous drawings of Thomas Rowlandson (1756–1827). By the time Turner had begun to make his youthful experiments, the caricature tradition had blossomed in England. Print-shops were full of political and social satires; the two great masters of the genre, Rowlandson and James Gillray (1756–1815), had evolved distinctive styles of comic draughtsmanship of which Turner must have been well aware. Humour is an important strand in his work, perhaps underestimated on account of the dramatic, not to say operatic, quality of his characteristic Sublime subject matter. But it can never be ignored, and some of his most serious subjects incorporate comedy, wry or boisterous, as a necessary element in the conditions of human existence he was dedicated to recording. Rowlandson, too, must have impressed Turner as a draughtsman of no mean ability, and in the early 1790s the caricaturist's drawing had not yet succumbed to the slack facility that often mars his later work.

Rowlandson's drawings, in their idiosyncratic way, provide another instance of the supremacy of outline in the period. Characteristically executed with a reed pen dipped in reddish-brown ink, they vividly embody the idea of constantly changing outline as his droll figures tumble and flutter across the surface of the sheet. Translated into etched prints that sold in quantity, this line of Rowlandson's was encountered everywhere, a staple of the visual world of Turner's youth. In landscape too, Rowlandson could use his pen line to expressive effect, perhaps not comic but certainly ebullient, an embodiment of the lusty growth of living plant forms, the movement of water and the grander undulations of geological structure. We have noticed

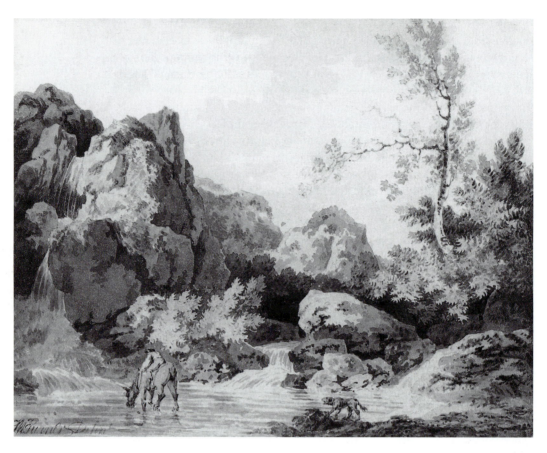

4.1 *Landscape with a Man watering his Horse* (drawing in the style of De Loutherbourg, signed: W. Turner Delint.), c. 1792, pencil and watercolour, 15 x 19.7 cm (private collection, Australia)

the awareness of the energy that informs all natural life that imbues Turner's landscape drawings from at least 1790, and it is reasonable to imagine that Rowlandson's example helped him arrive at some of his earliest expedients for realizing that perception.

But there is not much in Turner's output that can be safely labelled 'influence of Rowlandson'. One of the stormy Loutherbourg-inspired coastal scenes, *Sailors getting Pigs on board a Boat during a Storm*,[15] could well be described as 'Rowlandsonian', with its sweeping washes and jaunty figures engaged in a somewhat ludicrous exercise, but the actual drawing technique is more Loutherbourg than Rowlandson. Nor does Turner seem to have adopted for long the reed pen that imparts their special character to Rowlandson's drawings with its unctuous, broad, softly defined and supple line. But the reed pen was often used by another draughtsman whose work was to bear significantly on the next development of Turner's style. This new manner was quite a fresh departure. Its genealogy was not from traditional topographical practice, nor from any Paris academy. It was the highly idiosyncratic drawing technique of another master of landscape who played an important part in the development of British art in the eighteenth century: Antonio Canal, always known as Canaletto.

Canaletto (1697–1768) had worked in London for a number of years in the mid-eighteenth century, and had been collected enthusiastically by noblemen and by George III, who had acquired the large group of pictures assembled by Consul Smith in Venice. While there was much demand for his well-known Venetian subjects – which glitteringly perpetuated memories of the Grand Tour – Canaletto was also expected to make views of London scenes, and of places elsewhere in England. As a highly efficient topographer, he made careful drawings of his subjects, and these drawings themselves became prized collectors' items. They are easily recognizable, not only by the characteristic *mise-en-feuille* and general approach to design, but also, and especially, by their unmistakable technique. Canaletto was as capable as any other architectural draughtsman of employing the ruler and compasses for large-scale structural elements, but what is exhilarating about his work is the precise control of such structural lines in a context of apparently carefree calligraphy. More often the whole subject is depicted freehand. The pen – often a reed dipped in bistre or brownish-black ink – moves in steady, clearly directed lines that are nevertheless not absolutely straight but crinkled or kinked. Their progress is interrupted or finished off with whimsical little flourishes that denote crumbling masonry or flickering reflections. The picturesque irregularity of buildings and their settings is conveyed in the same shorthand that firmly constructs and places them in geometrical space. Canaletto would often wash these outlines with grey, making presentation drawings that could be sold.

A number of British artists copied Canaletto's idiom. The most notable perhaps was Joseph Farington (1747–1821), who made it his own in a much less flamboyant, more domesticated version. In 1817 he recorded that Henry Edridge (1769–1821), after a visit to France, proposed to make copies of his drawings 'washing them with India ink upon a brown outline in the manner of Canaletti'.[16] This was of course much later, but it is significant that Edridge had been a pupil at the so-called 'Academy' of Dr Thomas Monro, and that Monro was himself a collector of Canaletto's drawings (on 27 July 1820 he asked Farington to sell him some from his own collection). Monro played a vital part in disseminating ideas about drawing among the young artists of the 1790s, and Turner was to come into close contact with him. The initial connection came about presumably on account of his mother's mental illness: Monro, like his father before him, was an insane-doctor and a governor of Bethlehem Hospital. He was called in to attend the King during his bouts of porphyria. It seems likely that he took Turner's mother into his care for a short period early in the 1790s; she was later confined to Bedlam, where she died in 1804. In about 1793 Turner made drawings at Monken Hadley, Middlesex, where Monro had a small asylum which is probably where Mrs Turner was treated.[17] Shortly after that he was going regularly to Monro's house at no. 8, Adelphi, overlooking the Thames, to spend the evening drawing. In this he was accompanied by Thomas Girtin, his exact contemporary, and they sat one on each side of a desk, sharing a candle and, at the end of their exertions, a plate of oysters. There can have been no

question of their being *in statu pupillari*, since by 1793 both young men were well established in their careers as professional watercolourists and both commanded considerable technical skills. Since 'Dr Monro allowed Turner 3s. 6d. each night' and kept the drawings ('Girtin did not say what He had'), he must have seen himself as their patron rather than their teacher.[18]

However, he cannot have wanted the huge quantity of copies that they produced simply for the sake of the copies. His idea must have been that the young artists would learn from copying drawings in his collection. It was a wide-ranging assemblage, with Old Masters and modern, and particular stress on landscape. Monro admired Gainsborough and not only collected his drawings but imitated his style, using black chalk and India ink stump to make formulaic compositions that usually manage to achieve a certain picturesque charm. This, however, was not the manner he inculcated into his protégés. Rather, Monro showed Turner and Girtin his holdings of John Robert Cozens and Edward Dayes – two artists who generally avoided ideal, or abstract, landscape and adhered to topography. They were topographical in different degrees, however.

Dayes (1763–1804) was by the early 1790s a successful painter of watercolour views, but a varied artist, who worked as a book illustrator as well as a topographer. He also essayed grand historical subjects in watercolour. He was for a time Girtin's master, so that Turner, always looking over his shoulder at developments among his contemporaries, would have been particularly aware of him. Even within the topographical category Dayes is surprising. He could work on a large scale, producing grand exhibition pieces with figures, and had distinguished himself particularly with a series of large London subjects populated with crowds of contemporary characters. There was a lively market for these kinds of subjects on both sides of the Channel, and Dayes may have taken as his model the French draughtsman Philibert-Louis Debucourt (1755–1832), whose aquatinted scenes of Parisian street life epitomized the fashionable world of the years immediately before the French Revolution. But there were notable English precursors, too, in the large and crowded compositions of Rowlandson, whose famous view of *Vauxhall Gardens* was executed in 1784, very likely with French examples like Debucourt's in mind. (Rowlandson had studied in Paris in the 1770s and was in France again in the early 1780s.) Dayes's scenes give more weight to topography than do either Rowlandson or Debucourt, but the spirit is similar. The outstanding example is his *Buckingham House, St James's Park* of 1790.[19] Turner's own master Thomas Malton had also made views in which figures are prominent, though again his overriding purpose is topographical and, however elegantly introduced, his figures do not possess the energetic life so characteristic of Rowlandson and Dayes. It is certainly likely that Turner was looking beyond Malton to Dayes, Rowlandson and even perhaps French exemplars when he executed his energetic, crowded view of Oxford Street in front of *The Pantheon, the morning after the Fire*, shown at the Academy in 1792.[20] Here the figures are prominent in the foreground and are by no means mere 'staffage': they are

designed to narrate the story of the fire, the activity of the fire brigade and the concern of the building's owners as well as the curiosity of the crowd. This style of topographical exegesis was to become central in Turner's developing attitude to landscape.

But it was not the kind of subject that Monro favoured. He was an aficionado of the Picturesque,[21] and preferred, and collected, Dayes's views of romantic scenery in Wales and the Lake District which exemplified that aesthetic principle. These were usually executed in a more modest format, with little or no colour: only washes of grey and blue with, occasionally, some green and ochre. The absence of colour may have been a deliberate choice on Monro's part: he may have wanted to direct his students' attention to outline, light and shade alone, or at any rate to set them a task that could be finished in a single sitting. Farington tells us that 'Girtin drew in outlines and Turner washed in the effects';[22] the vast number of surviving drawings confirms that this was true in many cases, but it is clear that Girtin sometimes drew and coloured drawings entirely himself, and Turner did the same. As they progressed – and they continued to attend these sessions over a period of at least three years – they tackled increasingly large and ambitious subjects.

John Robert Cozens (1752–97) worked almost entirely in a narrow gamut of colours from dark green to pale blue, with considerable use of grey. The drawings he made on the spot during journeys round Italy and Switzerland are even more restricted in palette, and it seems to have been these that the Monro students were given to copy. They were not expected to reproduce them exactly; each dealt with his respective task in his own way, and the methods they used (allowing for the undemanding nature of most of the subjects) can be seen to fit into their general stylistic development. Girtin may well have found the outline work tedious, but he executed it efficiently and confidently, in a vigorous, decisive hand that betrays the influence of Canaletto's manner. At the behest of Monro, or of Monro's Adelphi neighbour John Henderson, he made a number of copies of Canaletto subjects, using a technique that is more explicitly based on Canaletto's. His own style is appreciably different, more angular and emphatic, but it undoubtedly owes some of its drive and bounce to Canaletto's example. No direct copies of Canaletto by Turner are known, but it is evident that he must have studied the Italian master's drawings carefully.

At first, Turner and Girtin seem to have been at the Adelphi on their own, and they were apparently the first young artists to benefit from Monro's support. This is the moment of Turner's closest association with Girtin, at any rate stylistically, and in many of the drawings they were making in 1793–94 it is hard to tell them apart. Both use a line that breaks into squiggles, dashes and dots in a way that is obviously derived from Canaletto. Adrian Stokes has referred to it as 'pointilliste',[23] but that is to import associations with a wholly different way of seeing. The 'Monro School' version of Canaletto's line functions as the receptor of particular sense-impressions, recording with spirited flexibility the modulations of a subject from solid to ruined masonry, from foliage to water and so on. But it remains a formula, a predetermined

repertory of wrist-movements that can be adapted to all purposes. Girtin's version is generally distinguishable by its firmness and by the sharp serrations of his zigzag lines of grass or leafage. Turner's line, no less energetic, is more fluid and subtle. The picturesquely dilapidated mill, built mostly of timber, requires a certain rhythm of line to indicate the variety of surface; the intricate Gothic ornament that covers the surface of the cathedral calls forth a different, more finicky but equally controlled use of the pencil. Intricate details, foreground foliage or deeply-cut Gothic ornament, sometimes elicit a more varied weight on the pencil point, with heavy emphases, sometimes broad black patches of shiny graphite, alternating with finer lines to create small areas of chiaroscuro. These relatively dramatic moments only serve to reinforce the general impression of extreme linear simplicity in the work of this time.

Although these distinctions are often difficult to make in practical terms, in front of particular drawings, the temperaments of the two artists are fundamentally different, and the overall atmosphere of a sheet usually indicates the author. A rare early commentator on this phase of Turner's career, the topographer and journalist William Henry Pyne, would write in 1833:

The water colour drawings of Turner and Girtin, which Doctor Munro [sic] possessed, were very remarkable for a strong resemblance to each other ... Turner's are distinguished by an elaborate and careful detail of every object, whether of buildings, figures, trees, or distant scenery, yet combining altogether exquisite taste, breadth, harmony, and richness. Some of Girtin's are almost as careful, but he seems to have soon launched out into that free and bold style which carries with it an imposing effect, by its being executed with apparent ease. Turner never seems to have aimed at this seductive style of execution; all his drawings display the utmost feeling for finish and detail, but at the same time preserving the breadth and harmony of nature.[24]

The distinctions are less easy to trace when Turner and Girtin are both involved, of course, and there is a further problem in that they were often copying Dayes, whose own style can also be confused with theirs. It was presumably his grey and blue wash manner that they were specifically imitating when they used that technique at Monro's 'Academy'. Although effective, it is somewhat stiff, with an insistent ribbon-like application of washes, sometimes very black, in depicting foreground water. It does not achieve the sparkle and economy of touch that Turner manages at his best. Dayes's pencil-work, too, is a good deal fussier than either Girtin's or Turner's. It is characterized by a tendency to indeterminate, small curling loops as a formula for foliage that is quite unlike their respective methods, which are never indeterminate. But it must be noted that the Girtin–Turner partnership was suspiciously productive. At the sale of Monro's collection in 1833, a large number of lots were labelled 'Turner', and a few as by 'Girtin'; Turner himself bought a fair number of them. Many more were scattered.

Monro was to continue encouraging young artists to look at Canaletto, as witness Henry Edridge who did not come to work at the Adelphi until the

end of the decade, or William Henry Hunt (1790–1864), who was also to produce literal copies of Canaletto drawings. Over the years the Doctor totted up an impressive roll-call of distinguished artists whom he had encouraged; he clearly had an eye for talent. He also put his own sons, John, Alexander and Henry, to similar tasks. Henry went on to become a serious professional artist, but died very young in 1814; he evolved a style of drawing not unlike Edridge's, in which the influence of Canaletto can be clearly felt through a well-rounded personal idiom.

The 'Monro School' style was adopted by other artists who worked for the Doctor, and it is now hard to be certain how many are really by the original pair. In any case, their work varies from the elaborate to the perfunctory, and indeed only by proceeding at great speed could they possibly have done as many as are attributed to them. Even then, the question remains, why did they do so many? Surely after the first hundred the exercise had served whatever purpose it had? These are mysteries that have not been satisfactorily resolved. Opinions differ as to how much Turner learned from the unvarying diet of minor examples of Cozens and Dayes. His quick intelligence will have extracted the important lessons that those artists could teach, and Cozens will have impressed him as a major master of landscape, if not from the sketchbooks that Monro offered for copying, then from the finished watercolours Turner would have encountered in his and many other collections.

In particular he would have recognized that Cozens had effectively solved the problem of satisfactorily evoking immense landscape space in watercolour. He did this by establishing a hierarchy of touch: distances applied with broad washes of transparent colour, foregrounds built up with tight strokes of a brush loaded with strong, dense pigment. This was a development of standard watercolour practice, but it was significant, in that Cozens was able to imbue the formula with a palpable atmosphere, a gentle melancholy that persuaded everyone who viewed his work. Turner must have perceived the significance of this in his search for a means of using watercolour to paint landscapes with a powerful emotional charge.

He would also have understood the importance in Cozens's art of a very limited range of colours. The origins of that phenomenon lie deep in the theory and practice of his father, Alexander Cozens (1717–86), whose output as a drawing-master and obsessive analyst of the processes of pictorial composition was extensive and influential. It was also symptomatic of its times, of the age in which the physical description of the universe was proceeding under the impetus of Newton's writings, and in which a new self-consciousness had entered into the business of painting landscape. For landscape painting could now be seen to be a process of description akin to that of the scientists. Alexander Cozens's attempts to render the observation and delineation of nature into a series of 'systems' were not strictly scientific, but his lists and calculations partake of the general flavour of natural science as it was often perceived at the time. His landscapes, whether drawn in pen or brush with India ink and sepia wash or painted in oils, follow his curious

taxonomies, in which colour plays almost no part: the arguments and theories are worked out in endless monochrome permutations of a compositional model, often with the aid of his notorious system of 'Blots', random ink marks on a sheet of paper, crumpled and then used to suggest a landscape composition.[25]

These taxonomies were not so idiosyncratic that they meant nothing to a later generation: Constable, for instance, took them quite seriously. As we know, he himself liked to think of his approach to nature as in a sense scientific, but he also recognized the difference between Alexander and his son. 'Cozens', Constable said, referring to John Robert, 'was all poetry.'[26] This is the crucial distinction, which divides Alexander the eighteenth-century theorist from John Robert the Romantic pioneer. Alexander could achieve poetry; John Robert knew no other way to express himself. But he retained the compositional self-consciousness – and originality – of his father, and respected Alexander's preference for monochrome. On the whole, though, he avoided the bistre or sepia brown that was Alexander's hallmark. His dull greens and greys, blending into soft blues and the white of the paper, suffice for almost all his purposes, and his most dramatic ideas make more use of black than of any colour.

The studies that John Robert made on tour in Switzerland and Italy are still more restricted in palette. The Swiss sketches he made in 1776 when he travelled with Richard Payne Knight are mostly executed in grey with some pen and a little blue; the sketchbooks he normally used while he was in Italy in the 1770s have smaller leaves and are technically even simpler. Sometimes a pencil outline is amplified with a little monochrome wash or a stroke or two of the pen; that is all. It was these sketches and studies that supplied the bulk of the subjects that Girtin and Turner copied, and they did so not by imitating Cozens's effects but by paraphrasing them in the agreed manner of the 'Academy', which was, as we have seen, loosely based on Dayes's procedures. The more profound and permanent impact of Cozens's drawings on Turner's imagination is to be encountered in a large number of the watercolours that he was making in these years, for patrons on commission, or for exhibition at the Royal Academy's annual spring shows. A comparable development of sensibility is to be found in Girtin's work of the same period, and the debt to John Robert Cozens must be great in both cases.

Apart from the perhaps indirect influence of Canaletto, other Continental artists provided inspiration for Turner's technical development in the 1790s. The Swiss Abraham-Louis-Rodolphe Ducros (1748–1810) was admired by Britons who went to Italy on the Grand Tour and it so happened that an important group of his watercolours was to be seen in a collection that Turner had an opportunity to get to know well. His early patron Richard Colt Hoare had been in Italy in the 1780s and had commissioned from Ducros in Rome a set of twelve views which he brought back to hang at Stourhead, his Wiltshire seat. Ducros worked in oil as well as watercolour, and his watercolours were strikingly large, with an arresting force of tone and design that rivalled the oils. As Colt Hoare put it, rather blowing his own trumpet: 'the advancement

from drawing to painting did not take place till after the introduction into
England of the drawings of Louis du Cros'. He explained that Ducros's
'works proved the force as well as the consequence, that could be given to the
unsubstantial body of water-colours, and to him I attribute the first
knowledge and power of water-colours. Hence have sprung a numerous
succession of Artists in this line.'[27]

Ducros's sense of the monumental scale of ancient ruins must have
derived from Piranesi (whose famous etchings were also well represented at
Stourhead). His ability to convey the drama of the famous sites in Rome,
Tivoli and elsewhere depended on a carefully elaborated process using
strong, deep pigments and much gum arabic. Such techniques were not new;
Alexander Cozens had experimented for much of his life with India ink and
varnish to create dramatic chiaroscuro. In the field of 'straight' topography
William Pars (1742–82) had used gum in some of his Greek views of the
1760s, occasionally achieving (though on a smaller scale) an overall depth of
tone that prefigures the work of Ducros in surprising respects.[28]

Turner seems to have visited Stourhead for the first time in about 1795.
The impact on him of Piranesi's etchings and Ducros's watercolours must
have been considerable. There is an outpouring of monumental architectural
subjects, both exteriors and interiors, from 1795 to 1800, that reflects a need
to get something very significant out of (or into) his system. The interiors of
Westminster Abbey, Ely, Durham, Christ Church at Oxford, Salisbury and
Ewenny Priory in South Wales all became the subjects of impressive
watercolours in these years, and there are views of the insides of churches in
watercolour and bodycolour (notably in the *Wilson* sketchbook) and in oil. All
these works are studies in the deployment of rich chiaroscuro. They are also
exercises in the sheer virtuoso draughtsmanship required to present a large
and complex architectural design on paper. Interiors preoccupied Turner at
least partly because they were decidedly more difficult than exteriors. This is
apparent in the large pencil drawing that he made in 1794 of the interior of
the octagon at Ely (Figure 4.2), a tour de force in itself, which he used as the
basis for two very similar exhibited watercolours shown in successive years,
1796 and 1797 (see Figure 5.2). Despite the grandeur of the subject, and the
combined technical proficiency and sublimity of Turner's treatment, one of
them, together with a view of *Llandaff Cathedral* also exhibited in 1796,
prompted some deprecating comments from Finberg:

If we may judge from the rather cold impression these two drawings make upon us,
it is probable that they owe their existence rather to the artist's professional diligence
rather than to any overmastering impulse towards artistic expression. But ... every
mechanical difficulty is fairly faced and mastered with imperturbable coolness,
patience and dexterity. So palpably is the artist's attention fixed upon the executive
side of his art, especially in the 'Llandaff Cathedral,' that a contemporary prophet
might well have been excused if he had seen in it only the promise of the making of
a marvellous petit-maître, and had declared that its author could not be possessed of
a spark of native genius.[29]

Yet it is precisely in the *Llandaff* that Turner's superiority to most

4.2 *Ely Cathedral: the Interior of the Octagon*, 1794, pencil drawing, 78.2 × 59.3 (Turner Bequest XXII P; Tate Gallery D00369)

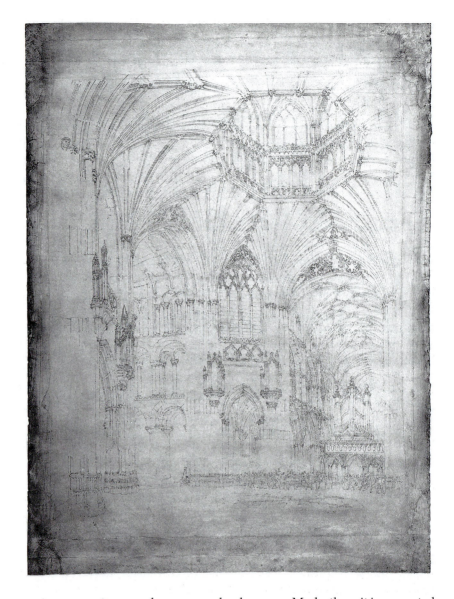

contemporary topographers comes clearly across. Modestly as it is presented, with tiny figures, it is nevertheless a composition thought through with creative concern for the relation of every detail to the whole. The fall of light across crumbling masonry is subtly expressive of the picturesque antiquity of the building, and the figures develop a poignant meditation on youth, age and decay: girls dance on a tombstone to the strains of a boy's fiddle, while two old men watch and gossip (reminisce?) nearby. The scene is presented as a significant whole, architecture and life integrated and illuminating each other. This is not the work of a merely 'diligent' artist, but a modest lyric by a budding poet of the human condition.

Turner's experience of Piranesi and Ducros was not the origin of his

interest in problems of scale, drama and chiaroscuro. He had already made experiments of his own that approach the strength of Ducros's views. In a little watercolour of about 1791 showing a cottage interior he broached the issues of moonlight, firelight and interior chiaroscuro long before the first acknowledged masterpieces of light and shade, *Fishermen at Sea* and *Ewenny Priory*.[30] There are plenty of studies of night scenes in the Turner Bequest, and a watercolour of Valle Crucis Abbey, near Llangollen, which must have been made in the immediate aftermath of a tour to that part of North Wales in 1794, is a powerful, brooding study of shadow in a valley above which on a hilltop an ancient ruin rises serenely (see Figure 4.3).[31] It is impossible to know whether Turner had already seen Ducros's work when he made this watercolour; the likelihood is that he had not. But Girtin had already achieved a similarly dramatic effect in at least one instance: a small watercolour that may date from as early as 1792 depicts a storm in a mountain valley with comparable verve and technical adventurousness.[32]

Here, in the mid-1790s, we encounter a practical, draughtsmanly aesthetic that corresponds in its intentions to the Neo-classical. That Turner was strongly influenced by Girtin at this time is entirely apt. Girtin, of all the landscape watercolourists of the period, was the most attuned to the ideas of Neo-classicism, working as he did in broad simplified masses with a restricted and sombre palette. He died in 1802, at the age of 27, just as this style was attaining its apogee; it was continued in the work of John Sell Cotman who took over the Neo-classical implications of Girtin's art and developed them through the first decade of the new century, rendering them still more emphatic. By the middle years of that decade, Turner's own style had gone as far as it ever would in this direction.

At all events, from 1795 onward Turner's technique began to develop at an extraordinary rate, branching into many new areas of experiment. One of these was oil painting. He is recorded as having made at least one substantial oil painting around 1792, but this is unidentified. The small study of a water-mill that survives in the Turner Bequest, already noticed, can be dated to the same moment. From then there is nothing until his first exhibited oil painting, *Fishermen at Sea*, appeared at the Academy in 1796. This, a night scene, is so accomplished a work that it is hard to believe that nothing preceded it, and the probability is that the little nocturne, *Moonlight: a Study at Millbank*, that Turner showed a year later had actually been done first, by way of experiment.[33] He would naturally have been reluctant to show so modest a piece on his first appearance in a medium he intended to demonstrate his mastery of, but once *Fishermen at Sea* had been duly recognized he could afford, in conjunction with another ambitious picture, to show the little study from which it had grown.[34]

Fishermen at Sea clearly relates to watercolours in which Turner had been exploring the problems of representing the sea. An example is *On the Coast near Tenby* (W 170), which is dated 1796 and contains sharply observed and delicately rendered details of the movement of water, details taken up on a larger scale in the oil painting. The cross-fertilization of oil and watercolour

4.3 *The Ruins of*
Valle Crucis
Abbey, with Dinas
Brân, 1794–95,
pencil and
watercolour
with some
scraping-out,
46 x 37.5 cm
(Turner Bequest
XXVIII R; Tate
Gallery D08703)

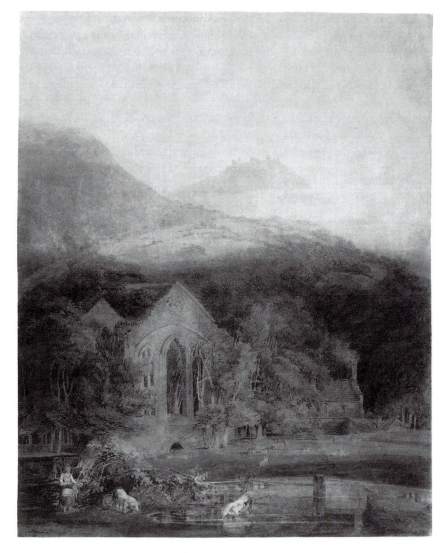

was to remain a creative dynamic of his work throughout his life. At this
stage it brought with it, inevitably, dialogues with other painters: marine
artists, the specialists in night scenes: Claude-Joseph Vernet (1714–89) and
Joseph Wright of Derby (1734–97) are equally implicated with Ducros and
Piranesi in the expanding web of influences and references with which
Turner was reinforcing his developing style. There is a copy from Vernet
among copies after Wilson in the *Wilson* sketchbook of 1797.[35] Drawing did
not exist as a discipline in a vacuum, bounded by the demands of
topography. And if painting was to proceed to the higher flights of serious
art, drawing must accompany it. For that task, it must evolve into a highly
efficient, flexible and expressive tool, not simply the means of recording what
the artist observed, but the constant companion and interrogator of his
thoughts and experiences wherever he went.

It is worth noting, by way of conclusion to this chapter, that many of the key influences on these formative years were the drawings, prints or paintings of contemporary, or near-contemporary Continental masters – Canaletto, Piranesi, Ducros, Loutherbourg, Vernet – who all in their different ways displayed characteristics that were emphatically un-English. By the end of his 'apprenticeship' Turner had altogether absorbed and transformed these influences, but it is probably true to say that no other British artist of his generation set himself deliberately to imitate such a range of important foreign styles.

A mature shorthand

In his notes on drawings from the Turner Bequest, Ruskin came to the conclusion that Turner systematically practised one technical device after another, persevering with each until he had mastered it: 'first, five or six volumes full of pencil drawings of architectural detail. Next, a year or two of pencil tinting, at half a crown a day. Next, a year or two of pencil shading, carrying our work well up to the paper's edge, and chess problems in colour going on all the while ...'. And so on, until 'stiffness of hand is conquered' and the next stage can be tackled.[1] This is a clumsy simplification of Turner's progress in the 1790s. He did indeed do all these exercises, but not in sequence. He assessed each challenge and met it as it required, and steadily grew in technical accomplishment, but it is not possible to rank every drawing in a strictly chronological order that reflects his increasing skill.

The familiar division of Turner's long career into three periods – early, middle and late – like all such simplifications, is useful in a limited sense, but there is no aspect of his work that responds less amenably to cut-and-dried description than the development of his drawing style. It could be said that, once he had reached maturity – at whatever point that is deemed to be – his manner of drawing remained essentially the same for the rest of his life. It could with equal truth be urged that it changed gradually over the decades and was very different in the 1840s from what it had been in the 1820s. On the other hand, there is no argument as to the fact that his painting style, both in watercolour and in oil, changed radically in the same period. The relationship between the pencil drawings and the coloured works in either medium necessarily changed too. We must therefore look at the pencil drawings, however independent they are of work in oil or watercolour, as a function of that work. For Turner used his media in an organic way, integrating them into his conceptual and creative processes, making them, at all times, the direct transmitters of his intentions, and mixing them as he found necessary. In due course he evolved a method of working – it might as well be called a style – in which pencil drawing, watercolour and oil painting were parts of a continuous interlinked process. Some of the greatest works of his later years were produced in this way, and we shall examine them in the proper place. First, though, we must try to establish what Turner's mature drawing style was all about.

We have seen the various elements that went to make up his training and early experience, and in particular have noticed the liberating effect of Canaletto and Loutherbourg, with their un-English mannerisms, on his practice. These artists showed how, in different ways, the ebullience in Turner's own view of things could be channelled through elegant draughtsmanly formulas (see Figure 5.1). By about 1794 the essential patterns were in place: the movement of the wrist from line to hook to dot can be seen clearly in sketches Turner made during his so-called 'Midland tour' of that year.[2] Drawings of Lichfield Cathedral, or a mill near Llangollen, combine indications of both architecture and foliage, where long curved lines, confidently placed on the page, alternate with shorter, scalloped ones and still smaller interlocking curves that evoke the mass of foliage by nestling inside each other, analogously to the tightly packed brush-strokes of watercolourists whom Turner was imitating at this date, especially Cozens and a contemporary topographer, Thomas Hearne (1744–1806). The geometry of buildings is conveyed with long lines of remarkable precision, perfectly straight but never uniformly so: as with Canaletto they are broken to imply texture. It is striking how, when he tackles a really substantial architectural challenge, like the interior of the Octagon at Ely Cathedral already referred to (see Figure 4.2), the purposeful method is shorn of all mannerism or showy effect; the ruler is used when necessary, and the cool, unmodified line employed to render complex perspectives and elaborate mouldings with unaffected seriousness. As Ruskin noted,

It will be observed, that throughout, the sketches are made not for effect but for information; a little bit of each portion of the building being completely drawn, the rest indicated. All Turner's sketches from nature are made on this great principle; though the kind of information sought, and the shorthand by which it is stated, vary with the subject and the period.[3]

By the end of the 1790s he had drawn so much that by habit as well as necessity he had formulated a coherent language of line in which to set down his observations and ideas. It is perhaps important to emphasize again that the pencil line was the means he chose, all his life, for the great majority of his drawings. This was a matter of sheer practicality. As he is reported to have told a student in Rome in 1819, 'it would take up too much time to colour in the open air – he could make 15 or 16 pencil sketches to one coloured'.[4] It was as a practical expedient that he developed his way of using the pencil in response to his observations.

As his Rome comment indicates, an essential concomitant of the use of the pencil is the speed with which drawings are made. Rapidity is built into the very idea of the pencil sketch. Even so, many of Turner's drawings are carefully wrought, and evidently took a considerable amount of time to complete. Is there a distinction to be made between rapid, half-minute sketches at one end of the spectrum and elaborate, half-hour drawings at the other? Clearly there are differences. But both types of study can be said to be constructed from the same essential elements. That is the language of Turner's mature drawing style, which will be the subject of this chapter.

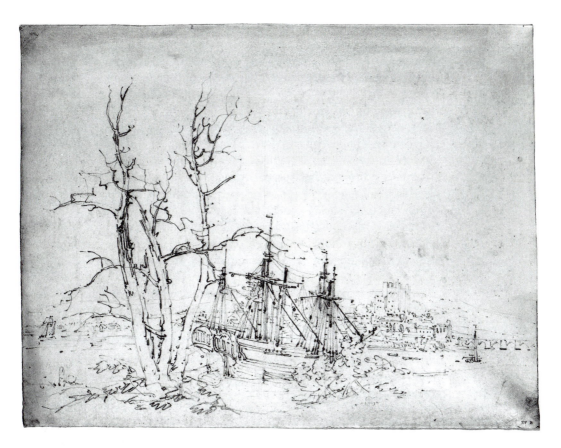

Pencil outline

By the time he was elected Associate of the Academy at the end of 1799 Turner had created for himself a system of notation that was not simply his own 'style'. His way of drawing was a different kind of description from that of other artists. This is not to say that he did not make 'conventional' drawings, that is, transcriptions of objects in terms of lines more or less literally corresponding to the perceived forms of those objects. But for the purposes to which he mostly put drawing, he was not concerned with literal transcription. His curiosity about the world was vast: on any given journey or tour he set himself the aim of observing and recording a huge amount of information. 'Every glance', he said, ' is a glance for study.'[5] For this reason alone he needed an efficient shorthand, and that is effectively what his sketches are.

Over two or three years after 1795 his pencil-work steadily rationalized itself, eliminating hooks and curls and concentrating increasingly on the line and the curve, marks that could be made to suggest every feature of a given scene, including its spatial extent. At the same time there is a greater delicacy, one might almost say tenderness, of response to what he sees: this is perhaps the most remarkable quality of Turner's mature drawing style. It is both

5.1 *Distant view of Rochester*, c. 1793, pencil, 21 x 27.2 cm (Turner Bequest XV B; Tate Gallery D00158)

crisply functional and wonderfully expressive. The drawings of trees that he made at Norbury Park and at Cassiobury, seats respectively of William Lock and the Earl of Essex, exhibit a sweet fluency of rhythm that owes much to the disciplines of Monro's desk (they are often coloured with washes of blue and grey like the drawings for Monro), but which expands with a naturalness that reflects the organic habit of the trees that he is observing. As William Henry Pyne put it, 'His early studies of trees are invaluable, they show exquisite taste, beautiful and graceful forms, with careful drawing, and they generally are of the most simple and rustic character.'[6]

Finberg admitted that Turner's pencil drawings in the *North of England* sketchbook of 1797, evoking with clarity and breadth the ruined antiquities of Yorkshire, County Durham and the Tweed Valley, display 'the most delightful ease, accuracy, and charm'.[7] They assuredly demonstrate that he had moved on from the relatively limited recording of the Midland tour. David Hill has gone so far as to suggest that the North of England journey marked a decisive turning-point in his career: 'Turner set out on this tour an architectural draughtsman, and returned from it a painter of landscape.'[8] This attractive notion is belied, however, by the enthusiastic landscapes that Turner conceived in the Avon Gorge in 1791, scenes of rocks and water, with some shipping, but no architecture, or the stormy coastal subjects that he invented shortly afterwards in the manner of Loutherbourg. Architecture and landscape were always bound inextricably together in his imagination as the essential and complementary components of topography. The human figure was a third crucial element, as we shall notice in due course.

In the pages of the *Hereford Court* sketchbook of the following year, 1798, the demands of the scenery of Wales elicit further technical evolutions. Interlocking curved lines for foliage have given way to looser, more open marks, often almost circular, to indicate single clumps or even whole trees; a serpentine line is placed deftly to present the recession of a foreground road or river; a serrated line evokes hilltops or cliffs. Buildings become mere blocks, cubes with slanting lines for roofs. Yet the local character of the architecture is understood and conveyed. All is minimal, but so precisely placed and related are these elemental lines that not only the physical facts but even the atmosphere of a scene is evoked. The perfunctoriness that Finberg noted in the work of 1794 or 1795 is transmuted into something genuinely expressive as well as useful. Turner is responding not only to the pressing urgency of his task, but also to the ideas concerning clarity and economy of line that were being promulgated in the 1790s as the ideal of Neo-classical beauty.

By the end of the decade this technique was established, and Turner was beginning to experiment with variations on it. A notable example of his experimentation is to be found in the group of drawings that he made as an adjunct to the sketches he drew while touring Scotland in 1801. These Ruskin labelled 'Scottish Pencils' and thus we know them now (see for example Figure 5.4, p. 71). They marry the new, bold, economical pencil-outline style with a toned ground. They were made, as Turner told Farington, 'with Black

Lead Pencil on white paper tinted with India Ink and Tobacco water and touched with liquid white of his own preparing'.[9] But in order to understand the significance of this experiment we must look in more detail at Turner's study of tone in the 1790s.

Tone

Turner intended from the early 1790s to paint in watercolour subjects that demanded much of the medium. The interiors that he had occasionally produced from as early as 1791 had challenged existing techniques, and he had borrowed ideas from other artists who were exploring new textures and sonorities. Ducros supplied important lessons once Turner had encountered his work. A figure we have not yet considered, because there is no evidence of direct influence, is Richard Westall (1765–1836), who was a pioneer of the 'exhibition watercolour' as an alternative to oil for historical and sentimental subjects. In the opinion of one contemporary, he 'was as much intitled to share in the honour of being one of the founders of the school of painting in water-colours, as his highly-gifted contemporaries Girtin and Turner'.[10] His subject matter and methods alike were radically different from those Turner favoured; he mixed watercolour with gouache (bodycolour) and quantities of gum arabic to create a medium of intense richness and gloss. Turner deliberately avoided such adulterations of the pure watercolour medium, but would undoubtedly have been affected by the powerful results a fellow-Londoner like Westall was obtaining.

Westall was also a practitioner in oil, and his work in water-based media was governed by the aesthetic of oil painting. Turner's own ambition to paint in oil resonated with his experiments in watercolour in quite different ways. His early ventures in oil painting opened up the gamut of methods normally restricted to that medium, but which he immediately began to translate into watercolour, not, as Westall did, by reinforcing watercolour with admixtures of gouache and gum, but by using pure watercolour in a more complex manner; we shall address this matter in detail shortly, but it is important to bear in mind Turner's simultaneous movement forward on several fronts during this decade.

It was in his preparatory studies and sketches that he adopted mixed media: the pages of the *Wilson* sketchbook, which belongs with his first major exercises in oil around 1796–97, are of a coarse blue wrapping paper washed a dark earth red, and Turner worked on them in chalks, watercolour and bodycolour, achieving rich harmonies of warm tone.[11] The subject matter of these studies is itself significant. There are stormy skies, snow scenes, several church interiors rendered in surprising detail, and the transcriptions from paintings by Wilson and Vernet that we have noted. These last of course indicate the tendency of Turner's thoughts as he was using the book. The depth of tone and richness of effect obtainable in oil were qualities he was studying to appropriate in watercolour, but he had already succeeded in this

aim in several works in pure watercolour exhibited at this time: two of his most impressive architectural interiors, *St Erasmus in Bishop Islip's Chapel* (the chapel is in Westminster Abbey) and *Trancept and Choir of Ely Minster*, as well as the intense little *Internal of a Cottage, a Study at Ely* were shown at the Academy in 1796,[12] and in 1797, together with a second version of the Ely subject (Figure 5.2), a remarkable essay in Piranesian (or even Rembrandtian) gloom, *Trancept of Ewenny Priory, Glamorganshire*, accompanied another grand cathedral interior, the *Choir of Salisbury Cathedral*.[13] In the *Wilson* book, on the contrary, he avoids the usual pure watercolour method, and imitates the oil painter's procedure, working from dark to light on the dark (earth) ground, the highlights added in opaque white.

Roughly contemporaneous with this book is a series of studies made on the beach, showing fishing boats hauled ashore or putting out into choppy seas. The paper is usually a buff or buff-grey wrapping paper, and again the pigment is at least partially opaque bodycolour. The spume of the breakers is rendered in Chinese white. A small sketchbook, the *Studies near Brighton* book, usually dated to 1796, contains similar work on blue paper washed with a red ground.[14] These exercises set a pattern on which Turner could call whenever his subject matter suggested it. On his tour of Wales in 1797, for instance, he again had recourse to prepared paper, covering several leaves of the *Hereford Court* book with a grey (not red) wash on which he painted studies of mountain scenery.[15] There are striking instances of this use of a grey washed ground dating from different moments in his career. The Rhine drawings of 1817 are a famous case. A whole sketchbook used at Tivoli during his first visit to Italy two years later is particularly surprising. It is employed for drawings in pencil with scraping-out so that the white paper appears through the ground. Despite their apparently subdued atmosphere, these studies have prompted one writer to describe them as 'radiant'[16] – suggesting that Turner intended the intensity of his simply achieved chiaroscuro as a metaphor for the intensity of Italian light. One or two other books he used in Italy make use of colour as well as the grey washed ground. At odd times subsequently in his career, Turner employed a grey wash: on the Moselle in 1828, on the Rhine in 1840 and so on (see Figure 5.3).

The 'Scottish Pencils' have been considered to occupy a specially significant place in this lifelong sequence (see Figure 5.4). They are, to begin with, on fairly large sheets of paper. He had already experimented with large sheets on tour: the big views of Snowdonia, done on the spot in 1799, are considerably larger, and they too have the character of a unique experiment. They embody Turner's fully engaged response to the highest mountains he had yet encountered, spontaneous transcriptions of Sublime scenery in an already mature, flexible, expressive watercolour medium. Rarely again would he ever use such large sheets of paper for watercolour out of doors. He was to use large sheets in France and Switzerland in 1802; on these he worked almost exclusively in black chalks with occasional touches of white bodycolour.[17] The 'Scottish Pencils' lie between the Snowdonia studies and the 1802 tour: they are not coloured, but much concerned with rich tonal

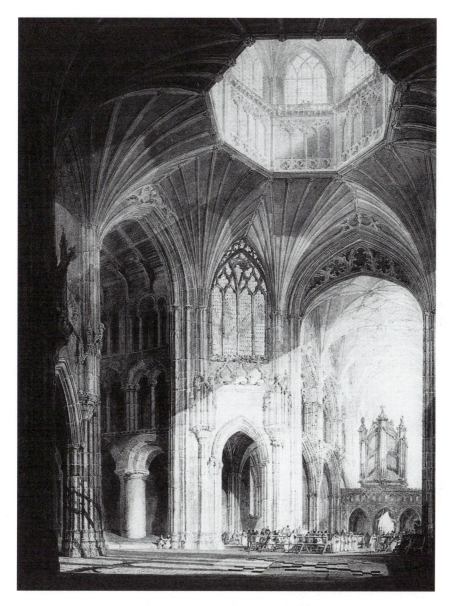

5.2 *Ely Cathedral, South Trancept*, 1797, watercolour, 62.9 x 48.9 cm (W 195; Aberdeen Art Gallery 54.2)

variety, and make use of pencil and white bodycolour on a dead grey ground – the 'India ink and tobacco water' Farington mentions.

Once again, Turner confronts high mountains – the Scottish Highlands are even grander in scale than North Wales – and once again the confrontation sparks off a technical experiment. It is hard to resist the conclusion that his choice of media was directly linked to the subject matter he faced. He may have wished to record a particular quality of light, though there is no reason to suppose that Scotland was especially gloomy that autumn. More likely he needed to register the very colour of the grey granite of which the landscape was composed. As Ruskin noted, the pencil is used densely, itself a medium

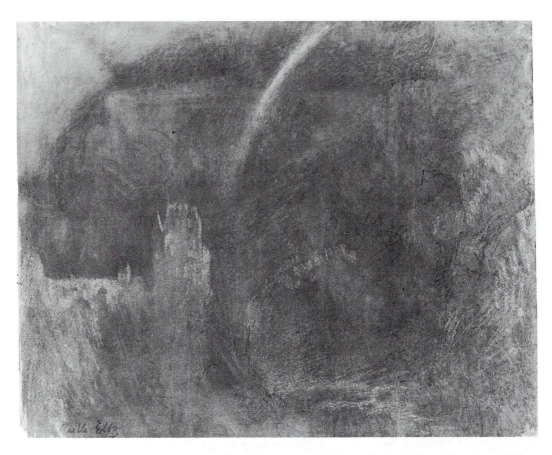

5.3 *Burg Eltz*, 1839, pencil and scraping-out on a grey-washed ground, 17.5 × 23 cm (courtesy of Sotheby's)

through which tonal values are expressed, and it is reinforced by the addition of white bodycolour so that, as in the *Tivoli* sketchbook, the grey ground is the mid-tone of a monochrome gamut.[18] Joyce Townsend notes that the effect of the pencil work in these drawings is analogous to that of a wash, though imparting a gloss or 'sheen' that contrasts with the matt surface of the ground.[19] This is a use of pencil that anticipates the methods of Richard Parkes Bonington (1802–28) and his followers in the 1820s and 30s, though they rarely applied shiny pencil highlights over such expanses as Turner does in some of the Scottish drawings.

The white, on the other hand, is never used sufficiently extensively to raise the general key above the sombre. This leads to a further consideration: the technique of the 'Scottish Pencils' may be compared with the use that he was making at this date of grey or blue paper for his academic studies and preparatory drawings for pictures. Since Turner by instinct had in mind finished works of art even when making slight sketches from nature, it would have been natural for him to use drawing media that paralleled the process of painting in oils.

Ruskin's view was that these drawings are 'scientific in the extreme'.[20] This observation suggests a more tenuous interpretation of the coloured ground,

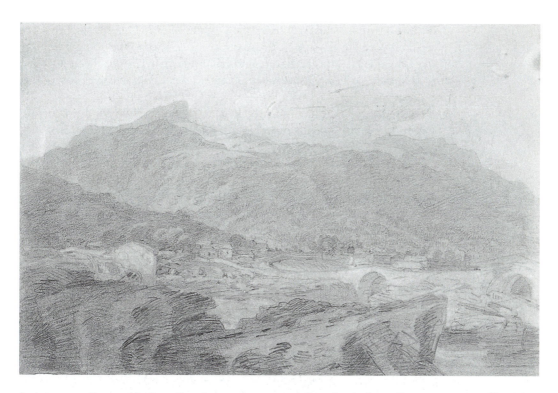

5.4 *Killin and the Falls of Dochert* ('Scottish Pencil'), 1801, pencil and white gouache on prepared grey ground, 34 × 49 cm (Turner Bequest LVIII 42; Tate Gallery D03421)

but one worth considering, that it may 'represent' the physical medium in which the perceived objects exist. It is therefore not to be understood as transcribing the character or even the general tone of the light, but rather as standing for a palpable 'air' that envelopes everything seen. It is purely symbolic, the objects emerging from the ground as they do from atmosphere. Certainly it is difficult to grasp why Turner, on his first visit to Italy and evidently intoxicated with the brilliant light, should have chosen to record, as just noted, the sights of Tivoli and Rome on a dark grey ground. If the ground is understood as standing for the medium in which things are perceived it then becomes a positive acknowledgement of the importance light and air had for Turner at this juncture.[21] If this theory has any value it points to the use of coloured grounds as having in certain circumstances the specific intention of registering a new climate or quality of light. Turner's first visit to the Scottish Highlands could well have stimulated such a response.

The sketchbooks

Having evolved an effective system of notation, Turner adapted it to a multitude of different practical requirements. The sketchbooks demonstrate in the way he used them that sketching was a perpetual urge, a necessary function, a nervous tic, as I have expressed it elsewhere, that never left him.[22] He knew that his mind would retain his experience of natural phenomena,

but the act of sketching ensured 'the perpetuity of the objects wished to be retained' (see Figure 5.5).[23] The artist must 'select, combine and concentrate that which is beautiful in nature and admirable in art',[24] and the assembling of images in sketchbooks by means of an efficient shorthand was part of that process.

Although he must have ensured that a notebook of some kind was always within reach, he did not draw, as a rule, when he was out and about in London. There are occasional drawings of interesting buildings – St Paul's or the Tower, for instance, made with a specific topographical purpose in mind.[25] But very few studies of the life and buildings of London's streets have been identified. He drew along the Thames round the various homes that he established for himself, at Hammersmith, Isleworth and Twickenham. It was when he set out on his travels that the sketchbooks came into their own, however. It became a matter of routine for him to travel at least once, if not twice, a year to collect material for his work. In the early decades of his career the itineraries were often determined by commissions he had received, and there is usually a connection between visits to Yorkshire, Lancashire or the Isle of Wight and projects for series of picturesque or antiquarian views. But he also set himself the task of exploring England, Wales and Scotland for the sake of landscape itself. After Snowdonia in 1798 and 1799, and the Highlands in 1801, the Alps followed naturally and, as luck had it, he was enabled to make a journey to the Continent the following year, thanks to the Peace of Amiens which brought a brief lull in the wars with France.

Once those wars were over, he set off for some part of Europe almost every summer or autumn for the rest of his active life; the tours only ceased when, in 1845, he became too feeble to travel. Again, his destination was often fixed by a particular requirement: in 1817 his objective was to see the battlefield of Waterloo, and he travelled up the Rhine and into Holland on the same trip. In 1835, with plans for a National Gallery in hand in London, he seems to have appointed himself an unofficial one-man committee to report to the Academy on the new museum in Berlin, and on other collections in Germany.[26] Other journeys through Germany, Belgium and France were prompted by the ambitious project to publish a series of 'Annual Tours' charting the course of the great rivers of Europe. The Danube, the Meuse, the Moselle and the Rhine were all on his 'to do' list, and he made many studies, and even finished designs, for these, but only the Loire and the Seine achieved publication, in three volumes issued from 1833 to 1835.[27]

This dynamic relationship between commercial projects and annual travels continued until the end of the 1830s. He made some journeys apparently under less demanding conditions, travelling with a friend and making studies of whatever attracted his attention. A tour to the Val d'Aosta of 1836, when he was accompanied by his friend and patron the Scottish collector H. A. J. Munro of Novar, is an example of this more relaxed mode of touring. In the early 1840s his visits to Venice, Switzerland and the Rhine

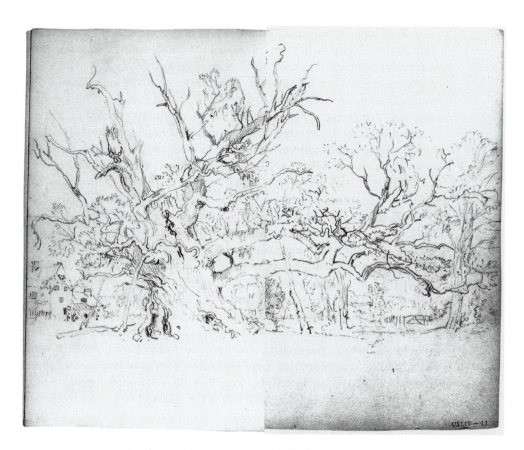

Valley were motivated by nothing more than an intense love of those places, and the long sequences of colour studies, which are far from being fact-finding exercises, often record the same views over and over again, in varying lights, in a sort of ecstasy of communion with the world about him.

The sketchbooks that he carried with him on all these tours were of variable size; the early books were sometimes large, bulky, leather-bound volumes with as many as four brass clasps. He had them made up in London; occasionally, as we have noticed, he concocted one himself out of odd sheets of paper and card, or he would simply fold and tear a large sheet into many small pieces of paper which he kept in a pile, tied perhaps with tape. He occasionally bought new books abroad, either because he needed more drawing-space, or because he wanted to try out a different paper.[28] The average size of the books tended to become very much smaller over the years, partly because of the growing practice of sketching by amateurs, which led to many innovations in the way such books were manufactured, and partly because Turner's own requirements changed. He carefully kept his books, numbering them according to a system that no one has yet explained, and usually labelling them with some indication of their contents. It is these 'contents labels' that give us the names we use today for the majority of the books that have survived intact.

5.5 *Yorkshire 1* sketchbook, ff. 10 verso – 11 recto, study of Cowthorpe Oak, 1816, pencil drawing, page size 15.4 X 9.4 cm (Turner Bequest CXLIV; Tate Gallery)

As the books became smaller, and as his habit of sketching became more compulsive, Turner's system of notation grew more effective, more economical of space. It was a primary asset that the shorthand could be adapted for use on a small scale. His paring away of superfluities, his establishment of a clear, direct use of line, justified itself in the often tiny notebooks that he put in his pockets on his journeys across England and the Continent. The usual pattern all his life was to make a single drawing on each page, sometimes using the verso as well as the recto, but often leaving the verso blank. In sketchbooks treated thus we are very conscious of the possibility that each image might achieve metamorphosis into a finished work. The edge of the page seems automatically to suggest a frame, and the relations of the parts of the subject are already disposed as if in a considered composition. The larger the page size, the more likely this is to be the case, but the rule applies to drawings on any scale.

There are many exceptions, of course. The most striking is that of the multiple use of a page, and it is interesting that this happens mainly with books that are in any case small. The reduced scale encourages a miniature way of working, and image can follow image, jotted down one after another like items in a written list (see Figure 5.6). There is probably a correlation between the pace of the journey and the need to be able to handle a book easily: sitting in a jolting carriage, for instance, or standing up in a boat moving on the Rhine would require a book easily held and manipulated. The motion of the boat is smoother than that of the carriage, and so the drawings from the water are neater than those done on the road, but they are even more likely to be crammed in quantity onto the page.

Another consequence of continuous movement is the eliding of images, the amalgamation of elements in different views into the same sketch. Since Turner's object was to produce not merely records of places, but coherent pictorial expressions of those places as human experience, it was more important to capture the salient characteristics of a region than the precise relation between one object and another. In very few, if any, of Turner's mature works is the topography literally reproduced. Ruskin discoursed at length on Turner's adaptations of literal topography,[29] pointing out the essential distinction between information and expression. We are today more sensitive, perhaps, to such modifications than in an age when the camera was still a novelty. We accept without question that a photograph delivers the truth about external facts. We are, of course, aware that the camera can lie, but we do not attribute the divergence from truth to the contrasting natures of the two means of recording. The camera consists of a lens which is part of a piece of machinery, and however carefully the photographer chooses his subject and sets up his apparatus, the image is created mechanically. The artist creates his image by means of a lens (his eye) connected not to a machine, but to his brain. As E. H. Gombrich has shown, the mind adapts and adjusts what the eye delivers in accordance with its preconceptions and contextual information.[30] A mountain range seen on the distant horizon is registered by the camera as an almost undifferentiated row of saw-teeth.

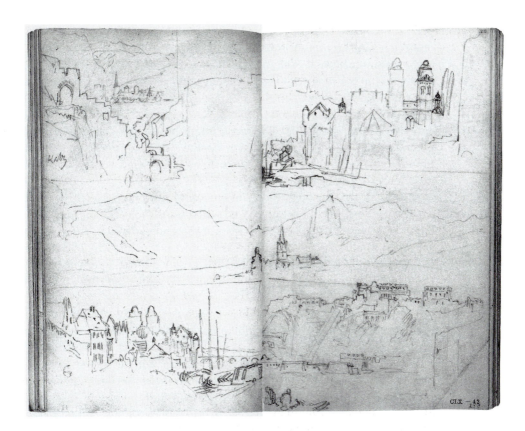

Because the mind of the viewer can compensate for the distance, the eye 'sees' much more of the mountains than the camera does.

In Turner's time, that opinionated tourist and pundit of the Picturesque, the Reverend William Gilpin, had made the same point:

> In the exhibition of distant mountains on paper, or canvas, unless you make them exceed their real or proportional size, they have no effect. It is inconceivable how objects lessen by distance. Examine any distance, closed by mountains, in a camera [i.e. a camera lucida], and you will easily see what a poor, diminutive appearance the mountains make. By the power of perspective they are lessened to nothing. Should you represent them in your landscape in so diminutive a form, all dignity, and grandeur of idea, would be lost ... We must ... enlarge the scale a little beyond nature, in order to make nature look like herself.[31]

Turner may well have been thinking of Gilpin's precept when he formulated his own account of the artist's role as interpreter of perceived phenomena: the eye and hand cooperate so as to invest any object with 'its proper proportion distance by size that the light shade and color may unite so as to imply [and] impress that general [view] of distant object[s] [that] even the most uncultivated eye seem[s] capable of ow[n]ing ...'.[32]

This perception lies at the root of his attitude to distortion, and its relation to Sublime landscape painting. His intentions as an ambitious artist were aided by the use he made of his own 'fine grey eyes', so often described by

5.6 *Waterloo and Rhine* sketchbook, ff. 41 verso – 42 recto, sketches at St Goar and Coblenz, 1817, pencil, page size 15 × 9.4 cm (Turner Bequest CLX 41a–42; Tate Gallery)

people who knew him as 'penetrating', sharp and bright, hawk-like and all-observing.[33] As he himself said, 'He that has that ruling enthusiasm which accompanies abilities, cannot look superficially.'[34] His awareness of everything in his range of vision ensured that even distant detail in a view was transferred to the paper. An example is the slight note that Turner made in his *Scotch Lakes* sketchbook[35] which records a view in Sma' Glen, south of Amulree in the Highlands. The scene might barely attract the notice of a photographer, but the quick sketch of the artist registers the inherent grandeur of mountain forms because he apprehends it as a mental experience, not a purely visual one.

Thanks to the perspicuity of Turner's shorthand, each sketch, however small, is not only readable but packed with information. The rectangle for a building, its windows indicated by rows of short lines, the circle for a tree, the cross for a windmill – these signs are as succinct as those on a map, miniature versions of the formulas he evolved early on for use on larger sheets; they come together in minute compositions that fully evoke the character of the place they show.

One element in this process of reassembling observed reality on the page is the relating of objects to one another in an implied space. It was not the purpose of the pencil sketches made on the spot to evoke atmosphere or to convey a sense of space in any atmospheric sense. But Turner's sure instinct for what it was necessary to express in line and what could be omitted, or left to his memory to supply, results in drawings that unerringly group and compose, or perhaps more accurately suggest compositions, so that to turn the pages of a book like the *Holland* sketchbook,[36] used on a tour of 1825, is to tread the streets of Dutch towns and to drift along their waterways, the lines of houses, the squares and bridges, opening up to the view one after another and admitting glimpsed perspectives of turnings to right and left (see Figure 5.7). A. G. H. Bachrach has demonstrated the precision with which each building in Rotterdam is depicted and located in its setting in a succession of drawings obviously made very rapidly, but always noting both the detail and the relative scale and general character of every structure. Sometimes, as on folio 71 verso, a mere outline gives the silhouettes of buildings and the shape of a long line of houses on a canal, while some jottings at the bottom of the page supply enough information to fill the foreground with boats and figures. The next page, folio 72 recto, has the view looking the other way, with, inset in a sketched 'frame', a thumbnail composition of the scene with added trees. Another corner of the sheet has a detail of the clock on the Lutheran church to the right. He spots a heraldic cartouche in a pediment and makes a separate note of it, or sees the pennant on a boat in a canal: 'D[ark] Blue Flag White Edge in parts'. Successive pages show Turner circling round the Lutheran church, incorporating it in a variety of views, and noting other features. A bold line summarizes a horizon silhouette on folio 85 recto; on a double-spread, folios 87 verso–88 recto (see Figure 5.7, p. 77), the whole of the Oude Haven is laid out before us, the receding canal left as blank paper while its boats are indicated in swift curving strokes. Windows are mere single

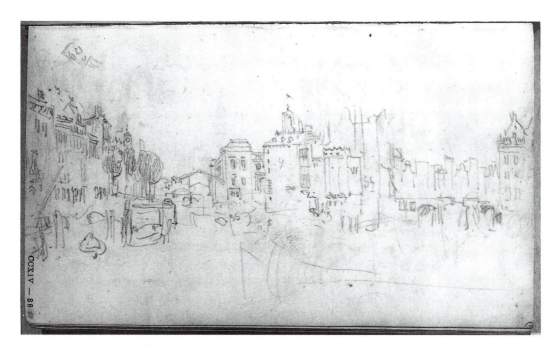

vertical strokes in serried rows, and omitted when the pattern is repeated, with perhaps a number – '9' – to remind him of the fenestration. A distant bridge is two sloping lines; a few trees are hatched lollipops, making a distinctive dark area among the busy outlines. Nothing extraneous to the immediate purpose of registering the scene is needed or admitted, yet the whole view comes to life in this vividly pregnant shorthand.[37]

The overriding impression given by the sketchbooks is that Turner used them as an extension of himself, a means of rendering in physical terms what his eye and mind apprehended in an uninterrupted flow of impressions. On his travels, he often drew more or less continuously, with a fluency that struck one observer as like 'writing rather than drawing'. The same friend also remarked on his tenacity of purpose: he went on making his sketches regardless of external conditions.[38] For Turner, visual experience was instantly internalized, but the artist needed some means of keeping so much material under control:

our different conception of forms, color and every occurrence of our lives are by the immediate perception of the interlectual power of the mind, either contrasted or combined or ever ready to combine what is most proper usefull and efficient, and to reject what [is] low little or absurd that to the utmost of our lives this power demands fresh supplies of further knowledge by more observation . . .[39]

The sketchbooks were also Turner's diaries and commonplace books. Cecilia Powell lists some of their contents 'apart from the sketches themselves', at random:

Snippets of diaries; excerpts from books; snatches of poetry (both his own and that of others); drafts of letters; financial accounts relating to patrons, journeys or merely

5.7 *Holland sketchbook*, f. 88 recto, 1825, pencil, page size 13.7 x 8.7 cm (Turner Bequest CCXIV; Tate Gallery)

food and drink; travel notes; lists of work in hand or yet to be done; tiny copies of paintings, prints and maps; recipes for painting media; medicinal remedies . . .[40]

to which we can add jottings of the grammar and vocabulary of foreign languages – French, German, Italian; lists of clothing; fragmentary drafts of lectures and speeches; plans for his own house at Twickenham and its garden; recorded conversations; lists of bank-note numbers; and very occasionally even drawings made by other people.

The outline of thought

Drawing in pencil or pen was for Turner not only a means of recording observed facts. It was equally an essential procedure in the noting down of ideas that came from within, trains of thought that incorporated his observations of the world around him into composite statements of the pictorial objectives those observations served. These composite statements are, indeed, compositions, in more than one sense. They are usually conceived within a rectangle, either drawn on the page or defined by the edges of the paper, and are concerned with the disposition of pictorial elements within that space. This was an exercise practised by artists since the Renaissance, an ordering of ideas prior to starting work on a picture. But the process had been given new significance in late-eighteenth-century England by the theories and practitioners of the Picturesque: both Alexander Cozens and Thomas Gainsborough had devoted much time to the systematic permutation of elements within the pictorial rectangle in order to create new landscape images. Both adopted more or less artificial aids in furtherance of this practice: Cozens his pseudo-scientific analyses of the proportions of the picture-space taken by sky, cloud, foreground, water and so on; Gainsborough his table-top theatre equipped with broken glass, broccoli and lumps of coal that could be moved into ever new combinations that inspired compositions.[41]

We know that Turner was well aware of these procedures and although he did not imitate them himself the Picturesque system must have been deeply ingrained in his imagination.[42] He had his own ways of ringing the changes on a single compositional idea, and in several sketchbooks there occur sequences of drawings which play with progressive variants on a theme. The *Studies for Pictures: Isleworth* book is particularly interesting in its alternation of drawings made from Thames-side scenery and depicting wholly imaginary classical harbours which nevertheless seem to evolve naturally out of the compositions he found in local nature (see Figure 5.8).[43]

The composition studies draw together several trains of thought into one unified image; as such they make particular demands on the artist's technical skills, eliciting a swift, highly articulate use of line. They occupy a special place in Turner's working processes, a modest outpouring of virtuoso calligraphy in pen and ink, sometimes chalk, usually pencil. They may occur in a sketchbook, or on the loose sheets that Turner always had by him at

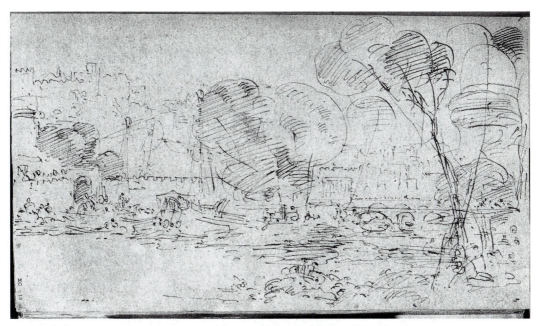

5.8 *Studies for Pictures: Isleworth sketchbook, f. 16 recto, study for a classical harbour subject,* c. 1805–06, pen and ink on white paper washed with grey, page size 14.7 x 25.6 cm (Turner Bequest XC; Tate Gallery D05512)

home: of their nature they are casual inspirations, momentary notes of ideas caught on the wing. In them the bold curves and loops that, as we have noticed, had already in the late 1790s become the shorthand in which he sketched his broader subjects assume a new stature, signifying even more of the correlative subject matter. A complete panorama may be expressed as a sinuous curved line opposed to a swirling circle – river and tree, with a jagged distance, either a mountain range or, in more block-like shapes, a castle or city. As the sketches from nature compress quantities of information into a minimum of marks, so these ideas for compositions expand under the eye into whole landscapes: foreground, distance, repoussoirs, reflections, all complete, at least by implication.

The genesis of an important painting was often the occasion for such sequential studies. There are examples in the *Calais Pier* sketchbook, relating to the evolution of Turner's ideas for the *Bridgewater Sea-piece*, a major marine exhibited in 1801; these are in black and white chalks and pen on the blue paper of that book.[44] Studies for other important pictures in gestation at that date also occur in this book, notably *Sun rising through Vapour* and *Calais Pier* (see Figure 5.9). The broadly handled chalks, amplified by pen, evidently reflect Turner's sense of the Old Masters at his shoulder.[45] Much later, a Carthaginian harbour scene, *Dido directing the Equipment of the Fleet* of 1828, was planned in a sequence of studies on the torn blue paper that he favoured in the late 1820s and 1830s, using pen and ink with white chalk.[46] The chalk is used schematically to indicate highlights in the sky and water; architecture is indicated by wiry pen outlines, and masses of darker tone either by rapid pen hatching, in the trees, or by a smudge of ink, in reflections.

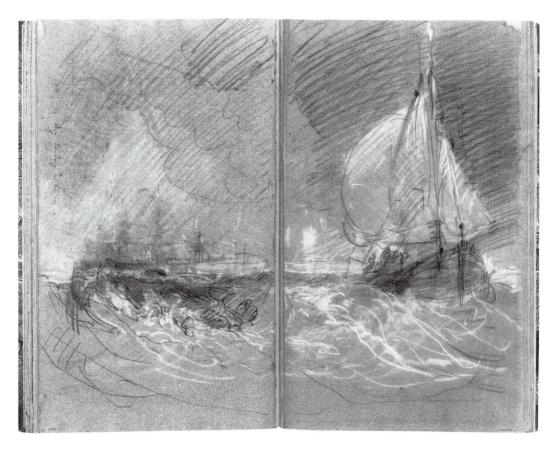

5.9 *Calais Pier* sketchbook, pp. 74–75, c. 1802, black and white chalks on blue paper, page size 43.6 × 26.7 cm (Turner Bequest LXXXI; Tate Gallery)

A more developed class of formal study is to be found among the drawings Turner made during his tour of France and Switzerland in 1802. The so-called *Grenoble* sketchbook is in fact a series of drawings in black and white chalks on grey paper that he mounted in an album, as though for presentation. They have been worked up into varying degrees of finish; some remain relatively slight, hardly more than the quick sketch made on the spot; others are effectively finished compositions, in which the darks and lights of the two chalks, on the mid-tone of the paper, create a sophisticated pictorial structure that is to all intents and purposes 'finished': 'pictures in embryo', in David Blayney Brown's words.[47]

On one or two occasions, Turner actually presented uncoloured pencil or ink outline drawings to friends. The examples that have been traced are usually marine subjects, groups of ships at sea or close to land, executed in a sure, calligraphic flow of line that is even more like handwriting than usual, and is even signed like a letter: his familiar mature signature of the four initials *JMWT* run together into a form of monogram. It was this signature that was to be adapted for the studio stamp applied to most works in the Bequest and to all works – prints and other items judged not to be 'from his own hand' – sold at auction from his house in 1872 and later. These 'presentation'

drawings are similar to some of his more complete sketches done on the spot and appear, from records kept with them, to have been made on request as mementoes during his stay with the architect John Nash at East Cowes Castle in the summer of 1827 (see Figure 3.2, p. 31).[48] Turner may well have taken them from the sequence of studies he was making there; he rapidly signed them and gave them to someone – an extremely rare occurrence. He was perhaps charmed into this betrayal of his normal practice of jealous retention of every scrap by a young lady's fluttering eyelashes. The fact that they are signed does not alter their status as working studies.

Line and colour

The pencil outline was so much the basis for Turner's working method that it is proper to examine it separately. But the introduction of tone into the very structure of a drawing by making the marks of pencil or brush emerge from a washed ground is only a step away from the use of colour. Turner's use of colour and his interest in colour theory, from that of George Field to that of Goethe, have been extensively discussed by several scholars;[1] I do not propose to re-examine the subject, except in so far as it relates immediately to drawing.

The anecdote recording his gruff summary that he could do twelve pencil drawings to one in colour (see p. 64) comes from his first visit to Italy, when, in addition to innumerable pencil sketches, he made a fair number of substantial watercolour studies. There were, then, always exceptions to his own rule, and it might be said that the true position is rather that colour was always intrinsic to his thinking, at least from 1795 on. We have already noticed that the execution of his first exhibited oil painting was a watershed, and seen how the sketchbooks demonstrate his awakened sense of the integral role that colour plays in the understanding of any subject. His use of tone carries with it always the implication of colour, and the *Wilson* sketchbook of around 1796–97 already makes it clear that a subject treated tonally was by extension being treated chromatically.

'No settled process'

The year 1795 marks the beginning of other practices that spring directly from this perception. Turner's sharply analytical mind quickly found it necessary to explore colour more extensively than was possible in his sketchbooks. Any subject that he decided to work on brought with it problems of colour that required to be tackled on a scale comparable with that on which he intended to finish the work. So from a very early date we find him dedicating sheets of paper to preparatory colour studies that adumbrate the whole design. Initially, these are often simply lay-ins: broadly washed indications of the principal masses and general disposition of light and shade. They seem

capable of being worked up into finished watercolours, just as the lay-in in oil would be worked up. Examples occur in the *Smaller Fonthill* sketchbook, where two studies, now disbound, show Turner planning Oxford views in about 1799, one of *Christ Church from the River*, the other of *Canterbury Gate, Christ Church*.[2] The relationship between study and finished drawing is in each case clear. Some compositional changes occur, but the general sense of each design is present, and some features – the sky in the river view, for instance – are worked up to an extent that gives them expressive weight. Indeed, these studies stand on their own as powerful images in their own right, and are in fact arguably more atmospherically 'Romantic' than the finished topographical views they adumbrate.

The inherent expressive power of such studies has tempted many commentators to assume that Turner intended them as complete statements. There is no evidence whatever for this; they remained among his papers, whether bound or loose, until his death and it was only much later in his career that he extracted certain 'unfinished' studies from his sketchbooks and allowed his agent to sell them. Those are drawings that fall into a wholly different category from the 'beginnings' we are now considering, and they will be dealt with in their place.

Even before he made the Christ Church studies, Turner had developed a system of experimentation with colour that was unique to him, a sophisticated reflection of the complex analysis to which he subjected his subject matter. The primary impulse was perhaps not the influence of his own oil painting, but the study of the masters of chiaroscuro with whom he had become familiar in Colt Hoare's collection and elsewhere in the middle of the 1790s. When he came to make his own grand experiments in chiaroscuro, he encountered the need to rationalize and control the powerful forces with which he was working. He harnessed them by means of large-scale studies, about the size of his projected watercolour, in which the basic structure of the design was worked out in the boldest possible masses of colour. They have often been known as 'colour structures' because of this; Finberg's less satisfactory but more inclusive phrase was 'colour beginnings'. There is no necessity for a strict definition of these terms, but they are generally used to refer to colour studies with the specific role of plotting the disposition of the larger colour masses of a composition, and not to the coloured drawings in the sketchbooks, such as those in the later, 'roll' books.[3] The novelty of Turner's conception in working in this way can be seen from a group of studies that he made in 1799 after his tour of Snowdonia in that year. Five large sheets of Whatman paper are devoted to the working out of a single motif, the outline of Snowdon as seen from Llanberis Lake (see Figure 6.1). Turner repeats in each a simple silhouette, using a uniform wash of purple, dark blue or, in one case, a very pale violet. The silhouette includes two peaks, which are sometimes treated as a single plane, sometimes as overlapping planes. More or less of the foreground, with light reflected off the lake, is included in each; in the pale violet study only the shape of the mountain appears. The viewpoint varies slightly from one to another, as

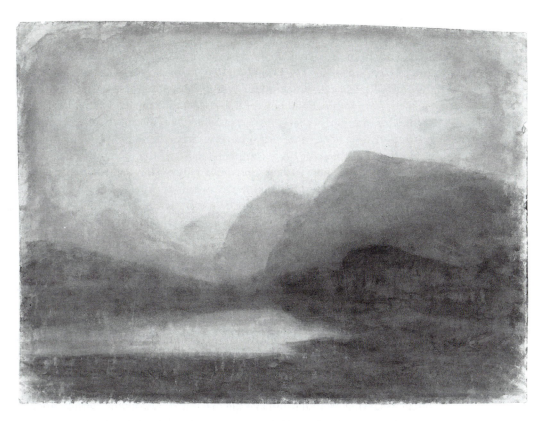

though Turner were testing the effectiveness of shape against colour and
tone, juggling and balancing the elements.[4]

There are in addition two similarly large studies of the scene more or less
finished, with the lake in the foreground and the detail of Dolbadarn Castle as
a focus for the eye on the distant shore.[5] Each of these has its own viewpoint,
atmosphere and character. The whole series represents a single train of
thought. Late in his life, Turner was to pursue a similar sequence of ideas in
response to another mountain, the Rigi beside Lake Lucerne, and it is worth
looking ahead to that series in order to place the Dolbadarn studies more
precisely in his development. In the 1840s, he had not entirely given up using
large sheets like those of the Welsh set, nor the practice of adumbrating a
composition in simple masses of colour, but his more usual procedure was to
work in a so-called 'roll' sketchbook, with pages stitched into paper covers
which can have afforded little support for an outdoor drawing, even folded
over on itself. We know from several contemporary accounts that he carried
such books rolled in a pocket, but he must usually have kept them flat in a
portfolio, or taped together with other books. The sheet size is approximately
230 x 300 mm. On this scale he could work in any degree of detail he required;
we shall examine the evolution of this facility in due course. For our purposes
here, we need only notice that the large Welsh sheets have the function of
broadening Turner's technique commensurably with the scale of the scenery

6.1 *Llanberis
Lake*, colour
beginning,
c. 1799,
watercolour, 54.7
x 76.5 cm
(Turner Bequest
LXX d; Tate
Gallery D04181)

he is contemplating. At the same time, his generalized 'structural' schemes, consisting of more or less unmodulated washes, are bold and crude. We should not be inclined to interpret them as direct responses to the scene before him. They are clearly experimental, part of a process, and represent unresolved parts of a whole that is yet to be realized, parts that have been isolated for examination, powerful but incomplete. By contrast the Rigi studies of the early 1840s, varied as they are in finish and density of realization, each achieve perfect self-sufficiency. The slightest of them, a very pale primrose silhouette,[6] is a complete record of the mountain at a certain moment just after sunset. It belongs in a long series of meditations on the subject, but not in a line of related steps towards one finished work, or several.

The comparison I have just made between studies of the late 1790s and of the early 1840s has the obvious effect of pointing up the tentative nature of the earlier work. But that should not obscure the extraordinary maturity and confidence with which the Welsh studies are handled. When he set himself to render the mountains he saw in front of him, even on a large scale, Turner evinced a clarity of perception and a fluency of handling that have no equal in the work of any other watercolourist, let alone of one still in his early twenties.[7] The Turner Bequest includes some large sheets, inchoate exercises relating to watercolour subjects, which show him venturing to the extremes of possible expression in the medium. One, a preparatory study for a view of Dolbadarn Castle seen from close beneath it,[8] has pigment mixed with a thickening agent, perhaps flour paste, so that it preserves the texture of the brush as it whirled and swooped over the paper. The whole sheet is washed with delicate layers of pale pink and blue, partly lifted with a brush full of clear water and blotted, to reveal a layer beneath or the white paper under all.

It is a graphic illustration of Turner's own account of his methods as recorded by Farington: 'He told me he has no systematic process for making Drawings, – He avoids any particular mode that He may not fall into manner. By washing and occasionally rubbing out, He at last expresses in some degree the idea in his mind.'[9] On another visit to Farington, he named names: 'He reprobated the mechanically, systematic process of drawing practised by Smith [i.e. John 'Warwick' Smith] & from him so generally diffused. He thinks it can produce nothing but manner and sameness.' Turner was determined to avoid the formulaic clichés of watercolour, and this determination seems to have led him to adopt a procedure analogous to that of Alexander Cozens with his method of developing landscape compositions from random blots. Farington went on to paraphrase some further comments that reiterate what he had been told before: 'Turner has no settled process but drives the colours abt. till he has expressed the idea in his mind.'[10] A few years later, in 1804, he gave Farington more explicit details of how he obtained his effects:

The lights are made out by drawing a pencil [i.e. brush] with water in it over the parts intended to be light (a general ground of dark colour having been laid where required) and raising the colour so damped by the pencil by means of *blotting paper*; after which with crumbs of bread the parts are cleared. Such colour as may

afterwards be necessary may be passed over the different parts. A white chalk pencil (Gibraltar rock pencil) to sketch the forms that are to be light. A rich draggy appearance may be obtained by passing a camel Hair pencil *nearly dry* over them, which only *flirts* the damp on the part to be touched and by blotting paper the lights are shown partially.

As the Victorian painter John Calcott Horsley recalled,

It was Turner's habit to keep the paper in a fluent condition of moisture. It is most noticeable that in whatever stage his drawing might be left, it was always beautiful. This is very plainly seen by looking at his unfinished sketches; these are in all stages, and every one of them is interesting. An amateur lady artist tried to get some criticism out of him on a drawing. 'Put it in a water-jug, my dear,' was his sole answer.[11]

The sequential analysis of the colour masses in the Dolbadarn group illustrates more clearly than any other works the degree to which, at this early stage, Turner was prepared to pursue the internal visual and chromatic logic of his chosen subject matter, to dissect it and hold each separate element up to scrutiny. When he came to synthesize the various lessons he had learned in the process of making a succession of specialized studies, he needed a correspondingly complex and subtle procedure, which, again, involved a deliberate refusal to succumb to a predetermined method or 'manner'. Contemporary descriptions of him at work are rare enough, since he vouchsafed first-hand knowledge to few, and only rarely discussed his working practice with others. We are reliant on Farington for much of what we know.

One procedure that Farington did not find out about was a trick he used on several occasions in the years around 1800 when attempting the grand manner in watercolour: to lay in a broad approximation of the composition of his picture *on the back of the sheet of paper*, thus reinforcing the dark areas with earth colours that reduced the transparency of the medium while using very light pigments, or none, in the sky, which was by that means supposed to have enhanced luminosity. It is difficult to determine whether this cunning ploy had any important effect, but Turner certainly thought it worth trying.[12] He does not seem to have continued the practice for long.

But many of the procedures that he invented in the late 1790s served him well for much of his life. We see him following them in the working-out of a large finished watercolour in the 1820s, *Grenoble Bridge*.[13] His theme is a characteristic one, the excitement of the traveller on approaching the Alps. That excitement is expressed through the disposition of large crowds of people in the town, on the river or crossing it over the bridge, the hotels – 'Bon logement ici' is written on the wall of one – and so on. The mountains which are the goal of the journey appear only in the background, hovering distantly as they would be seen by the anticipatory traveller. It is a complex subject – taken from a drawing he had made during his tour to the Alps twenty years earlier[14] – and Turner evidently felt the need to disentangle its component parts and decide by practical experiment how he was to assemble them. Accordingly, he made a study, on a sheet rather larger than the final

work, that does little more than lay down the broad opposition of warm and cool colour – ochre and blue – that is the foundation of the composition. Another sheet plans the geometric skeleton: the cubes and rectangles of the buildings, so that amorphous colour is given spatial location (see Figure 6.2). Here and there odd details are introduced, to test, as it were, the scale of the architecture, humanity and geography one against another. Having looked at these studies, we at once see that the final watercolour is indeed made up of a fundamental opposition of blue and ochre, upon which the local hues are placed directly, with a fine brush, as though Turner were drawing.

These local colours are occasionally very bright; he enjoys the effect of a spot of vermilion as much as Constable did at the same date, with his rustic boys in red waistcoats. The new emerald green was introduced from Germany in these years,[15] and Turner was quick to experiment with it and introduce it as a focal point in his foregrounds. He was also fond of blue and white stripes, the sort of ticking that country people in England and on the Continent obliged him by wearing as a matter of course. These precise touches are always applied to staffage – to the people in his foregrounds or to their impedimenta, of which he was a fascinated observer. Their dress, their laundry, their loaded wagons and carts, their shop displays, are all carefully noted in his sketchbooks and incorporated into the finished pictures. The same colours and patterns occur in the topographical watercolours of contemporaries like Samuel Prout (1783–1852) and John Sell Cotman, and it is reasonable to suppose that Turner looked carefully at what these artists were doing and had no intention of allowing them to monopolize the topographical market; he had, after all, been brought up to it, and in ambitious pieces like *Grenoble Bridge* was no doubt consciously measuring himself against them. Cotman's brilliant palette of the 1820s with its saturated reds, yellows and blues must have had its effect on him,[16] and the general lightening of Turner's own palette in this decade, which has usually been attributed to his experience of Italy in 1819, is just as likely to have been a response to the new, brighter style of these post-war draughtsmen, who were turning decisively away from the Sublime aesthetic of 'sad and fuscous' colours, as Burke put it,[17] towards the bright, cheerful gamuts favoured by the new bourgeois market in the decades following Waterloo.

Turner's 'colour beginnings' have been connected with his lifelong interest in architecture.[18] They are indeed studies that attempt to isolate and display the underlying structure of the composition, though there may be no evident man-made architecture in the subject. We have seen that Turner could deploy the method with a theme as purely natural as the mountains and lakes of North Wales. But it may be that it was indeed architecture that triggered his thinking on this matter, as we might suspect given his involvement with architectural topography in the formative stages of his early career. Although we do not have 'colour beginnings' as such from the early and middle 1790s, some of the watercolours of those years seem to have been conceived with a strong sense of the architectonics of the composition in mind, as though

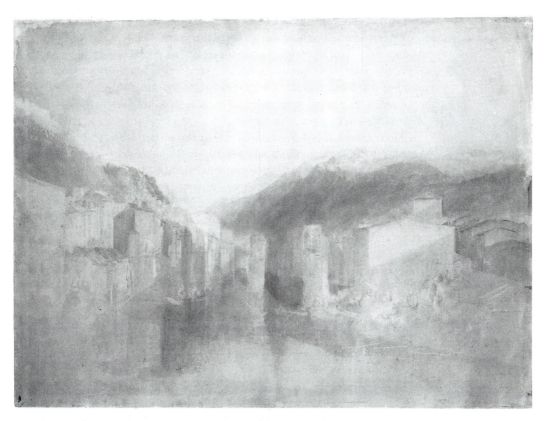

6.2 *Grenoble*,
colour
beginning,
c. 1824,
watercolour, 55.5
x 75 cm (Turner
Bequest CCLXIII
346; Tate Gallery
D25469)

Turner had executed 'colour beginnings' in his head before putting brush to paper. The view of Valle Crucis Abbey already referred to is an example (see Figure 4.3, p. 60). The upright composition is divided very distinctly into horizontal bands of contrasting light and dark tonality – a highly self-conscious arrangement that departs quite radically from the conventional layout of Picturesque composition. This scheme is related directly to the subject matter: below, the abbey ruins brood in the shadow of the valley, while above the hill of Dinas Brân with its ancient castle rises up into clear light. The effect is dramatic, but there seems no inherent reason for the contrast, beyond the opposition of foreground and background.

A more interesting specimen which documents the continuation of Turner's thinking on this theme is the view of Lincoln Cathedral from Exchequer Gate, another product of his tour through the Midlands to the Dee Valley, that Turner sent to the Academy in 1795.[19] The strong tonal contrast of *Valle Crucis* is replaced here by a subtle alternation of warm and cool colour, and the 'real' architecture of the view is used to create a powerful compositional structure. The top half of the sheet, in delicate blues and greys, is opposed to the lower half where, below a firm horizontal created by the top of the gateway, the scheme is dominated by warm browns and buffs. In this lower half, the subject is the life of the street, with shops, travellers and stray animals. These are aptly portrayed in the earth colours Turner has used.

Above, the spires of the cathedral rise up in an airy pattern of silvery, ethereal tones that seem to embody the spiritual life symbolized by the building. This sophisticated development of a topographical view into a complex statement about the inner and outward life of the place described marks a crucial moment in Turner's intellectual development: the understanding that topography can achieve more than the simple recording of facts, and can project ideas in its very structure.

Colour therefore asserted itself as intrinsic to the process of building the complex formulations that were his finished compositions; that is, it was established as part of the structure of the subject, not simply as a local application to its surface. The final work was equally built up stage by stage, both as the expression of many-layered content and as the natural consequence of the drying times of watercolour pigments. He could work on many drawings simultaneously, washing several sheets of paper with the broad masses of colour that established the main oppositions of the design, hanging them up to dry and in due course applying further washes and eventually the details with a fine brush. He would adopt this practice wherever he happened to be working.[20] At Farnley, 'when Turner's bed-room door was open', Walter Fawkes's young daughters 'saw cords spread across the room as in that of a washerwoman, and papers tinted with pink, and blue, and yellow, hanging on them to dry'.[21] This anecdote rings absolutely true. Both the 'colour structures' and the finished drawings themselves testify to a 'production line' on which several were developed at once, using a similar range of colours. It was precisely this procedure that Turner was to employ henceforward in nearly all his finished works in watercolour, and indeed often in oil too. The relationship between the two media, which amounts to a virtual identification, was the inevitable outcome of his long experimentation with both, and is the key characteristic of his most typical late work.

Lawrence Gowing speaks of 'the uncontrollable hazards of watercolour' which, he suggests, 'were the medium of Turner's private imaginative life'.[22] The implication that Turner was not in full control of the medium of watercolour, and that his art profited from this, as though he were a proponent of random or gestural painting for its own sake, is wide of the mark. As Ruskin's analysis makes clear, Turner was always in complete control when he worked in watercolour; the stories of his virtuosity in the medium are sufficiently abundant to confirm that. A famous one is the report of the young Hawkesworth Fawkes at Farnley, watching him create his *First Rate taking in Stores* in 1818,[23] with its description of him 'working away like a madman' and of how he 'tore, he scratched, he scrubbed it in a kind of frenzy and the whole thing was chaos' until 'gradually and as if by magic the lovely ship, with all its exquisite minutia, came into being'.[24] The 'tearing' literally took place: he grew an 'eagle-claw of a thumb-nail' with which to create sharp lightning-like highlights in water and wherever else he required brilliant notes.[25] J. C. Horsley supplies further details of the event: 'The child stood by him and he proceeded to put in all the details with explanatory

comments: "this is the body of the ship. Now come the masts – here go the guns!" What evidently most impressed the child was the extraordinary rapidity, and the way in which, as he said, he "made the paper bubble".'[26]

Notice that the process of creating the complex image, whose primary purpose was to make for Fawkes 'a drawing of the ordinary dimensions that will give some idea of the size of a man of war', involved both the impressive scale of the ship and its 'atmospheric' qualities as an evocative presence on the sea, but also its 'exquisite minutia' – the gun ports, the intricate rigging, the sweeping curve of the bow – and the telling figures in the small boat alongside, dwarfed by the huge vessel. All these motifs, which are of a particular descriptive kind, are conscripted in the task of conveying the central idea which is in an important sense abstract: vast size is here a very specialized aspect of the Sublime.

Gouache

Turner's attitude to gouache, or 'bodycolour' as he would have called it, was ambivalent. It was an integral part of the watercolourist's equipment: powdered pigment mixed with an opaque medium such as lead white which ensured that saturated colours could be applied to tinted as well as plain white supports. It had been used extensively for decorative purposes where strong colour was required: fan-painting is an example. By the early nineteenth century it had become particularly associated with the views of Naples and Vesuvius (usually erupting spectacularly) that tourists liked to buy when abroad. It was, in a sense, not serious. To use opaque lead, zinc or Chinese white as a substitute for the white of the paper was to traduce the medium. Horsley records a discussion about 'permanent white' among artists including J. D. Harding (1797–1863) and David Roberts (1796–1864), both conspicuous for their use of bodycolour in their work, in which Turner ('omnipotent, and standing completely alone') objected to 'permanent white' and 'its use in any way either as a compensation for leaving the pure white paper for lights and delicately toning it with transparent colour where required, or for washing or scraping out the spaces devoted to the light portions of the subjects'. Horsley adds that Turner was

generally a reticent talker, but on this occasion he wound up a strong speech by shaking his fist at Harding, Roberts, and some others, who were supporting feebly the *convenience* of the vulgarising material in question, and saying quite fiercely, 'If you fellows continue to use that beastly stuff you will destroy the art of water-colour painting in this country.'[27]

Horsley's memory is not always reliable, and there are elements in his account that do not ring quite true. Turner did in fact employ gouache sparingly in his watercolours, as a means of intensifying the colour of foreground detail, especially the costumes of figures. But it is correct to say that he did not use it for highlights, or as a substitute for the white of the

support, at least until the very end of his career. The opinions Horsley records were common enough in the nineteenth century, though many younger artists, like Harding and Roberts, consciously ignored the 'rule'. However, it was a matter of pride with Turner and his watercolourist contemporaries that the medium could stand on its own without the adventitious aid of bodycolour. There may have been an element of sheer professional sentimentality about this, but he could cite practical objections to mixed media. Gouache tends to behave differently from watercolour, drying and cracking and creating an unstable surface; if used in conjunction with watercolour it begins over time to take on a different appearance, so that the picture as a whole goes 'out of keeping', with its tonal relationships destroyed.

But when it came to working on paper that possessed its own tint, such as the blue or grey wrapping papers that Turner became fond of in his fifties, gouache was virtually a necessity. He first used gouache extensively in the drawings he made for his patron and close friend Walter Fawkes in the years around 1820: souvenirs of his Rhine journey of 1817 (see Figure 6.3) and views of Fawkes's home, Farnley Hall on the banks of the Wharfe, neighbouring properties of the family and the surrounding countryside. They have always been remarked on for their intimacy, for their apt celebration of the affection that subsisted between the two men. It is as though Turner chose the medium – 'not at all allowing the mixture of transparent with opaque pigment', as Ruskin observed[28] – and its corollary support, rough buff paper, in order to emphasize that these images were not formal, public statements, but private and personal, to be shared between only a few individuals known to one another. There is an agreeable mixture of topography and anecdote: huntsmen process to Caley Hall with the deer they have killed; a horseman gallops up the carriage drive just ahead of a coach piled with luggage. Inside the house, the rooms are empty but eloquently bespeak the domestic life that takes place in them, the music-making, the dining, the reading and talking.

He chose gouache again in similar circumstances at Petworth in Sussex, the house of another friend and patron, the 3rd Earl of Egremont. He took up the habit of staying there about a decade after he had executed the Farnley series. Fawkes died in 1825 and it was in 1827 that Turner's regular visits to Petworth began. His long series of studies in and around the house belong to about 1827, by which time he had developed a partiality for working on blue wrapping paper, torn into small rectangles measuring about 140 x 190 mm. These made pocket-sized bundles, tied with tape, and demanded to be worked on in bodycolour. The transformation of Turner's palette had now taken place, and he exploited the full potential of gouache as a medium of brilliant colour. The Farnley drawings, by contrast, seem subdued, reflecting the rainy Yorkshire autumns when they were done.

The small scale of the Petworth drawings enhances their jewel-like brightness, and the series is among Turner's most popular works (see Figure 1.3, p. 7).[29] Like the Farnley subjects, they are drawn directly onto the paper

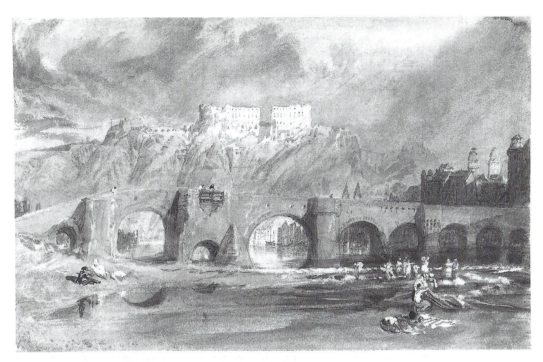

with the brush, with no under-drawing in pencil or ink. It is interesting that Turner's first experiments with the piles of torn blue paper, at East Cowes Castle in the summer of 1827, do not make use of colour, but are executed in pencil and pen with black or brown ink and some white chalk. Some Petworth subjects are views of empty rooms, as at Farnley, drawn with the brush in delicate detail, but always with a magical sense of the shimmer of light through curtains and across Turkey carpets. Preponderantly, though, the Petworth series is notable for its broad handling; even the scenes with several figures are usually sketched with great rapidity. The glimpses of bedrooms, the views across the park, are brought to life with bold sweeps of the brush loaded with strong colour. Indeed, the main difference between the two series is that the Farnley subjects, however intimate in feeling, are finished statements, whereas the Petworth drawings are much more spontaneous, the surreptitious jottings of a familiar allowed to wander the house at will, undisturbed and unquestioned – even when he entered another guest's bedroom. The Petworth sheets were never sold off by Turner,[30] but he made the Farnley set specifically for Fawkes himself.

The longest of all the series of works in gouache is that made in connection with the *Rivers of Europe* project on which Turner was engaged for over ten years. It was planned as a series of illustrated volumes on the scenery of the principal European rivers, but only three were published, although Turner made hundreds of drawings for the remainder. There were pencil studies in sketchbooks, slight pencil or colour sketches on his favourite blue paper, and fully worked-up designs, also on the blue paper, and entirely in gouache. All the finished designs for the three published books, *Turner's Annual Tours* of

6.3 *Moselle Bridge at Coblenz*, 1817, watercolour and gouache on white paper prepared with a grey wash, 199 x 311 cm (Makepeace Investments, courtesy of the Art Gallery of Ontario)

the Loire and the Seine (1833 and 1834–35, the latter occupying two volumes), were likewise in gouache. Here at last we encounter gouache in use at all stages of the production of topographical views, from sketch to finished work. Clearly, the choice of medium was related to Turner's growing interest in saturated colour, and his ideas about the relationship between colour and its translation into the monochrome of line-engraving.

Drawing and printmaking

This raises the question whether Turner's subjects and technical methods were influenced by the form in which his compositions were to appear before the public. In general his watercolours were engraved in line; mezzotint was a rarity, though from the large plate of the *Shipwreck* of 1807[31] until at least the late 1820s he favoured mezzotint as a medium for publishing his oil paintings. To this observation must be added the rider that those paintings were, by and large, early Sublime subjects whose dark tonality naturally lent itself to interpretation in mezzotint. The presence in London of an exceptionally fine mezzotinter like Thomas Lupton in the 1820s must have had some influence on Turner's choice of medium for plates like *Whiting Fishing off Margate*,[32] which is a blond-toned work of that decade.

But no discussion of Turner's use of mezzotint can proceed without a consideration of the *Liber Studiorum*. The plates for this long series were executed in mezzotint over an etched outline. Occasionally Turner himself etched the outline, and later in the project he even mezzotinted plates; the more usual procedure was for professional engravers to do both tasks. The originals from which they worked were monochrome drawings that Turner prepared specifically for that purpose, using pen and brown ink wash. He had in mind the mezzotinted plates of Richard Earlom (1743–1822) in his well-known publication of Claude Lorrain's *Liber Veritatis*, which had appeared in the 1770s and was, of course, a kind of Bible for a Claude-follower like Turner. His invocation of both Claude and Earlom was a highly self-conscious gesture. Just as the *Liber Veritatis* was a record of Claude's finished compositions, so the *Liber Studiorum* was, at least in its original intention, a survey of Turner's output to date. In practice, he frequently invented new subjects especially for it, since he wished it to serve a didactic purpose, covering the various branches of landscape art: Mountainous, Historical, Marine, Pastoral and 'Epic Pastoral' – if that is what Turner's initialized category 'E. P.' means: he evidently intended to distinguish between the 'ideal' or 'classic' pastoral of Claude and the 'rustic' pastoral of the Dutch, which he interpreted in subjects such as *The Straw Yard*, *Hedging and Ditching* and scenes of children playing – *Juvenile Tricks*, *Marine Dabblers* and *Young Anglers*.[33] The intention to advertise his scope as a landscape painter as spanning the southern and northern European traditions is very evident, as is his wish to claim for himself the ground that David Wilkie (1785–1841) had recently so successfully occupied as heir to the Dutch genre

painters. Gillian Forrester has seen in the *Liber* plates an attempt to evoke not only Wilkie but several other stars in the firmament of British painting – Augustus Wall Callcott (1779–1845), George Morland (1763–1804), Gainsborough, Girtin, Wilson and others – arguing that Turner intended a 'visual manifesto' for the British School.[34] But his innate competitiveness inevitably made the exercise more a demonstration of his own comprehensive mastery than a wholly altruistic desire to advertise the merits and range of his colleagues' work.

The *Liber Studiorum* drawings are quite different from any other project Turner undertook (see Figure 1.4, p. 7). There is indeed, something self-consciously archaic about their style. Turner is both measuring himself against his most venerated predecessor in landscape, and setting himself up as a teacher. He is not, in this long succession of subjects presented as exemplars, appearing in the role of rebel. The 'white' pictures with their pale grounds that offended his more conservative critics in the later 1810s were not the images that he chose for this work.[35] The technique he adopted must be regarded as a deliberate throwback to an eighteenth-century convention perpetuated in a long list of publications reproducing Old Master drawings, from Arthur Pond (1705–58) in the 1720s to Francesco Bartolozzi (1727–1815) and Earlom in later decades. These artists drew on several different technical systems to achieve what they hoped were facsimiles of pen and wash drawing: etching was the staple, which effectively reproduced pen and ink; tone might be added by means of wood blocks, aquatint or mezzotint.

In the early nineteenth century lithography began to usurp these processes as the most efficient and flexible reproductive method. Although it was the newest technology, and very widely used from the 1820s on, Turner, interestingly, made virtually no use of it at all.[36] This is uncharacteristic in so far as he embraced the new in most fields with enthusiasm, but he probably considered that lithography, while admirable as a means of reproducing pencil or pen drawings, was flat and cold when it came to evoking light and shade. Even the comparatively artificial and labour-intensive process of line-engraving could achieve greater richness of texture, and by the time lithography had become common he had established longstanding working relationships with a group of line-engravers with whom he evidently felt comfortable, on whom he could rely to understand his requirements.

If Turner consciously allied himself with an earlier tradition in his *Liber* designs, he was able to use the pen outline that this method involved as a means of translating the language of his pencil sketches into something more permanent. The fluent shorthand he had developed for use on his travels becomes a discreet yet forceful framework on which the tonal structures of these compositions are built. The published plates (unless they happen to have etched outlines by Turner himself) inevitably lose something of this very personal touch, although the engravers were able men and closely supervised by the artist. W. G. Rawlinson in his catalogue of the *Liber* plates attempted to distinguish Turner's own etching style from those of his engravers, and Ruskin corroborated his conclusion that it was indeed to be

differentiated, and specified its richness and fluency, together with a nervous response to the textures of natural forms that was transmuted into mere formula by the professionals.[37] As for the monochrome washes, they are always purposeful and enhance the poetry or drama of each design. As Rawlinson noticed, the range of browns, from the 'natural cool and pleasant' sepia to the 'more sombre' bistre or the 'red or "foxy"' umber, lends considerable variety to the drawings;[38] but only in a few, such as *Peat Bog, Scotland,*[39] do they take on independent force and assume the burden of the whole visual statement. In these cases, Turner's interest in the translation into mezzotint seems to intensify, his instructions to the engraver are more pressing and the final print can be even more powerful than the drawing.[40]

His passionate interest in the monochrome washes of the *Liber* series spurred Turner to create a further set of prints independent of that project. The sequel, the so-called 'Little Liber', consists of a small group of plates, some unfinished and none published, in which he is seen simply experimenting with a medium that had evidently come to fascinate him. Lupton's virtuosity may have had something to do with piquing his natural competitiveness. In 1826 another mezzotinter with whom Turner had had dealings over many years, F. C. Lewis (1779–1856), engraved an atmospheric marine painting, *Sunset at Sea,* by the Bristol painter Francis Danby (1793–1861), which may have drawn his attention once more to the value of mezzotint. At least one of Turner's 'Little Liber' plates seems to acknowledge a debt to this.[41] The slight colour studies that he executed as preparations for these plates are beautiful, and mark a moment in his development when his use of coloured washes becomes more liquid and evanescent, an important step towards the diaphanous atmospheres of his late studies. Perhaps his involvement with the broad tonal statements that mezzotint was capable of had its effect on this process.

It would be convenient if Turner had adopted mezzotint from this time on as his preferred print medium. Its complete lack of any linear component would have made it entirely suited to a style of painting that increasingly eschewed outline. But with the exception of a few large plates after oil paintings, none of which were published in his lifetime,[42] he superintended no further mezzotints after his brief, if for the moment passionate, 'Little Liber' experiment.

The pen and ink or etched outlines of the *Liber* may also presage a later technical development, as we shall see when we examine the late Continental studies, with their integrated use of pen.

Scale: topography and illustration

Turner's instinct to make drawings in sets or series was not only a function of his technique, of the process of creating a work. It had its roots in a characteristic circumstance of late eighteenth-century topographical publishing: the demand for collections of illustrations to be issued in series, whether as parts of a topographical survey like the *History of the River Thames* (1794) that Joseph Farington illustrated for the printmaker-publisher

John Boydell (1719–1804), or as decorations for popular almanacs and pocket-books. One of Turner's first substantial commissions was for a long series of small designs to be engraved for John Walker's *Copper-Plate Magazine* – a periodical that flourished in the middle years of the 1790s, though it changed its name more than once.[43] Such work accustomed him to thinking in terms of sequential images, related to one another in scale if in nothing else, and usually in their approach to subject matter as well. In the end, he came to think that the value of his finished work lay precisely in its character as a 'series' – or series of series. His often-quoted wish that they be 'kept together' seems to reflect this idea, but although it makes perfect sense with regard to the *Liber Studiorum*, say, it is usually interpreted as referring to the oil paintings, towards which he had an ambivalent attitude. On the one hand he would sell them for as much money as he could get; on the other he would buy them back, or keep them all his life (in the unfavourable conditions of a badly leaking room) to be housed after his death in a permanent gallery. Apart from the paired subjects – *Modern Italy* – *the Pifferari* and *Ancient Italy* – *Ovid banished from Rome*, for instance[44] – one of the more obvious 'series' among the finished pictures is the long sequence of Carthaginian subjects that begins with *Aeneas and the Sibyl*, an unexhibited work of about 1798, and concludes with the four canvases he showed at the Academy in 1850. But it is an odd 'series' that contains so many and such heterogeneous works, including as it does *Hannibal crossing the Alps* of 1812 and a second version of *Aeneas and the Sibyl* of about 1815.[45] Ruskin spoke of 'the series which gave the key to their meaning', but it is hard to see how the majority of them gain from being 'kept together' in any respect other than from the cumulative power of a great artist's work seen *en masse*. Perhaps that is all Turner meant.

The topographical series, however, had a real hold on him as a creative matrix. His insistence on continuing to work in that way even when no commission was forthcoming, at the end of his career, is striking evidence of this. The Swiss views he painted in 1842–44 and even later constitute perhaps the greatest of his 'series' and were the result of the force of habit, not of economic or publishing logic.[46]

So topography was by no means a field of activity that he renounced as Academic honours fell on him at the end of the 1790s. He was elected Associate Academician in 1799 and a full R.A. in February 1802, rapidly developing his reputation as a conjuror of sublime effects on canvas. But he continued to accept commissions to make topographical watercolours for antiquarian publications, and although there was something of a lull in the years immediately after 1802, he filled it with his own project for a long series of small-scale designs, the *Liber Studiorum*. As a project initiated by himself, this followed on, with incomparably greater confidence, from the abortive 'Views on the River Avon' that he had planned in 1791. But once the *Liber Studiorum* was under way, he was happy to accept commissions for substantial quantities of topographical work, and would continue to do so until the late 1830s.

The first was a request from the engraver-publishers William Bernard and George Cooke in 1810 for a set of views on the southern coast of England, which entailed tours from Kent to Cornwall, and resulted in a set of some forty watercolours, executed on the very modest scale of sheets measuring approximately 150 × 220 mm.[47] It is significant that this small format stimulated him to some of his most elaborate designs.[48] They are often panoramic, and equally often incorporate minutely detailed foreground activity illustrative of the place depicted. Adrian Stokes associated Turner's adoption of the high overview of his subjects with 'the old-fashioned viewpoint from above … the means of survey, of the bather's deliberate contemplation from the diving-board'. The way in which Turner takes the convention of the 'bird's eye view' and recreates it for his own purposes is far from being the mere adoption of an 'old-fashioned' formula. The analogy of the diver is perceptive: 'We are given the opportunity to linger there, and through our own volition we are thereupon immersed and enveloped by the scene.'[49] This accurately describes the desire we experience when confronted by a splendid landscape to possess it, which may be achieved by swimming in its lake or river, by climbing its cliffs or hills or, equally, by drawing it.

The characteristic note is struck in *Falmouth Harbour*,[50] seen from a height on which sailors on shore leave revel in their brief leisure. The harbour at Falmouth is a geographically complicated interlocking of water and land, with shipping, fortifications and other buildings as well as people taking their appropriate places. Turner opts to include a huge expanse of the view seen from a high point, and its components are as lucidly presented as in a map or diagram, though with far more expressive interest. Another place of involved geography, Plymouth, is the subject of two views that exploit this compositional intricacy further.[51] In *Plymouth Dock, from Mount Edgecumbe* the distant harbour is seen through a screen of trees, while a party of merry-making sailors and their girls descend the hill. One of them waves a fiddle, and when the drawing came to be engraved, by W. B. Cooke, Turner took particular care to ensure that this fiddle was clearly delineated – 'can you make the fiddle more distinct', he asked Cooke in a note, and supplied a pencil drawing of the instrument as he wanted it depicted.[52] *Plymouth, with Mount Batten* is a crowded scene on several levels: the foreground grassy slope, with its resting men and women; the fort on the neighbouring hill; the water below crowded with vessels; and the distant town and battery. All are brought together in a comprehensive survey of the place that loses nothing from having been executed on a piece of paper measuring a mere 146 × 235 mm.

All this is achieved by drawing with a brush into the broader colour-fields established as the general structure of the designs. The rigging of the ships at Plymouth, the tackle of a tin-mine at Tintagel, the glitter of fish on the beach at St Mawes, are rendered by drawing, in colour, with a fine hair point, sometimes, we are told, with a brush of only one hair.[53] The landscape background is treated with equal refinement. Turner observes the rolls of clouds, the fall of waves, the fissures of rocks, with scrupulous regard for

their exact form and character, inscribing them into his atmospheric envelope with the same linear clarity that he brought to his swift but tightly disciplined pencil sketches. It is important to understand the drawn detail in his watercolours as belonging to a continuum with the sketchbook studies; this links the work of these years naturally with the later output, where technical distinctions between oil painting and watercolour become less and less important.

The technical and conceptual language of Turner's mature topographical watercolours was forged in the elaborate panoramas of the *Southern Coast* project. Some commentators, though, have felt that it was in his next series that it reached a peak of expressive concentration. This was the double set of even smaller drawings, also commissioned by W. B. Cooke, that appeared as mezzotints by Charles Turner and Thomas Lupton between 1823 and 1828. The two sequences were titled *The Rivers of England* and *The Ports of England*. Whether the knowledge that they were to be mezzotinted influenced Turner's working method is hard to say, but these watercolours, although some of them are couched in not dissimilar terms to those of the *Southern Coast* set, have an altogether denser, sharper, more brilliant effect. The use of fine hatching with the brush approaches closer to the technique of the miniaturist; colour is more saturated, each touch a telling contribution to the atmosphere of the whole design. So vivid are the hues in the view of *Norham Castle on the Tweed* that it has been suggested that Turner was adumbrating a theory of primary colours that was to be important in his work of the 1840s.[54]

Despite their smaller size, the *Rivers* and *Ports* designs show a much more varied approach to composition than the *Southern Coast* set. Some, like *Kirkstall Abbey on the River Aire*,[55] are picturesquely pastoral in a quite old-fashioned way, while others, like *Newcastle upon Tyne* or *Dartmouth on the River Dart*,[56] exploit the plunging perspectives and multiple vistas of the most complex *Southern Coast* subjects. *Kirkstall Lock, on the River Aire*[57] is a record of industrial activity in the spirit of almost scientific interest that Turner had already demonstrated in his account of the burgeoning industrial life of Leeds of 1816.[58] Another industrial subject is *Shields, on the River Tyne*,[59] but this is a night scene, and Turner's decision to create a moonlight subject may well have been a response to the fact that it was to be rendered in mezzotint.

After the gem-like scenes of the *Rivers* and *Ports of England*, he was fully equipped to express an immense range of ideas on whatever scale he pleased. From the end of the 1820s his oil paintings tended to diminish in size until they established themselves at a standard 900 x 1200 mm (though of course with many divergences from this norm, in both directions). The preference for sheer size in watercolours, fostered by the fashion for the Sublime and by the requirement to 'tell' among the crowded competition on the Academy's walls, similarly waned, and the new middle-class market for handsomely illustrated books pushed many artists towards a very small scale of work indeed. Turner was not immune from the implications of this economic trend, and indeed threw himself into the swim with enthusiasm. The gouache

designs for the *Rivers of Europe* of the late 1820s and 1830s are, as we have seen, on a very small scale, and he also accepted commissions to make illustrations to the complete works of Sir Walter Scott, and to the poems of Byron, of Samuel Rogers, of Milton, of Thomas Moore and of Thomas Campbell: a representative cross-section of the literary idols of the age. In all, some three hundred of his designs were published as illustrations to poetry and other literature during the 1820s and 1830s: a body of work substantial enough to have made any other artist's reputation.

Although we are tempted by the stature of his other work to relegate the vignettes to a marginal place in Turner's output, they embody almost everything he was capable of. The wide range of natural effects, and of human observation, that is to be found in the larger watercolours and the oil paintings can be found in these illustrations (see Figure 6.4). The process of refining his watercolour technique to the point at which he could express any idea, however vast, however minutely detailed, on any scale, had brought him to the point where size was immaterial. Some of his conceptions are clearly adapted to the intimacy of the vignette; but more often they ignore dimension and open up whole worlds of light and perspective, full of specific detail and frequently crowded with figures. It was these miniature masterpieces, in their engraved and published form, which first drew the young John Ruskin to Turner, and 'determined the main tenor of my life'.[60]

Ruskin had been given a copy of Rogers's *Italy* as a thirteenth birthday present, just after it had been published in a new edition in 1830 with the vignettes by Turner (which transformed its fortunes in the bookshops). The boy set himself 'to imitate them ... by fine pen shading'. He did, in short, what innumerable amateur artists of the period did: replicated the effect of line engraving by means of a fine pen dipped in black ink. This was not a way of working that Turner himself would have pursued. He stuck to his well-established habit of composing his designs for the engraver in colour, not, as has been suggested, out of a refusal to change his methods – he would have had no difficulty in reverting to the monochrome he had used for the *Liber Studiorum* – but because it was only by means of colour that the full meaning of his designs could be conveyed to the engravers. The remarkable part of the process is the way in which he trained those engravers in the 'translation'[61] of the complex system of signs that he embodied in his colour into a rich and meaningful language of black and white. This was not the inherently sumptuous medium of mezzotint, but the much cooler process of line-engraving with a burin pushed manually into the dry metal plate. Ruskin took the view that the process of translation from colour into monochrome was nothing more than a rationalization of Turner's essential perception of the world: 'He paints in colour, but he thinks in light and shade; and were it necessary, rather than lose one line of his forms, or one ray of his sunshine, would, I apprehend, be content to paint in black and white to the end of his life.'[62] This extreme formulation does place in its correct context the artist's affinity with reproductive engraving, and the fruitful relations he cultivated with around eighty engravers in the course of his career. He gave the

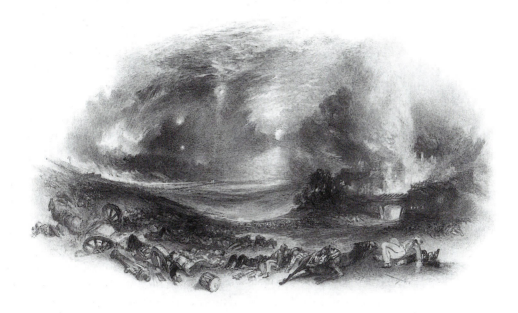

question much careful thought, as is demonstrated in his draft of a lecture where he goes so far as to propose a direct correspondence between specific colours and the lines on the engraved plate: 'if these lines had originated with the Painter ... such a Theory would have been established ... that the associated idea of the colouring of each Painting would be recognized by every one who view'd an engraving.'[63]

Here is a further interpretation of the significance of line in Turner's approach to his art. For while he appreciated the particular value of individual lines in relation to form, mass and colour in his finished works, he must also have been conscious of the weight to be attached to line in every pencil or pen drawing that he made.

6.4 'The Field of Waterloo from Hougoumont' (vignette illustration from *The Works of Lord Byron*), c. 1832, watercolour, 19 x 26 cm (Makepeace Investments, courtesy of the Art Gallery of Ontario)

Drawing and painting

For Turner, all aspects of experience and of creativity fed into each other. He regarded drawing as an essential discipline not only in the collecting of information but also in the execution of his pictures in both oil and watercolour, even the least circumstantial of them. Both practices functioned symbiotically in his output, and they consequently developed into an integral process so that in the work of his later career it is often impossible to separate the two elements. This is the very antithesis of Kenneth Clark's reading of the late work. Two examples from the very end of Turner's life will make the point.

One of the most ostensibly 'abstract' of his paintings, the *Snow Storm: Steam Boat off a Harbour's Mouth* of 1842,[1] was done because, he said, 'I wished to show what such a scene was like.' Gowing thought that Turner's story of having 'got the sailors to lash me to the mast to observe it'[2] was 'probably . . . precisely true', yet he argued that the picture 'had no reference to observation'. It is, rather, 'a picture of his dream of endurance and defiance'.[3] That the picture embodies such themes – endurance, defiance and many others – is undeniable, but that Turner presents them without giving them any physical identity is difficult, I would argue, to sustain, especially in the light of his own emphatic assertion of his descriptive intention.

In the case of a snow storm at sea, light and colour are indeed the principal means by which information may be conveyed, yet even in this case there is actually very little 'colour'. All is grey, streaked with a creamy white and black, and the composition is dominated by sweeping arcs – the waves, the smoke of the steamer, the swirling snow. Those arcs, suggested as they are rather than explicitly stated, interconnect and counterpoint each other so as to construct the picture: they are responsible for the coherence of the composition. Even in this extreme manifestation, then, Turner's concern for the abstract elements is bound closely with a concern for linear description and organization. The 'architecture' of the design remains fundamental.

A more telling instance is *Rain, Steam, and Speed – the Great Western Railway*, of 1844, whose equally 'modern' subject matter has encouraged many essays in modernist interpretation.[4] The envelope of atmosphere – a wonderfully observed account of just those three 'abstractions' that Turner

enumerates in his title – is founded on a design that pays tribute to that most draughtsmanly of Old Masters, Nicolas Poussin. The geometry of the receding perspective in the foreground viaduct and the firm horizontal that divides the whole composition in half is a reference to one of Turner's favourite pictures, the *Landscape with a Roman Road* that he had known for much of his adult life in the Dulwich Picture Gallery. It was then firmly attributed to Poussin, and exemplified for him the virtues of stability in drawing and design.[5]

Compositional structure is only one way in which draughtsmanship can provide solid foundations for the painter. More generally, as we have seen, drawing supplies the heart of the subject, whatever atmospheric treatment it may be given. Clark singles out as pre-eminent among the late studies in pure light the Venetian views of the 1830s and 1840s. Venice, he says, 'effected the final release of Turner's imagination', although 'We must also admit that some highly finished pictures of Venice, painted after too long an absence, are as embarrassing as an unsuccessful deception.'[6] Which these 'embarrassing' finished pictures may be is not entirely clear. Perhaps the most elaborate, the most subservient to the 'Keepsake' aesthetic of the time, is *Juliet and her Nurse* of 1836, yet this was one of the pictures that first fired Ruskin to pen an impassioned defence of Turner against his critics.[7] It is also one of the most elaborately organized in terms of architectural structure and perspective, with its bird's eye view and panoptic involvement of St Mark's Square and its surroundings. But it can surely not be discounted as over-wrought. In recent years its dense superimposition of narrative and atmosphere has generated much discussion, none of it dismissive.[8]

Oddly enough, the Venetian pictures are the least suitable for interpretation as essays in 'pure' light and colour. A few of the preliminary lay-ins that Turner made for them happen to have survived in their unfinished state, and constitute some of our strongest evidence that his intentions were always representational, and never 'abstract'. The most rudimentary of these include indications of detail, notably the characteristic crowds of people that preoccupied him in so many of his late works. The suggested faces, even the buttons and collars of the clothing that are clearly discernible,[9] tell us not that figures were for Turner an afterthought, a necessary compliance with fashionable taste: they were the very stuff of his vision, organically integrated into his view of place from the moment of conception. There is no abandonment of draughtsmanship here: even at this late hour it defines his subject. And the setting in which these Venetian crowds surge and throng is one of vividly evoked buildings, well known and frequently drawn by Turner in pencil in his sketchbooks. The drawing is transferred to canvas, on top of the broader applications of the 'lay-in' or subsequent washes of background colour, by means of a fine brush, with which architectural details are rendered with as much precision as in the days of his topographical apprenticeship. A splendid specimen of this meticulous work can be found in the Venetian picture he showed the year previous to *Juliet and her Nurse*: *Venice, from the porch of Madonna della Salute*,[10] where he

traces the intricate features of the portico of the church with a fine brush dipped in black paint (see Figure 7.1 and Figure 8.6). Outline is used here just as it would be in an architectural drawing to record the appearance of the structure. Other buildings at a greater distance are also carefully rendered, by the use of fine lines in different colours. He continued with this procedure into the 1840s, though by 1841 the luminous envelope through which Venice is perceived has begun to interpose itself more palpably between viewer and object. The buildings are pushed further away, so that light and air are increasingly the subject matter of the work, yet the architecture remains finely and accurately rendered: *The Dogana, San Giorgio, Citella, from the Steps of the Europa*, of 1842, testifies to Turner's sustained interest in the buildings of Venice[11] and, notably, to his continuing indebtedness to Canaletto, who is celebrated in several, if not all, of these works. In one the reference is explicit: the painting *Bridge of Sighs, Ducal Palace and Custom-House, Venice: Canaletti painting* dates from 1833 and is the initial canvas in the series;[12] but Canaletto is clearly invoked in several others, including the view from the steps of the Hotel Europa.

The survival of Turner's lay-ins of Venetian subjects makes this group especially valuable in illustrating his practice of finishing pictures at the Royal Academy's varnishing days. In particular, it points up clearly his working methods at this date. The canvas on which he begins to paint is prepared with an almost white ground, and the initial blocking-in of the subject is in scarcely modulated blocks of white. The finishing of the picture involves the application of washes of colour and what is effectively drawing: the sharpening of all details with the fine brush. This process is exactly equivalent to the system he used in making his watercolours. The white underpainting supplies a brilliant ground, as luminous as white paper, and the colours are applied like watercolour, to take advantage of that luminosity.

Some of the late lay-ins contain enough information to have gained them acceptance as works to all intents and purposes finished, according to the lights of twentieth-century audiences. The series of compositions that Turner based on subjects taken from his *Liber Studiorum* of over thirty years earlier were not sent to the Academy, and do not exhibit the characteristics of even his freest late exhibited pictures. A canvas that has been associated with that group is the glowing *Sunrise with a Boat between Headlands* (Figure 7.2, p. 107).[13] The sweeps of warm yellow and white, set off by a patch of blue, envelope the scene so completely in hazy light that any specific descriptive content has been dissolved. No *Liber Studiorum* design corresponds to it. Yet substantial forms may be discerned within its envelope of atmosphere. With a fine brush dipped in red colour, he draws houses, fortifications – a tower and crenellated wall – and steps leading down to the water. The technique is similar to that used in the watercolour series of Heidelberg views of 1844, and the effect of diffused sunlight also recalls that group. A town nestles at the foot of the river bank on the left; with a ruined castle on a high cliff opposite. This is surely Germany – not too far from Heidelberg, perhaps, and almost certainly the Rhine. There are subjects from Turner's earlier travels along the

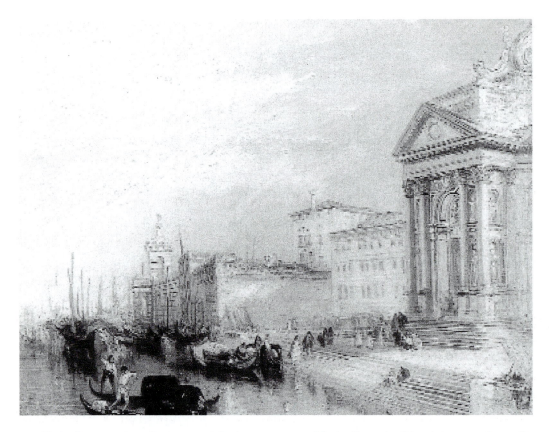

7.1 *Venice from the porch of Madonna della Salute* (detail), 1835, oil on canvas, 91.4 x 122 cm (BJ 362; Metropolitan Museum, New York)

river that present features comparable to those in this picture; perhaps the closest is the view of the Drachenfels that he made for *Finden's Landscape Illustrations to . . . the Life and Works of Lord Byron* (1832–34). In that design, the detail of which is very clear in Finden's engraving after it, a long slope of road leading up the cliff of Rolandseck on the left corresponds to a diagonal flight of steps in the painting, a group of boats in the foreground becomes a shadowy presence with long reflections, and the island of Nonnenwerth on the far right is raised high above the level of the river, so that its large white convent appears to be on the farther shore. In both versions, the Drachenfels looms in the distance.[14] He had drawn the view on his Rhine journey in 1817, and made of it one of the fifty drawings that Fawkes bought from him.[15]

Butlin and Joll describe the *Sunrise with a Boat between Headlands* as 'one of the unfinished oil paintings in which Turner approaches closest to his late watercolour style'. We may date the conceptual identification of oil and watercolour studies much further back in Turner's career. One of the most perfect of his paintings, the preparatory version of *Chichester Canal*, for a picture that was to be installed at Petworth, is handled to all intents and purposes exactly like a watercolour study of the same date, with thin yet brilliant washes of translucent pigment and calligraphically drawn trees, birds and distant, statuesquely motionless ship.[16]

By the 1840s his technique in both media had somewhat changed, but the

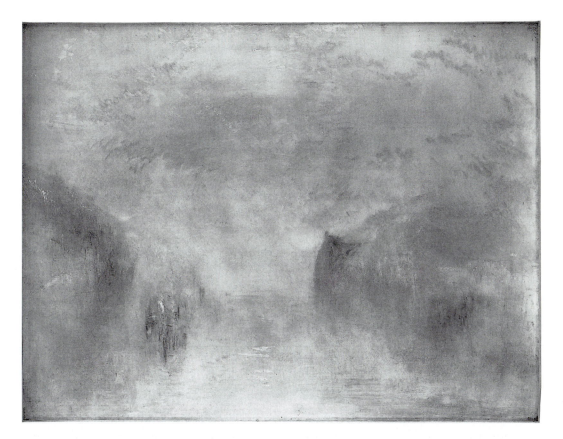

symbiosis is the same. There are indeed close parallels to the *Sunrise with a Boat between Headlands* in many of the watercolour studies of these years: they are executed in a virtuoso combination of pencil, wash and pen outline. In the studies Turner made in Venice and on Alpine journeys of the early 1840s it is often impossible to decipher how pencil and brush have collaborated: the image is an amalgamation of line and colour in such subtle interrelation that the removal of either would destroy its sense. The pen outlines are an additional mystery. Turner appears to have dipped his pen in his colours so that he could describe a form in colour by tracing its shape rather than by filling in its mass. The implication of colour in the outline is combined with the generalized washes that build up the atmospheric space to produce a three-dimensional, localized subject in which light and air are held in balance with defined form. Occasionally the texture is enriched by touches of coloured chalk. A representative example is the drawing that Ruskin called 'Descent from the Alps' which is now titled *An Alpine Pass, with Cascade and Rainbow* (see Figure 7.3).[17] The whole subject is dissolved in atmosphere, and given in a few broad washes of colour, sometimes in overlapping layers; simultaneously a few rough lines in soft pencil bring out some foreground detail while the pen, dipped successively in red, green or brown, touches in sharply described features of the landscape both near and distant. The sheet

7.2 *Sunrise with a Boat between Headlands*, c. 1845, oil on canvas, 91.5 × 122 cm (BJ 516; Tate Gallery N02002)

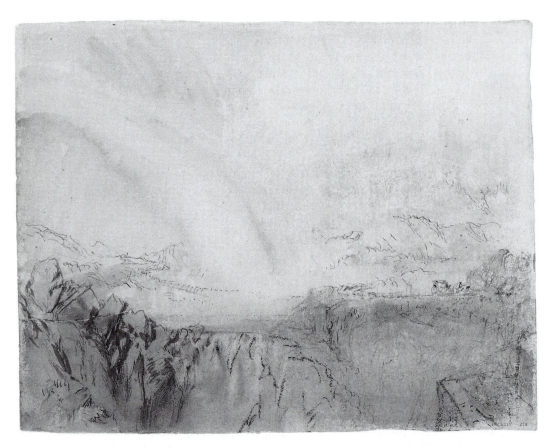

7.3 *An Alpine Pass, with Cascade and Rainbow*, c. 1842, black chalk and watercolour with pen, 22.1 × 28.8 cm (Turner Bequest CCCLXIV 278; Tate Gallery D36126)

contains, according to Ruskin, 'one of the best bits of sketching in this series' – a vivid evocation of heavy boulders on the edge of a ravine.

Ruskin's comments on another drawing of the group, now identified as showing the Via Mala gorge in the Grisons, looking towards Thusis,[18] elaborate the point, and exemplify his minute attention to Turner's technical procedures in relation to the truth of observed nature. The drawing is executed in broad washes of strong colour over a very slight and generalized pencil sketch, and sharpened with a pen dipped in red, yellow and other colours. Turner has also used some scraping-out to denote the spray of waterfalls.

In certain conditions of granitic rock, one of the chief characteristics of its water-worn mass is to divide into steps, – long and continuous, as in limestones, but in narrow vertical bands or columns – of which two are seen here in the high precipice on the right, and another has been taken possession of by the small secondary stream, whose undulations over the steps of it, exquisitely drawn and touched with blue reflections of the sky, are seen in the middle of the grey shadow; the water is hardly traceable above, its own spray forming a visible mist where the sun strikes, and hiding the stream. His strong sense of such granite structure in this particular rock is shown chiefly by the pencilling along the edge of the farthest precipice, where sloping lines in an almost equidistant succession, indicate the jags of the cliff at its most exposed angle . . .'[19]

This sense of the minutely specific in a context of the broadest atmospheric turbulence is the essence of Turner's late landscape painting, whether in oil or in watercolour. A vast distance seems to have been traversed since the early work, but the union of topography – strict and accurately observed reporting – with sublimity – the grandest natural effects – is as much the goal now as it was then.

The interpretation of marks on the picture surface as unconscious indications of the artist's mental or emotional state has played a not insignificant part in modern appreciations of Turner. If his pictures are seen as 'gestural' works, they are legitimate objects of psychological analysis. The argument of this book has been to suggest that Turner's earnest pursuit of the truths of the observed world – however 'indistinct' – leaves little room for the unfettered working of the unconscious. Nevertheless, Adrian Stokes argued from a line in one of Turner's draft poems that a deep-seated physicality lies behind his use of pencil and brush:

> As Snails trail oer the morning dew
> he thus the lines of beauty drew.[20]

The context is the fable of the Corinthian Maid, who traced her lover's shadow on a wall while he slept, thus inventing drawing and painting. The identification of physical desire as the impulse behind pictorial art had been taken up in the eighteenth century by Edmund Burke, who in his famous *Enquiry into the Origin of our Ideas of the Sublime and Beautiful* (1757) discussed Beauty in terms of the emotions associated with 'generation'. Burke applied this principle to the idea of beauty in nature as well as in the human form, and so there is a solid contemporary foundation for what Stokes seems to take as a modern, Freudian view of the matter.[21]

However, we should not underestimate the degree to which the action of drawing was for Turner a substitute, in a possibly Freudian sense, for the quotidian habits of other people. The scrappy erotic drawings that he made, presumably for his private amusement or gratification, which until recently it had been assumed were mostly destroyed in 1859 by the officials of the National Gallery at the instigation of Ruskin,[22] exemplify the idea of doodling that functions as an extension of the consciousness of the man without occupying a place in the processes of the artist. Although the landscape sketches clearly relate to Turner's activity as landscape painter, they are often so slight or so illegible (thanks, say, to the motion of a coach or boat) that they seem to have been done more at the prompting of an irresistible nervous compulsion than because they were likely to be of practical use. By the same token, Turner often revisited places he knew well, and drew them again and again. Sometimes, as in the case of the late colour studies of Venice, he may well have wished to capture effects of light unique to particular moments of the day or night, but there are plenty of examples of drawings he made not to record new facts but simply to gratify a perpetual urge to draw.

Turner's humanity

Throughout this discussion of Turner's draughtsmanship, I have referred to his figure drawing.[1] It is unavoidable, since the human figure recurs endlessly in his work; indeed, it has always been the yardstick by which the draughtsmanly abilities of any artist have been measured. Yet, as we have seen, it is a subject that has alternately embarrassed and irritated commentators. Adrian Stokes, a generally sympathetic critic, concluded that 'We cannot discover in Turner's art much affirmative relationship to the whole body, to human beings. They tend to be sticks, or fish that bob or flop or are stuffed.'[2] Perhaps because it has this effect even on his greatest admirers, they have inclined to the view that figures were of no real importance to Turner, that he included them in his works out of some kind of deference to fashion, or to the limited understanding of the public. Yet the most cursory survey of his output shows that he not only included figures in many of his most significant pictures, both in oil and in watercolour, but that he included them in quite astonishingly large numbers. There is no question of his adding the odd figure as token 'staffage', or as a foreground device to set off or introduce the viewer to the scene beyond. Those functions are, of course, occasionally performed by his figures, but it is rare indeed that he does not make his characters do more work than such minimal formal signposting. Repeatedly, they are invented to act out the drama of the landscape, to embody the economy of the place depicted, to constitute a chorus that comments, as in a Greek tragedy, on the world, on nature and on life. There is therefore a contradiction at the very heart of his art which requires elucidating.

Clark, who criticized most aspects of Turner's minuter delineations, volunteered that in spite of 'his inability to draw the figure in a conventional manner' he might be conceded a certain success thanks to his 'genial calligraphy'.[3] Ruskin had sprung to Turner's defence by saying that although the execution of his figures was 'singular, and to the ignorant in art ... offensive' it was 'absolutely necessary to the faithful representation of space'.[4] This odd explanation needs to be amplified by that of Henry Quilter, an art critic of the later nineteenth century, who claimed that 'generally they are as good as there is any necessity for them to be. That is to say, they are

only inserted into the landscape for the sake of forming patches of colour, or in order to lead the eye from or to some other point in the composition . . .'.[5]

There is some truth in that argument, but it seems to concede that Turner was not really interested in the figures for themselves, and it certainly implies that he didn't draw figures as well as he might have done. What both Ruskin and Quilter meant was that there is an integral 'rightness' in the way the figures are incorporated into the pictures, and that that 'rightness' is in the very drawing of them. They are part of a complex totality, and they keep their place in that totality. I would go further and suggest that they are treated as an organic part of the landscape, that their awkwardness is what makes them convincingly human, and that they are as transient in their setting as the waves and sunsets.

'There is abundant evidence', wrote Stokes, 'that Turner could both record and improvise figures or groups in any attitude and in a variety of styles. His sketchbooks reveal that he was attracted by crowded scenes and new forms of animation.'[6] That Turner was passionately interested in the crowds of figures that fill his compositions cannot be doubted: they do not seem in any way perfunctory, but rather, as I have said, they embody the topographical essence of the place depicted. Figures were an accepted, and expected, adjunct to topography, and books were published to aid less inquisitive artists in the invention of such staffage. William Henry Pyne's *Microcosm: or, a Picturesque Delineation of the Arts, Agriculture, Manufactures, &c. of Great Britain, in a series of above a thousand groups of Small Figures for the Embellishment of Landscape*, published in 1803, was perhaps the best known. Quite independently of Pyne's work, Turner seems to have had the idea of compiling his own works of reference on the same lines: his *Scotch Figures* and *Swiss Figures* sketchbooks, used on the tours of 1801 and 1802, contain studies, often in colour, of figures in local costume, obviously observed during his travels, but he did not sustain these collections, which peter out after a few pages in each case.[7] He filled another book of about the same date with studies of cows,[8] which were a hardly less important element than people in the foregrounds of his early views (they were integral to Gilpin's ideas on Picturesque landscape), and which are grouped with a monumental grandeur that suggests a lively sympathy with these beasts.

Turner's concern for the figure was signalled early on, in drawings like the *Pantheon on the Morning after the Fire* and *Don Quixote*, both of which have already been discussed. These subjects seem to have been chosen particularly on account of their narrative content, and depend for their meaning on large-scale figures. In selecting for illustration the pathetic comedy of Don Quixote he was surely aware that the hero of Cervantes's novel embodies the poignant fallibility of humanity: we laugh at Quixote's ludicrous misunderstanding of the world, while half-admiring him for his grandiose if misguided aims. The knight's embarrassment and disappointment in the episode of the Enchanted Barque were a paradigm of what awaited anyone ambitious for glory, as Turner undoubtedly already was. He was quite capable of reading himself into the Don's ambiguous role, and drawing a moral accordingly.[9]

Turner's career is often perceived as a steady development from tight, detailed description to broad, atmospheric evocation. This is a misconception. The fact is that at all stages he was concerned with both equally and simultaneously. Each complemented the other as an aspect of the observed world, and the notion that nature would be meaningless without the human experience of it is one that informs everything Turner did. As Samuel Palmer (1805–81) put it, 'Landscape is of little value, but as it hints or expresses the haunts and doings of man. However gorgeous, it can be but Paradise without an Adam.'[10] But while Palmer wished to see the world as an idyllic Eden, Turner was more down-to-earth. He does not idealize, and his people are all too real, endlessly varied in type and occupation, often pathetic, deprived, crippled and hungry, seeking their livelihood in demeaning or dangerous ways, but also frequently cheerful, enjoying the benefits of health and prosperity in picnics and country strolls, shopping, sightseeing, fishing or hunting.

All these activities take place in settings that are grandly conceived and evoked with stunning technical panache, but the *context* of human life is not the sole object of Turner's concern. Ruskin mistakenly thought that Turner had felt 'obliged' to depict the market and horse-fair at Louth although his real interest was in the medieval church behind them. That judgement betrays Ruskin's prejudices; Turner clearly (a glance at the watercolour is enough to persuade us) took a humorous and compassionate delight in the whole scene.[11] In this he was not necessarily much at variance with other topographical view-makers. Sandby, Rooker, Cotman, Prout, Roberts: all of these and numerous others took pains to delineate the inhabitants of the places they drew; the tradition stretches from the mid-eighteenth to the mid-nineteenth century. Sandby's people are lively emanations of the contemporary world, quickened by a Rococo grace that reflects the styles of his youth. John Sell Cotman's figures combine their convincing vigour with a foursquare solidity that enables them to take their places in the elaborate abstract jigsaws that are Cotman's compositions. Samuel Prout (1783–1852) is more formulaic, concerned rather with the placing of individuals and groups of figures as though on a model stage-set than with the realization of observed people, though he pays much attention to the picturesqueness of their local costumes. David Roberts's drawing style is highly efficient and accommodates figures with natural fluency but he rarely attempts to invest them with more than a perfunctory animation.

Turner renders the multifarious human detail of the observed world with a consciousness of the solidity of each individual, like Prout or Roberts, but with a livelier sense of the unique presence of each character in its local setting, which he inherited from Sandby and his eighteenth-century exemplars. He was willing to follow and imitate his contemporaries when he judged that they had achieved something worthwhile; but he outdid his compeers in his understanding and invention of figures suitable to his topographical purposes. He was, indeed, unusually susceptible to the urge to rival others, especially when they excelled in something that fell outside his

normal scope. Portraiture, history and genre were all forms that he tried his hand at when the fashions of the day presented particular challenges in those fields.

Portraiture he essayed very rarely, though one of his earliest finished works is a miniature self-portrait in watercolour of about 1790.[12] A rather later but still youthful attempt to demonstrate his abilities in that line resulted in a masterly likeness of himself, executed, it would seem, to celebrate his election as Associate of the Academy in 1799.[13] It is clearly a conscious exercise in the manner of his successful young contemporary John Opie (1761–1807). We shall note some later 'portraits' shortly. History painting was a branch of art that Turner had come to terms with early on, by the expedient of resolving to make landscape its equal in seriousness and emotional power. By the end of the 1790s, when the challenge of the Academy's walls was exercising its most powerful influence on him, he planned several canvases with historical or heroic themes in which the figure takes an important role.

He was always alert to hints and challenges in the work of other artists, and very much alive to the achievements of those who practised what Reynolds declared was the highest branch of art. For instance, the Irish history painter James Barry (1741–1806) was an inspiration to him;[14] and it is highly likely that he took notice of an important picture, as ambitious as anything Barry painted, depicting an event in recent British history, a painting which caused a stir in London at the end of the eighteenth century: John Singleton Copley's enormous canvas *The Defeat of the Floating Batteries*, otherwise known as *The Siege of Gibraltar* (Figure 8.1).[15] Copley finished it in 1791, whereupon it was exhibited in a tent in the Green Park; it is hard to imagine that the sixteen-year-old Turner, newly a Royal Academy exhibitor, did not see it there. Even if he failed to do so, he must have come across it after its installation in the Common Council Chamber of the Guildhall in the City of London, where it hung from 1795 until 1886.[16] Turner may well have criticized it: the painting of water is formulaic and lacking in dynamism; some of his own early seascapes might be construed as a gloss on this aspect of Copley's great work. But in terms of sheer ambition it can hardly have failed to engage his imagination. Not only was it huge; it showed a heroic subject in which dramatic action takes place simultaneously on land and at sea. The marine battle that fills the left-hand side of the canvas is one of the most vividly imagined in British art, with clothed and naked figures in violent movement. In the foreground are figures clustered in complicated relationships on a raft – a premonition of Géricault's *Radeau de la Méduse* of 1819.[17] The burning ship anticipates Turner's own much later canvas known as *Fire at Sea*,[18] and the whole scene must surely have played its part in the genesis of the now lost picture that he showed at the Academy in 1799, *The Battle of the Nile*. Most striking are the writhing, sinuous bodies of men hauling themselves and each other into and out of rigging, boats and the turbid water. In his *Marford Mill* sketchbook, which he was using about the time the Copley was hung at the Guildhall in 1795, Turner made a number of small sketches of nude men struggling, climbing and stretching in poses very like those in the great picture.[19]

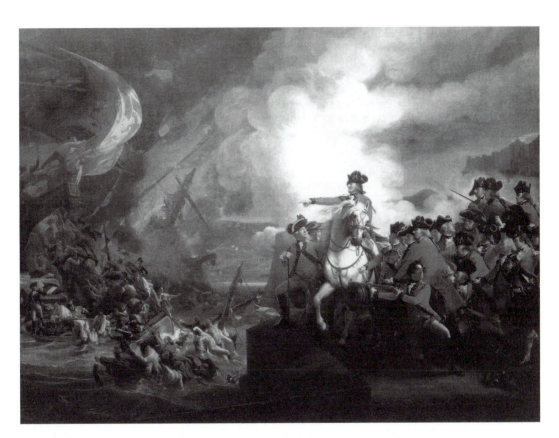

Some of Turner's figures appear to be among rocks; one is tangled in the branches of a tree; others are evidently involved in a shipwreck. The theme of wreck at sea was to occupy Turner in several pictures of the early 1800s, notably the *Shipwreck* of 1805 and the *Wreck of a Transport Ship* of about 1810.[20] In the first of these, particularly, the sea and its victims are set against each other by means of vivid characterization: on the one hand, a virtuoso depiction of the heaving waters, on the other detailed characterizations of the individual human beings, suffering and effortful in the midst of the catastrophe. Another picture of about 1805 that has its personnel struggling in water is *The Deluge*, an eclectic history picture that borrows ideas from many sources, and makes prominent use of large-scale figures.[21] One of Turner's ideas for this subject, sketched in the *Calais Pier* book, echoes the bipartite structure of Copley's picture, with figures clambering up a large building on the left-hand side (see Figure 8.4, p. 120).[22]

Genre could be assimilated into landscape rather as history might, though it was traditionally allotted a relatively lowly place in the hierarchy of art forms. Turner experimented with it as early as about 1790, when he made the watercolour already referred to of a cottage interior with children in front of a fire.[23] He was piqued into a more serious foray into genre by the arrival in London of David Wilkie from Scotland in 1806, with a picture, *Village Politicians*, that put the form on a completely new footing. Turner responded

8.1 J. S. Copley, *The Siege of Gibraltar*, 1792, oil on canvas, 543.6 × 754.4 cm (Guildhall Art Gallery, Corporation of London)

the following year with a bucolic political piece of his own, a work always known as *The Blacksmith's Shop*.[24] This answers Wilkie point for point, as it were: it is a rustic interior, and the title that appeared in the Academy's catalogue, *A country blacksmith disputing upon the price of iron, and the price charged to the butcher for shoeing his poney*, tells us that, like *Village Politicians*, this concerns a debate about current affairs. Turner does not perform with Wilkie's crispness, polish and comic precision, but his is a ravishing piece of painting, with well-drawn figures which seem to concentrate the very air of the hot, stuffy shed they inhabit. They are emanations of their atmosphere, existing in a unity with it.

He had clearly looked very hard at Wilkie's own figures, which are invented on the basis of searching observation of human character and manners. The variety of psychological expression in the faces, whether humorous or serious, was admired at the time (and is remarkable today); like many of his contemporaries Turner was impressed by it, attempting similar feats of description in his own Wilkie-inspired works. In the following years he attempted more subjects of this type, only one of which reached the walls of the Academy. This was *The unpaid bill, or the Dentist reproving his son's prodigality* (Figure 8.3). It is little discussed, an unsung masterpiece of interior lighting, containing passages of exquisite painting, and is indeed a *tour de force* of still-life, incorporating a multitude of objects scattered through a subtly lit space. The figures, true to Turner's consciousness of Wilkie's special gifts, are well and wittily observed, and tell the little story with perfectly judged humour: a dentist expostulates with his indolent son while his bemused but concerned mother looks on. The monkey and parrot who unexpectedly (and satirically?) share the dentist's work-room contribute to the quirky comedy, as does the dog, which seems to sympathize with its mistress's concern.[25]

Despite their keen characterization, the human figures are much less satisfactory in their drawing than those of *The Blacksmith's Shop*, an early indication of the kind of lapse in draughtsmanship that was to recur in Turner's figure drawing later. There is no fully adequate explanation for this shortcoming. The father's head and face are precisely expressive of his agitated concern, but they are touched in with hard, wooden lines. The boy's pose is nicely lackadaisical (he is seen from behind), but the figure seems two-dimensional. The mother, anxious but half-resigned, sits with her cheek leaning on a quizzically placed hand, while her left arm droops in her lap. The drawing of both arms is oddly perfunctory, as is the realization of her satin-clad lap and skirt.

These problems with the figure are clearly not the result of ignorance or inability. Years later, Turner could produce figures perfectly suited to their function in the compositions of which they form part. But when he was spurred once again into rivalry with the genre painters, he encountered similar difficulties, and a whole group of canvases from his high maturity bear witness to the struggle. That they record a more or less comprehensive failure on Turner's part has been obscured partly by the undeniably beautiful

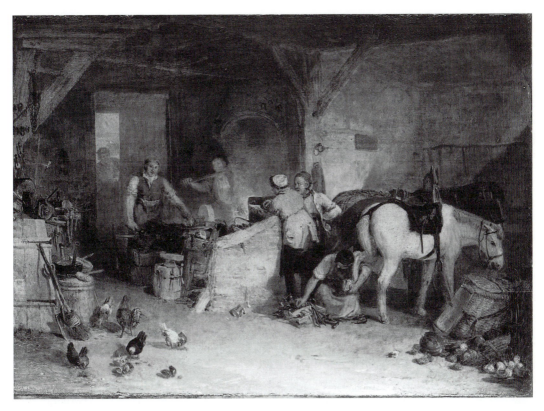

effects of light and colour that they contain, and also by the reluctance of commentators to address the combined problem of Turner – the mature Turner – as a chaser after mere fashionable figure subjects and as unable to realize them.[26]

Nevertheless, that is undoubtedly what was going on. His early response to Wilkie, like his lifelong addiction to writing poetry, was an indication of a deep-seated instinct to compete with other creative spirits. His career in the 1820s had reached a crisis. In 1825 he was fifty years old, and that year his great friend and most important patron, Walter Fawkes, died; four years later, in 1829, his father – his closest companion, studio assistant and loyal admirer for a quarter of a century – also died. There is a distinct sense that, surrounded as he now was by a new generation with new ideas for a new public in a new economic environment, he had reached what would nowadays be termed the 'mid-life crisis', and was searching for a fresh start in his career. In this he showed himself a member of his generation, the first of the true Romantics: artists who had rejected the protection of aristocratic patrons and were cast upon their own creative resources, needing to reinvent themselves periodically in order to maintain the interest of a fickle public.

The whole question of where painting was going had been opened up by the changes in taste and in the market which followed the conclusion of the Napoleonic Wars. Turner's decision to embark on a long series of demanding

8.2 *A country blacksmith disputing upon the price of iron, and the price charged to the butcher for shoeing his poney (The Blacksmith's Shop)*, 1807, oil on pine panel, 55 x 78 cm (BJ 68; Turner Bequest, Tate Gallery N00478)

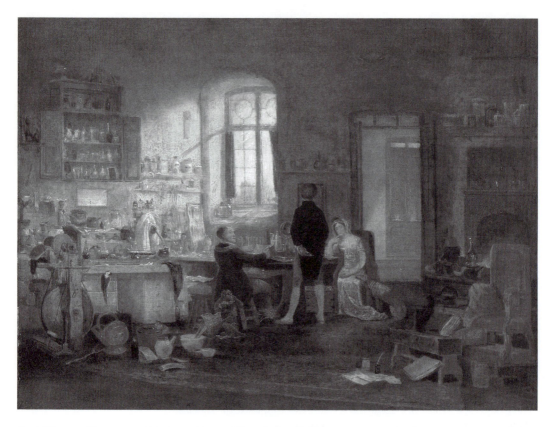

8.3 *The unpaid bill, or the Dentist reproving his son's prodigality*, 1808, oil on panel, 59.4 x 80 cm (BJ 81; private collection, photo courtesy of Christie's)

commissions for small-scale book illustrations in the late 1820s was a direct response to social and economic developments, but it looks, too, like an effort to distract himself from other problems, to explore fresh avenues. These were in large part generated by his determination to tackle a very different genre from anything he had handled hitherto. The critics were attacking his violent colour, and his long-standing adherence to the notion of sublimity in the depiction of nature was beginning to look somewhat old hat. And while he did not propose to abandon what he knew he did best, landscape painting, he was determined to try his hand at what was both fashionable and commercially viable.

The walls of the Academy were now filled which historical scenes that were no longer heroic and Sublime, but domestic and even comic. Large canvases depicting the climaxes of Shakespeare's tragedies were replaced by much smaller ones showing scenes from the comedies. Homer and Milton gave way to Molière and Sterne. A new generation of artists was working in idioms that appealed to a more bourgeois audience than before: pretty young women in romantic entanglements, domestic dramas played out in sunny gardens or well-furnished country houses of the sixteenth or seventeenth centuries – these were the standard fare of the 1820s and 1830s. Landscapes were very often topographical views of the Continental towns that English travellers could now freely visit. Turner's fellow-Academician George Jones

(1786–1869) was well known for his townscapes and battle pictures, but was old enough to retain a belief in the Sublime. He was an unashamed borrower of Rembrandt's gloomy chiaroscuro. In his historical compositions the figures tend to gather in crowds – as they might on a battlefield – emerging suggestively from swathes of shadow. Turner learned much from Jones.

When Jones embarked on a picture illustrating the story of Shadrach, Meshach and Abednego in the burning fiery furnace, Turner obtained precise details of the size of his canvas and painted his own version of the same subject, to hang at the Academy the same year. According to Jones himself, Turner asked him '"what size do you propose?" "Kitcat." "Well, upright or length way?" Upright. "Well, I'll paint it so – have you ordered your panel?" – No, I shall order it tomorrow. "Order two and desire one to be sent to me, and mind, I never will come into your room without inquiring what is on the easel, that I may not see it."' Jones was happy with 'friendly contests' like this; he claimed to think Turner's picture better than his own, and was grateful to him for using 'his utmost endeavours to get my work changed to the place he occupied'.[27]

What Jones does not remark on is the fact that Turner conceived his picture as a pastiche of Jones's own style (see Figure 8.5, p. 121). Hence, in part, Turner's refusal to see Jones's version of the subject while it was in progress: he had set the whole thing up, not so much as an act of friendly rivalry with a fellow-Academician, but as a secret 'dare': to paint a 'Jones' without actually copying one. This is the same thought as his creation of a 'Wilkie' in *The Blacksmith's Shop*. The episode illustrates vividly that at this advanced stage of his career he could and did still engage wholeheartedly with the work of his contemporaries. *The Burning Fiery Furnace* appeared at the exhibition of 1832.[28]

There is a group of drawings in one of the sketchbooks that bears the hallmarks of having been conceived with the Rembrandtian Jones in mind: a remarkable suite of erotic subjects, usually associated with Petworth and probably executed about the time Turner was thinking about his painting in Jones's manner.[29] They are very small, very allusive, shadowy studies, making use of the dark inky blues and browns favoured by Jones in his drawings of historical subjects. They are of much greater aesthetic interest than most of the numerous but slight erotic scribblings to be found in the Turner Bequest. Unlike these, they are not merely titillating; rather they evoke real erotic passion in real, if indefinite, spaces that may well, as has been supposed, be the bedrooms at Petworth, with their curtained four-posters. There is no evidence that Turner associated Jones with sexual feelings, but they were good friends (Jones spoke of their 'great intimacy'), to the extent that Turner appointed Jones one of his executors. They spent time at Petworth together; Jones recalled that once on a visit there with Turner when 'I hurt my leg, his anxiety to procure for me every attendance and convenience was like the attention of a parent to a child'.[30] This does not necessarily imply that they enjoyed love-making in one another's company, although such behaviour would not have been inconceivable under

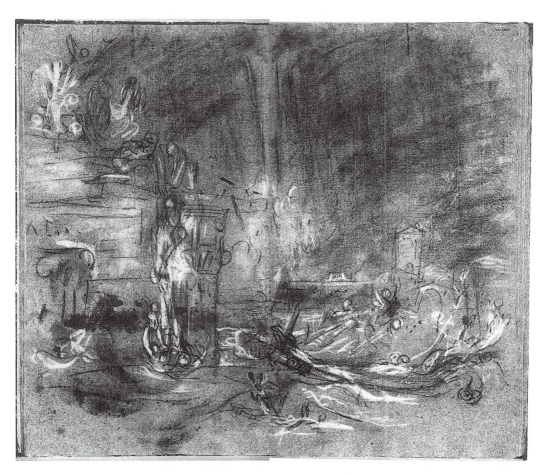

8.4 *Calais Pier*
sketchbook, pp.
120–21,
c. 1800–05, black
and white chalks
on blue paper,
page size 43.6 x
26.7 cm (Turner
Bequest LXXXI;
Tate Gallery)

Egremont's hospitable roof.[31] At any rate, the stylistic 'borrowing' in these drawings is appropriate to the subject matter, if not to any more clandestine connection between the two men.

As contemporaries went, Jones was less of a rival, perhaps, than the (relatively) young Turks, mostly in their thirties during the 1820s, who were sweeping all before them with their genre subjects, just as Wilkie had done in 1806. These included C. R. Leslie, G. S. Newton, R. P. Bonington and Daniel Maclise. Their success, and the proliferation of their work as engravings in popular publications, was an ever-present reminder of the order from which Turner might well feel himself excluded. He had already registered his interest in the new styles with some exhibits of the earlier 1820s. The very large canvas that resulted from his 1819 tour to Italy, *Rome, from the Vatican*, already incorporates a subject that belongs to sentimental historical romance; as Turner's subtitle tells us, it shows 'Raffaelle accompanied by La Fornarina, preparing his pictures for the decoration of the Loggia'.[32] The splendid panorama of Rome that forms the backdrop to this scene is perhaps the real subject; but the choice of moment, which has been understood as a celebration of Raphael's tercentenary, and also as a declaration of Turner's

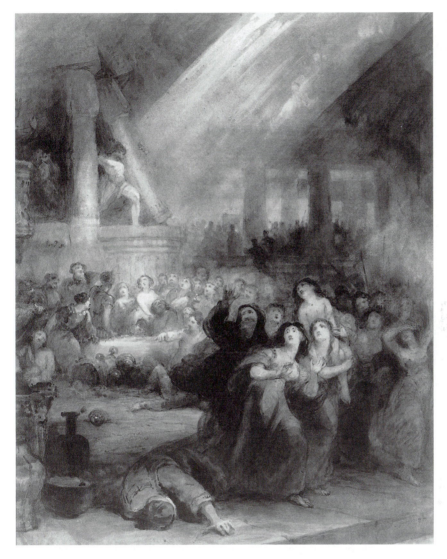

8.5 George Jones, *Samson destroying the Temple of Baal*, 1832, grey, brown and blue washes with gouache and gum arabic, 49.5 x 40 cm (private collection, photo courtesy of Sotheby's)

own pedigree and purposes as an artist, indicates his awareness of a shift in the public mood. His next large exhibited picture, *The Bay of Baiae*, shown in 1823,[33] reverts to the more conventional classical *dramatis personae* that the Italian landscape naturally suggested. Between these two major statements, however, his painting in oils almost came to a standstill. He submitted nothing in 1821, and only one small picture in 1822: *What you will! –* a pastiche of Watteau that also clearly acknowledges Turner's older contemporary, the prolific illustrator and decorator Thomas Stothard (1755–1834). It is a far from characteristic piece that sets in hesitant motion the progress of his experiment with modernity.[34]

The next two years yielded only three pictures, though they are important ones (and he was much occupied with watercolour at this time, but that was almost always the case). Two of the three canvases, *Harbour of Dieppe* and

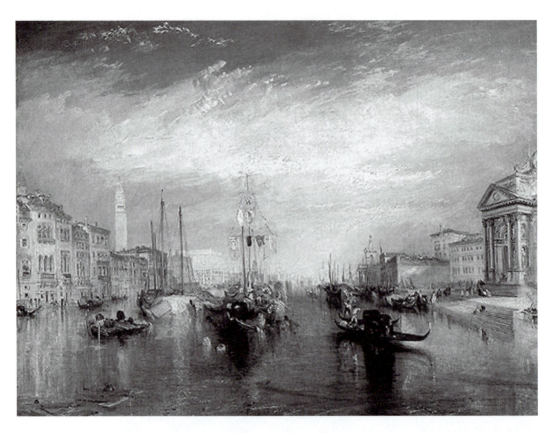

8.6 *Venice, from the porch of Madonna della Salute*, 1835, oil on canvas, 91.4 × 122 cm (BJ 362; Metropolitan Museum, New York)

Cologne, the arrival of a packet boat. Evening,[35] follow naturally from his *Dort* of 1817, which was itself a response both to an Old Master, Cuyp, and to a younger artist, Augustus Wall Callcott (1779–1845).[36] *Dieppe* and *Cologne* are very much in the new vein, but they are large – larger than the current style usually prescribed: even serious subject matter tended now to occupy less space, and, like the *Dort*, was more likely to be inspired by the Dutch school than by the Italian. It was not until 1827 that he showed another genre subject on the intimate scale of *What you will!* This was *Rembrandt's Daughter*,[37] a confessedly Rembrandtian affair that probably pays tribute not to Jones but to a much younger and perhaps more challenging artist, Richard Parkes Bonington (1802–28), the brilliant painter, based in Paris, who alternated landscapes with a pioneering and influential line in informal historical genre subjects, and who had been attracting attention in London with his exhibits at the Academy.

 In 1828 Turner showed *Boccaccio relating the tale of the Birdcage*, which again refers both to Watteau and to Stothard, whose illustrations to Pickering's edition of Boccaccio's *Decameron* had been admired when they came out in 1825 (see Figure 8.7, p. 124). And in 1830 two pictures appeared which conformed much more to this new interest in modern illustration than to Turner's customary preoccupation with landscape. As subjects, they are poles apart, united only by their deliberate concern with the human figure without the context of landscape – and, perhaps, with their illustrative

quality. Both would surely have seemed highly suitable as candidates for engraving in one of the 'Annuals', little presentation volumes, with titles like *The Keepsake* or *Friendship's Offering*, of illustrated prose and verse which published the work of so many of Turner's most successful fellow-painters in these years.

The association of the great artist with these ephemeral publications seems incongruous enough, and indeed he himself implied that he was not flattered when his work was included in them. In a letter of 17 June 1830 he wrote to an unidentified correspondent, evidently one of his engravers (Finberg suggested that it was Edward Goodall): 'I find the drawing you sent me is intended for an Annual. This has not added much to my comfort. So I must be in three beauties *nolens-volens*.'[38] Finberg cited the letter immediately after discussing the appearance of *Jessica* at the Academy in 1830 but failed to make the connection. (We shall discuss *Jessica* shortly.) In the event, no fewer than thirty-seven subjects after Turner were engraved for the *Keepsake*, the *Literary Souvenir*, *Friendship's Offering* and other 'beauties' (his term for the Annuals) between 1826 and 1837, so he cannot have found the experience too painful. And the evidence of the subjects (other than landscape) that he treated in these years points strongly towards a wish to be counted among their contributors (who included friends such as George Jones).

The first of the two pictures of 1830, *Pilate washing his hands*,[39] takes up the Rembrandtian theme again, but on a grander scale, even though the canvas is still of modest dimensions – 90.5 x 122 cm (see Figure 8.8, p. 125). Here too Jones may well have been the immediate inspiration, though Turner is evidently challenging himself to imitate the rich and sparkling light effects of Rembrandt's solemn liturgical interiors. The crowded scene presents several episodes from Christ's Passion, Pilate's hand-washing taking place in the background while Christ bears His cross to Calvary amid a group of mourning women in the foreground. The architectural setting is a great arched hall, and Turner evidently planned other subjects in similar surroundings, for several unfinished canvases in the Turner Bequest show light flooding through tunnel-vaults, with, usually, a suggestion of figures: the narrative subject remains to be realized.

These *ébauches* do not seem to belong to the category of oil sketches that includes the late marine studies, such as the *Rough Sea with Wreckage* or *Breakers on a flat Beach*, both dated by Butlin and Joll to the early 1830s,[40] in which Turner, again searching for new directions in his art, though in a manner more organically a part of his usual preoccupations, is exploring ways of painting sky and sea in various moods. These are studies that might supply information and technical knowledge for a finished picture, but they do not contain within themselves the essential components of a public statement or exhibitable idea. By contrast, the unfinished interiors of around 1830[41] are stage-sets waiting for a cast of characters, which indeed are sometimes adumbrated in ghostly form (see Figure 8.9, p. 126). The architecture is the context for a human drama that Turner cannot quite imagine, because it is by definition – by the parameters of the genre – artificial.

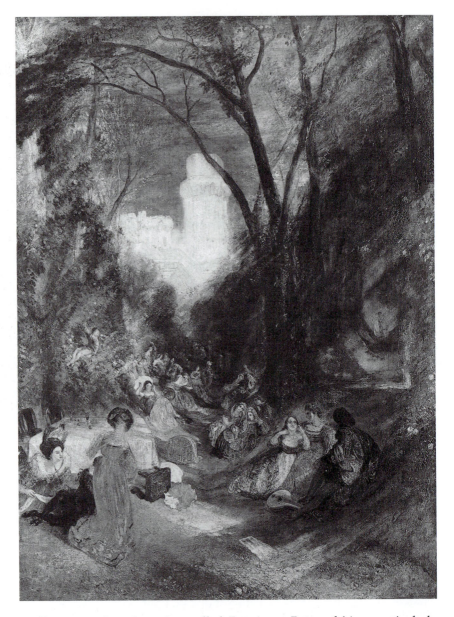

The canvas for a long time called 'Interior at Petworth' is a particularly tantalizing example of this type, since it is full of details that elude identification, but which nevertheless appear to be quite specific (see Figure 1.1, p. 3). What there is of the subject is painted over a scene at East Cowes Castle, the castellated mansion of the architect John Nash, where Turner stayed in 1827, and which he introduced into the background of *Boccaccio relating the tale of the Birdcage*. He also used one of its interiors for the study now known as *Music at East Cowes Castle*,[42] formerly called 'Music at Petworth'. The apsidal arcade that features in the latter canvas appears in the X-radiograph of the supposed 'Interior at Petworth', which must therefore

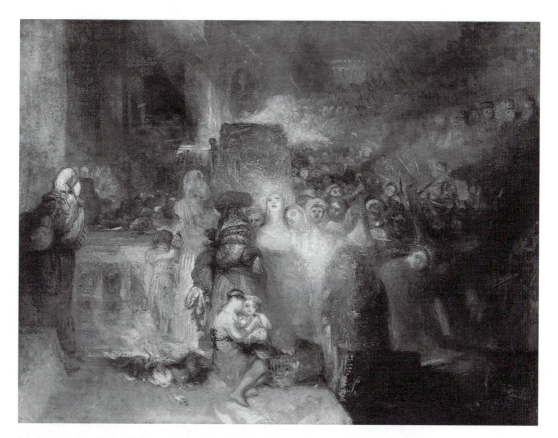

have begun life as an East Cowes interior.[43] A large piece of furniture that has
been seen as a sarcophagus (that of the recently deceased Lord Egremont,
according to one reading) is fairly obviously a piano, which would make this
overpainted beginning another version of the music-party subject. It was
substantially altered, however, the apse being replaced by a luminous
archway rising high above the cornice of the room. The floor is littered with
miscellaneous and strange objects, some apparently flung down in haste.
There is a not entirely consistent atmosphere of desolation, which has been
seen as confirming the view that this is Petworth after Egremont's death. But
the high arch is not a feature of Petworth, and the scattered objects have
nothing to do with Egremont. Furthermore, the palette of this interrupted
beginning conforms with that of *Pilate* and other pictures of about 1830, while
Egremont did not die until 1837. It is more plausible to suggest that Turner
was mulling over a scene of historical devastation, the sacking perhaps of a
large house, such as was to be depicted during the 1830s in two paintings by
Charles Landseer, characteristic period genre subjects of the time.[44]

Turner did actually complete two small historical genre pictures shortly
after this, and they have a material link to Petworth, being painted on what
are thought to have been the panels of Petworth cupboards: *Watteau study by
Fresnoy's rules* (Figure 8.10, p. 127) and *Lucy, Countess of Carlisle and Dorothy*

8.8 *Pilate
washing his
hands*, 1830, oil
on canvas, 91.5 ×
122 cm (BJ 332;
Turner Bequest,
Tate Gallery
N00510)

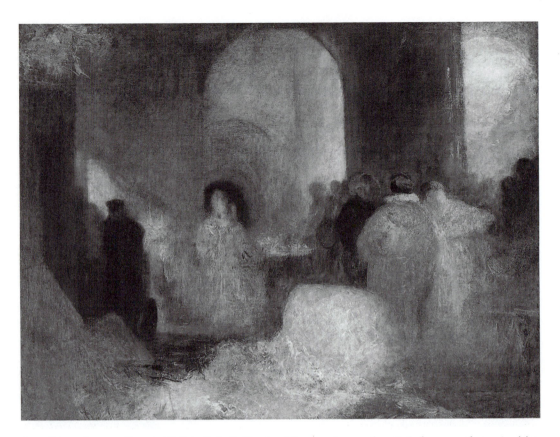

8.9 *Dinner in a Great Room with Figures in Costume*, c. 1830, oil on canvas, 91 x 122 cm (BJ 445; Turner Bequest, Tate Gallery N05502)

Percy's Visit to their Father Lord Percy, when under attainder upon the supposition of his being concerned in the gunpowder plot were both shown at the Academy in 1831.[45] They both pay tribute to other artists: *Watteau Study*, obviously, to Watteau (who had lurked as a secondary influence on *Boccaccio*) and *Lucy, Countess of Carlisle* . . . to Van Dyck, since all the figures are derived from portraits by Van Dyck at Petworth. But these little panels are even more evidently related to contemporary historical genre: Turner has in mind artists like two who were favoured by Egremont, Charles Robert Leslie (1794–1859) and George Clint (1770–1854). Once again, Turner's determination to essay the form is manifest, and if his execution is not as polished as that of his models, it is replete with the tender feeling and witty observation that we should expect, as well as being remarkable for the atmospheric integrity that we noted in *The Blacksmith's Shop*.

The lay-ins – for they are little more than that – usually exploit the same rich chiaroscuro as *Pilate*, but one at least is more startling in its chromaticism. *Two Women with a Letter*,[46] while certainly unfinished, is also more complete: the large-scale figures are palpably present, and their relationship is sufficiently fully described – they stand close together, facing one another, and the farther one reaches forward to get hold of a letter held behind the nearer girl's back (see Figure 8.11, p. 128). There are overtones of Watteau, once again, and the long neck and upswept coiffure of the nearer figure have

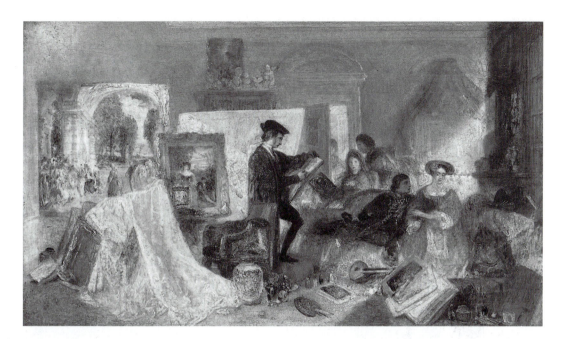

been related to several other female 'back-views' in Turner's oeuvre.⁴⁷ The
subject, with its whimsical romantic sentiment, plainly aspires to the
condition of the *Keepsake* illustrations, and it clearly derives from the same
impulse that produced *Jessica* in 1830,⁴⁸ which was bought by Egremont from
the Academy exhibition (see Figure 8.12, p. 129).

 Jessica has remained at Petworth, and is among the most popular pictures
in the house, selling more postcards than any other. It is certainly not a
'typical' Turner. Its single half-length figure is large-scale – the canvas is the
same size as that of the *Two Women with a Letter* – and confronts the viewer
uncompromisingly. The heroine of the subplot of Shakespeare's *Merchant of
Venice*, Jessica was a favourite among artists of the period as the subject of
sentimental illustrations; they usually chose the nocturnal love scene with
Lorenzo (Act V, scene 1). Turner depicts her at a different moment, on her
own, leaning forward ostensibly to close the shutters of her father's window,
but really to look out for her lover. Instead of citing Shakespeare, Turner
made up his own 'quotation' from the play, a curious telescoping of the sense
of Shylock's speech in Act II, scene v, lines 28–36: the Academy catalogue
simply has the caption '"Shylock – Jessica, shut the window, I say." –
Merchant of Venice'.

 Odd as the composition is for Turner, he had recently experimented with
another single female half-length, a paraphrase of Van Dyck, basing his
figure on one of the Van Dyck portraits in Egremont's collection at Petworth
(see Figure 8.13, p. 130).⁴⁹ That canvas may have been prompted simply by
the experience of being surrounded by fine examples of Van Dyck's work,
but it is likely that it would not have been undertaken without the current
fashion for pictures of pretty women in historical costume. It has no narrative

8.10 *Watteau
study by Fresnoy's
rules*, 1831, oil on
oak panel, 40.5 ×
70 cm (BJ 340;
Turner Bequest,
Tate Gallery
N00514)

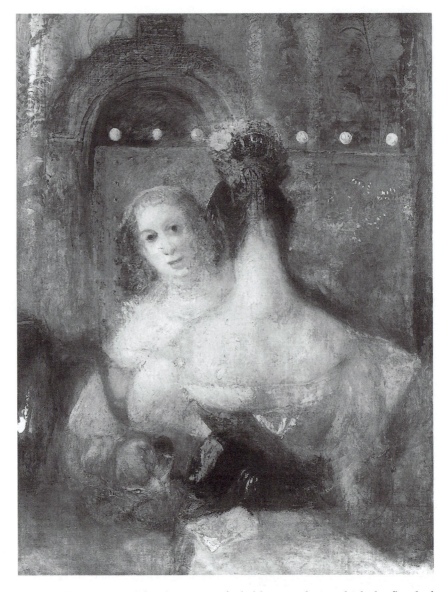

element, however, and for that reason feels like a study, in which the flood of warm light and the glow of fabrics make the subject, rather than the long-necked, rather rabbit-faced woman who confronts us.[50] Nevertheless, the composition as a whole can be compared to 'Annual' illustrations like C. R. Leslie's *The Bride*, engraved by Charles Heath for the *Keepsake* Annual in 1830 (Figure 8.14). Here too the subject is a lady in Van Dyck dress, but her action of turning away from her mirror while drawing on her glove suggests, in conjunction with the title, a specific and palpitatingly romantic moment in the young woman's life. (It was placed, in fact, as an illustration to a short narrative called *The Bride* by Theodore Hook.)

After this experiment, Turner was able to take another attempt at the type

8.12 *Jessica*, 1830, oil on canvas, 122 X 91.7 cm (BJ 333; Tate Gallery, Petworth House, Sussex, T03887)

much further. In fact, he finished *Jessica*, and it was exhibited and sold to one of his keenest admirers. The costume Jessica is wearing is modern; the broad-brimmed hat with feathers and puffed sleeves are the fashion of 1830. Much has been made of the Rembrandtian overtones of the picture, with its warm golden colour (it represented 'a lady getting out of a large mustard-pot' according to one critic),[51] which conforms with Turner's preoccupations at this time. The general idea for the picture seems to have been given him by a small work that one of the young Turks, Gilbert Stuart Newton (1794–1835), had shown in the previous year's exhibition, a *Young Lady in Cauchoise Dress*.[52] She stands at a window, looking down, with one hand up to put aside a curtain.

8.13 *A Lady in Van Dyck Costume*, c. 1827, oil on canvas, 121 × 91 cm (BJ 444; Turner Bequest, Tate Gallery N05511)

This is not far from Turner's idea. But a more direct model for his unusual composition is a small picture by one of Rembrandt's late seventeenth-century Dutch followers, *A Girl at a Shutter* by Gottfried Schalken. This was published as a mezzotint, in reverse, with an attribution to another Dutch artist, Jan Verkolje (1673–1746), and so could well have been known to Turner.[53]

What is it that makes *Jessica* such a popular picture? She has none of the suave elegance that most painters of this type of 'cheesecake' art brought to their task. The perspective of her left arm and of her red hat is awkwardly handled; there is a brilliant coarseness about the sparkle of light on her lace cape. Her face is not as short-nosed as that of the Van Dyck lady; it is indeed

8.14 Charles Heath after C. R. Leslie, *The Bride*, published in *The Keepsake*, 1830, line engraving, 9.2 × 7.5 cm (private collection)

a fine oval, and her neck is not so preposterously long. The features are far from obviously pretty, yet there is a poignancy in the dark eyes as they stare out of the warm shadow that captivates, and makes Jessica more real, more vibrant and human, than the more correct pin-ups in the *Keepsake*.

We may now be approaching some understanding of why Turner's figures work as well as they do in his pictures. That they sometimes fail is undeniable, but in many instances what seems at first like failure is better explained as a rendering of vulnerable humanity. E. M. Forster makes a character in one of his novels remark that 'Turner spoils his pictures by introducing a man like a bolster in the foreground.'[54] Turner was well aware of the aesthetic inadequacy of the human form. He was conscious that his own form, short and stocky, was less than ideal, and his work is a kind of encomium on the ordinariness

of people. Forster's character goes on to qualify his remark about bolsters by saying: 'in actual life every landscape is spoilt by men of worse shapes still'. This is the truth of humankind, and Turner renders it with humour and compassion. He shows toil in all its disfiguring reality: the stooped bait-gatherers on the beach at Calais, in a picture that appeared in the same year as *Jessica*,[55] seem ungainly, all arms and bums – which is surely exactly how they felt themselves to look after such a day of bending labour. There is another doubled-up figure, that of an old woman just got down from the stage-coach at Stamford, in the watercolour of that town which Turner made for the *England and Wales* series.[56] His choice of this pathetic creature, waiting patiently for her luggage to be handed down, unable to run like the young man nearby to escape the pelting rain-shower, is wonderfully tender and at the same time a commentary on the nature of travel and all human motion.

A common criticism of Turner's figures is that they are 'doll-like'; they have 'currant-bun faces', they lack individuality or articulation. In this they reveal not so much incompetence as a sense of the almost unbearable vulnerability of human beings, in the face of the great cycles of nature and history. In this they are reminiscent of the figures of Goya (1746–1828), whose figure drawing is often very similar. For example, the angels crowded into the vault and dome of the church of San Antonio de la Florida, in Madrid, which Goya painted in 1798, are remarkable for their 'currant-bun' faces – which give them a disarmingly childlike appearance, perhaps appropriate to their state of beatific innocence.

Even in large-scale portraiture, Goya's figures resemble Turner's: compare the 'dummy-like nude of the Maja', as Mario Praz characterized her, for instance,[57] or the recumbent *Marquesa de Santa Cruz* of 1805 (Figure 8.15) with the large unfinished *Reclining Venus* that Turner painted in Rome in 1828 (Figure 8.16, p. 134). If Turner's figure is somewhat awkward, it is rather less so than Goya's; indeed, Goya frequently betrays a curious lack of ease in drawing whole-length figures, especially when they are seated or lying. The effect of this is to make his subjects seem touchingly insecure, precariously poised in their roles, however outwardly grand.

'Time and again you see figures shaped like sacks, lumpy, lifeless, with enormous sausage-shaped limbs, with hats or caps or bonnets or helmets which make handsome faces – the seat of what is most human in man – invisible, and thus reduce the likes of us to dolls or clods without command over our destinies.' That sounds like a description of Turner's figures by one of his detractors. It is not: it is Nikolaus Pevsner's reaction to the characters that populate the seething compositions of Pieter Bruegel the elder.[58] Like Goya, Bruegel made the pathos and vulnerability of human beings a principal theme of his work. He frequently showed mankind thronging broad landscapes in which acts of nature, both beneficial and destructive, are as much a part of the condition in which humans live as the acts of men themselves. In this he prefigured many of Turner's themes, as well as those of Goya. Painters who elect to present such ideas in their work will inevitably draw men and women in ways that fail to conform to preconceptions of the

ideal and the beautiful. A particularly moving example of Turner working in a 'Bruegel' vein is *The Field of Waterloo* (Figure 8.17, p. 135), exhibited in 1818, where a scrimmage of figures, living and dead, occupies the foreground, embodying not only Byron's famous description of the battlefield but the most painfully human moment of the whole drama: women searching for their loved ones by torchlight, marked as individuals not so much by specific personalities as by the convincing pathos of their humanity.[59]

The impulse to depict humanity as frail and vulnerable may explain one of the most notorious of Turner's apparent failures of draughtsmanship: the small figure of Napoleon who stands in the centre of the incandescent landscape of *War: the exile and the rock limpet* (Figure 8.18, p. 136). This was one of a pair of canvases shown at the Academy in 1842, the other being *Peace – Burial at Sea*, which commemorated Wilkie, who had recently died on his way home from the Middle East. While *Peace* has always been admired as one of Turner's most inspired statements (and is incidentally proof that when Turner imitated his colleagues' styles he did so out of respect), *War* has had a more troubled reception. Kenneth Clark damned the figure of Napoleon as 'pathetically ill-drawn' and the entire picture as 'very ugly and entirely ludicrous'.[60] The drawing of this figure, it needs to be pointed out, is not inaccurate. The illusion of odd proportions is the result of the apparent extension of the legs by their reflection in the pool by which Napoleon is standing – a misjudgement of effect on Turner's part, perhaps, but not a solecism of drawing. It is the hat which sits too much on the top of his head that seems ridiculous. That Napoleon's trademark hat should, by the time of his exile, have become

8.15 Goya, *Marquesa de Santa Cruz*, 1805, oil on canvas, 130 × 210 cm (Madrid, Real Academia de San Fernando, photo courtesy of Christie's)

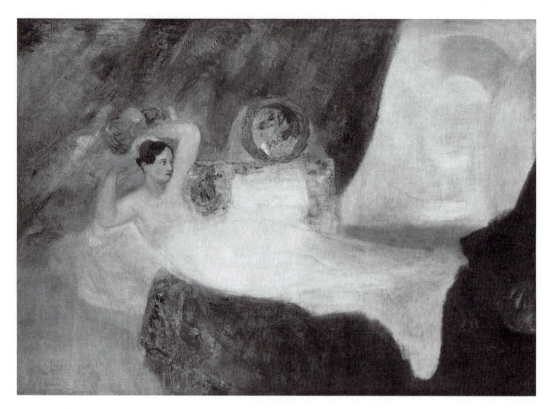

8.16 *Reclining Venus*, 1828, oil on canvas, 175 × 249 cm (BJ 296, Turner Bequest, Tate Gallery N05498)

ridiculous is surely a fair reflection on the fate of the whole extraordinary *persona* that the former Emperor had built up for himself. As he apostrophizes the limpet (in the words of Turner's own 'Manuscript Poem' the *Fallacies of Hope*):

Ah! thy tent-formed shell is like
A soldier's nightly bivouac, alone
Amidst a sea of blood —
– But you can join your comrades

he is a pathetic creature, reduced to communion with the lowliest of creatures and perceiving himself its inferior in fortune. Unlike the gastropod's, his own protection from the elements is too small and ill-fitting to be a source of comfort.

These observations are intended to show that Turner did indeed, as Ruskin indicated, paint the figures that his landscapes needed. When he abandoned landscape for genre, it was not so much an inability to draw figures as a failure to imagine them, because the subject matter did not lead him naturally to do so.

None of this is to say that there are no unsatisfactory moments in the canon, and it is important to admit that certain pictures do not work at all, just as we must acknowledge that his venture into sentimental genre in the years round 1830 was a mistake, and one he fairly quickly recognized as such. But just as Clark found not only the figure of Napoleon but the whole of *War* 'ludicrous', it is usually the case that Turner's figures strike us as faulty when the whole

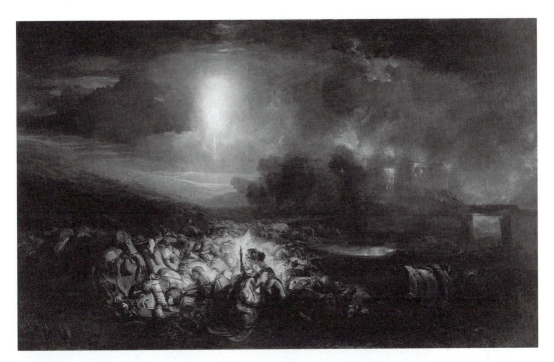

conception is awry. (Occasional failures are surely to be expected in such an extensive and intensely expressive oeuvre.) A well-known instance is the square picture *Bacchus and Ariadne* (Figure 8.19, p. 137), exhibited in 1840,[61] where a hazy landscape, above which the viewer seems to float as in a dream, is peopled by crowds of little figures, several of whom sport pairs of wings. The two principals are taken from Titian's famous version of the subject which had been in England since 1806, and in the National Gallery since 1826. In comparison with Titian they strike us as woefully inadequate, yet despite Turner's deliberate evocation of the Renaissance picture, the comparison is irrelevant. This is not a classical landscape of the humanist Renaissance; it is a whimsical Romantic fairytale setting, as incoherent spatially as the figures are anatomically. The winged figures are, if nominally classical putti, close cousins of the little people who populate the fairy pictures beloved of the early Victorians. That is the genre to which this, like one or two other late paintings of Turner's, belongs.[62]

The elusive, fey personnel are emanations of the natural world, kindred less to the vigorous *dramatis personae* of Titian than to the luminescent bubbles that announce the new world order in *Light and Colour (Goethe's Theory) – the morning after the Deluge – Moses writing the Book of Genesis* of 1843, the pair (and sequel) to *Shade and Darkness – the evening of the Deluge*, exhibited at the same time.[63] It should also be noted that *Bacchus and Ariadne* was the first of the sequence of smaller compositions, square, circular or octagonal, that Turner produced in the 1840s, and can be seen as an experiment in the new format, yet another venture into unexplored territory. The expansive golden landscape of earlier mythological subjects, for instance *Mercury and Argus*, a large canvas exhibited in 1836, or *Apollo and Daphne*, of

8.17 *The Field of Waterloo*, 1818, oil on canvas, 147.5 × 239 cm (BJ 138; Turner Bequest, Tate Gallery N00500)

8.18　*War: the exile and the rock limpet*, 1842, oil on canvas, 79.5 × 79.5 cm (octagonal) (BJ 400; Turner Bequest, Tate Gallery N00529)

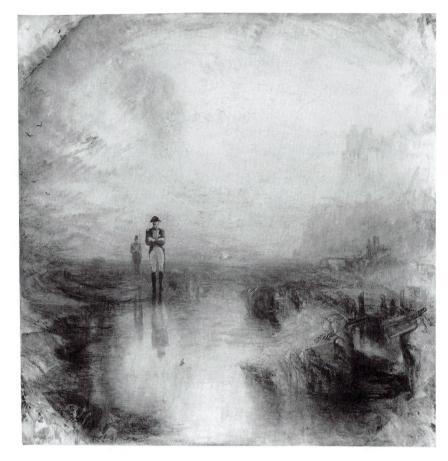

1837,[64] is condensed into a much more constricted space. Many of the contortions that both scenery and staffage undergo are direct consequences of this altered scale. These explanations do not accord the picture the status of masterpiece; it remains a failure, and that failure is in large part a consequence of the misapplication of Turner's idiosyncratic figure drawing to a genre in which he was not at home.

Yet what the picture does communicate is a sense of pulsating life, of a natural world populated with creatures that both emanate from it and comment on its meaning. This is the overriding import of Turner's late work. The 1840s witnessed the composition of his most ambitious hymns to humanity. In the middle of the decade he painted another couple of subjects, not so obviously a pair as *War* and *Peace* or *Shade and Darkness* and *Light and Colour*. He sent *The opening of the Wallhalla, 1842* (Figure 8.20, p. 138) to the Munich Congress of European Art exhibition in 1845, as a tribute to German civilization, regaining its authority after the depradations of Napoleon. The huge Doric temple that Ludwig I of Bavaria commissioned from Leo von Klenze to dominate the Danube at Donaustauf, just east of Regensburg, was a monument to the arts and sciences of the German lands past and present, a 'hall of fame' containing the likenesses, in the form of Neo-classical busts and

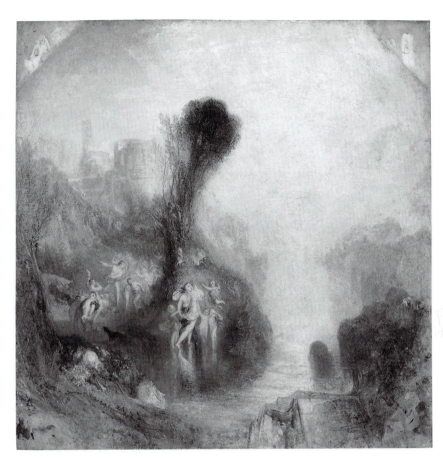

8.19 *Bacchus and Ariadne*, 1840, oil on canvas, 79 × 79 cm (circular) (BJ 382; Turner Bequest, Tate Gallery N00525)

some whole-length figures, of dozens of great men and women from Luther to Goethe. Turner drew the building just before its completion when he visited the site in 1840, noting details of its interior as well as the mighty exterior and incidents in the surrounding landscape, including the whole view looking down the river from below Regensburg. Some of these sketches are in pencil on the pages of a small notebook; others are on larger sheets of grey paper, using black and white chalks or gouache.[65] Whether he was already planning a picture is uncertain, but the final work is one of his most ambitious, both because it uses a large wooden panel, most unusual by this date in his or anyone else's painting, and because it is above everything else a triumphant crowd scene.

The verses he attached to the picture when he sent it to the Academy in 1843 make its purpose clear:

'*L'honneur au Roi de Baviere.*'
Who rode on thy relentless car fallacious Hope?
He, though scathed at Ratisbon, poured on
The tide of war o'er all thy plain, Bavare,
Like the swollen Danube to the gates of Wien.
But peace returns – the morning ray

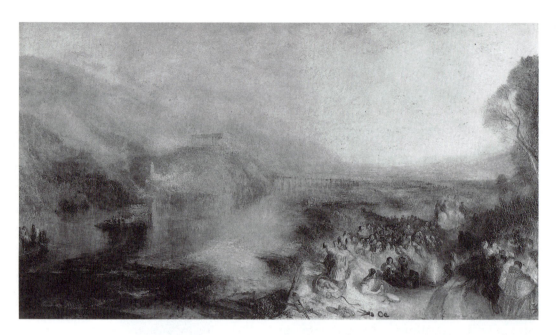

8.20 *The
opening of the
Wallhalla, 1842,
1843*, oil on
mahogany
panel, 112.5 ×
200.5 cm (BJ 401;
Turner Bequest,
Tate Gallery
N00533)

Beams on the Wallhalla, reared to science and the arts,
For men renowned, of German fatherland.

It is necessary to see the picture as contributing to the general argument of
the sequence of 'circular' pairs: like *War* and *Peace* it deals with Napoleon
('scathed at Ratisbon') and the arts as antagonistic forces; like *Shade and
Darkness* and *Light and Colour* it celebrates the redeeming power of creativity
after the horrors of cataclysm. In *Light and Colour* new energy is represented
in 'earth's humid bubbles' which,

emulous of light,
Reflected her lost forms, each in prismatic guise
Hope's harbinger ...

Here, at the Walhalla, that energy is a swirling throng of people from all
walks of life who celebrate, symbolize and represent in themselves the
creative forces of a liberated Europe.

The picture was laughed at in Munich; that is not surprising. Prince
Albert's failure to purchase one of Turner's pictures, despite several heavy
hints,[66] was good evidence that the master's late manner did not appeal to the
modern German (and increasingly the English) taste for crisp finish. Besides,
the plethoric and often puzzlingly obscure invention was guaranteed to put
off a literal-minded audience. Londoners too were worried by the 'licences of
art which Turner exercises to give effect to his pictures'.[67] Certainly the Prince
himself was not tempted to buy the *Wallhalla*, despite its celebration of
Teutonic culture.

Heidelberg, which must have been executed about the same time, has a
good claim to be paired with the *Wallhalla*. Although not on panel, it is of
roughly the same size (though slightly bigger in the upright dimension),

markedly larger than Turner's standard picture size at this period.[68] He never exhibited it, but it was engraved after his death by T. A. Prior with the title 'Heidelberg Castle in the Olden Time'. As Powell suggests,[69] in representing 'ancient Germany' it is to be set off against the *Wallhalla*'s 'modern Germany'. Together they treat, like other pairs in Turner's output, of the 'ancient and modern' contrast rather than that of *Peace* versus *War*.

Heidelberg is likely to have been inspired by visits to the city in 1840 and 1844; the latter prompted a sequence of ravishing colour studies exploring the geography of the site, on the north slopes of mountains dropping down to the River Neckar, which ensures that the visitor is always facing into the sun, with the details of the town and its slender-spired churches absorbed into the diffused light in which everything is enveloped.[70] Turner made no fewer than three finished watercolours of Heidelberg from across the river,[71] testifying to the special importance that its light and atmosphere had for him, but also, perhaps, to the significance he attached to the renaissance in German culture that he was witnessing. Heidelberg had an ancient university, and he liked to show its students wearing the nationalist, Dürer-period costumes that they affected. In his big painting of the city, however, he deliberately adopted a viewpoint high on the hillside, so that he could include not only the river and mountains, and a magnificent late afternoon sun low in the western sky, but also a big open space near the castle, swarming with people who are, like those in the *Wallhalla*, celebrating an enlightened royal event. The Elector Palatine Friedrich V married the English princess Elizabeth in 1613, and instituted a court that patronized the arts and entertained lavishly.[72]

The association of crowds with celebration recurs significantly often in the late work; there are two pairs of Venetian scenes, *Going to the Ball* and *Returning from the Ball*, that link the city with festivity,[73] and two views of another German-speaking city, Zürich, executed in 1842 and 1843. They formed part of two sets of finished watercolours made not in response to a publisher's commission but at Turner's own suggestion: he presented his agent with 'samples' from which clients were invited to choose subjects for completion.[74] Zürich appears in both as a teeming city, filled to bursting with its inhabitants who are all engaged in a communal and corporate activity, preparing for the vintage festival in the 1842 work, and out in the streets again *en fête* in that of 1843. There is no suggestion that these are complementary subjects: both present a busy urban scene with a delight in its positive qualities – the sun burns brightly down on gaily dressed people, and there is a sense of purpose and fulfilment in the way they encrust the city like moss, a living and organic element. This is the apotheosis of the old topography, in which a place and its denizens are presented as indivisible aspects of a single subject.

But there is more than topographical description here: as in the *Wallhalla* and the *Heidelberg*, there is an exultant acceptance of humanity and the human condition. Turner frames an emphatic restatement of Schiller's (and, of course, Beethoven's) great cry to the world in the *Ode to Joy*: 'Seid

umschlungen, millionen': 'O ye millions, I embrace ye.'[75] He drew humanity because he loved it, and he went to the trouble, and risked the criticism, involved in sending his picture of *Wallhalla* to Munich because he took a passionate interest in 'science and the arts' and in the corporate striving of civilized nations to build a better world.

Conclusion

Turner's output constitutes a colossus that overshadows the Romantic period through which he lived, and overshadows, too, the whole art of landscape painting in the West. No one survey can do justice to his achievement, and this book, which has attempted to concentrate on a single aspect of that achievement, has sometimes strayed too widely from its brief. In the case of such a figure one thing leads to another and nothing, in the end, is irrelevant. Rather than trying to encapsulate the significance of Turner's art, I will end with the briefest drawing-together of threads.

Given the grandeur and freedom of his escape from the trammels of traditional Academic discipline, it is always surprising to realize Turner's earnest devotion to the Royal Academy – a devotion that was not paralleled by other free spirits of the period, Gainsborough and Constable most notably. But if that fact about him is accepted and understood, it may not be so hard to comprehend the next point: that one of the qualities most frequently commended in his style has been delicacy. We have seen one of his few whole-hearted contemporary admirers, William Henry Pyne, singling out the 'exquisite taste', the beauty and grace of his drawing;[1] later in the nineteenth century, the author of an early biography, Philip Hamerton, wrote that 'We have plain proof in his works that his artist-nature was one of ineffably exquisite refinement . . . only amongst the most ethereal poets can we find a spirit of such delicacy as his.'[2] In his monumental study of Turner as the greatest of landscape artists, *Modern Painters*, Ruskin chose to stress, among all his encomia on Turner's art, that 'he *gave facts* more *delicately*, more Pre-Raphaelitically, than other men.'[3]

Ruskin's invocation of Pre-Raphaelitism is important. His remark occurs in the third volume of *Modern Painters*, which appeared in 1856. In the same volume he wrote,

Careless readers, who dashed at the descriptions and missed the arguments, took up their own conceptions of the cause of my liking Turner, and said to themselves: 'Turner cannot draw, Turner is generalizing, vague, visionary; and the Pre-Raphaelites are hard and distinct. How can any one like both?' But *I* never said that Turner could not draw. *I* never said that he was vague or visionary. What *I* said was, that nobody had ever drawn so well: that nobody was so certain, so *un*-visionary;

that nobody had ever given so many hard and downright facts.[4]

That seems to be an important and central judgement, coming as it does from Turner's most thorough critic, familiar not only with the work but with the man himself, into whose purposes and cultural assumptions he must therefore have had some insight. Yet Ruskin belonged to a very different generation – he was born in 1819, when Turner was in his forties – and was, in the end, not altogether on the same cultural wavelength. His own preoccupations and prejudices frequently influenced his interpretations. Nonetheless, he corroborated his insistence on Turner's capacity to draw, as opposed to evoking splendid but generalized natural effects, by pointing to a great many examples of precision of observation and of delineation: 'his eminent distinction above other artists, so far as regards execution, was in his marvellous precision of touch, disciplined by practice of engraving, and by perpetual work with the hard lead-pencil on white paper.'[5] It is precisely because this judgement could be arrived at in the years when Pre-Raphaelite compunctions about fidelity to nature were at their most demanding that it has real weight.

An influential twentieth-century critic, Roger Fry, betrayed the influence of Ruskin's book when, writing about Turner in 1934, he affirmed that

no one ever . . . saw so many things with acute observation. He drew and studied incessantly, and he had filled his mind with a vast repertory of precise images. He knew how a wave curled, how the spring of a branch of an elm differed from that of an ash, how a tree roots itself in the ground, what all kinds of cloud and rock form are like.

These details are not of Fry's own observation: they are taken straight from the pages of *Modern Painters*, which embodies Ruskin's highly personal interpretation of Turner's significance. It was under the spell of Ruskin that the young Fry admired 'those late watercolours, all mist and mystery, with a blue crag looming up here, and a splash of lemon yellow and rose there'. But Fry came to dislike Turner (as he did Ruskin himself) and the general adulation of him as something 'sacred'. He conceded that he was 'a man of dazzling genius, and even more than that, a man of staggering dexterity and adroitness . . . an unparalleled conjuror with paint', but this praise is, and is meant to be, faint. Fry's rapture is severely modified. Turner, in his view, was above all

practical . . . these images were his stock-in-trade and his tools. He knew that any fact about the look of things might come in useful in his business at any time. They were essential to the business of making pictures, and that was his passion . . . to make them superlatively well, and, incidentally, to beat others at the job.[6]

Fry denied that Turner had had 'any personal experience at all', asserting that his skill was confined to 'staggering dexterity and adroitness'.

For these reasons, perhaps, he could appreciate Turner's skill at drawing. Of the early architectural studies he says, 'it is an exacting task for the draughtsman to keep his sense of proportion and his feeling for the building as a whole amid the distracting details of Gothic mouldings and ornament.

And in this Turner surpassed all his rivals – even Girtin is not so light in touch, so elegant and free, though' – and Fry adds his qualification – 'he gives something more important which Turner missed'.[7] Considering Fry's emphasis on Turner's pyrotechnics, it is striking that he chooses to praise his 'light touch and elegance'.

Ruskin's word for that is 'delicacy'. He singled out 'early drawings' – he does not say which – where, unconcerned with colour, 'the artist was able to bend his whole mind upon the drawing, and thus to attain to such decision, delicacy, and completeness as have never in any wise been equalled.'[8] An early biographer, Cosmo Monkhouse, speaks of Turner's 'miracles of delicate drawing'.[9] Adrian Stokes, more recently, also has recourse to the concept of delicacy in draughtsmanship: 'Even the technique in some last oils whose calligraphy overlays an unbroken cake of paint, is foreshadowed by very delicate pencil drawing on paper prepared with wash rubbed out for the lights such as in the beautiful Dunbar sketchbook of 1801.'[10] Stokes also writes of 'the delicate use of the pencil in thousands of drawings, slight touches to enrich the paper as if it were a volume invoked by this touch, remarkable not only for this delicacy but for selectiveness'.[11]

Turner's 'technique by which he floats on to the canvas the most delicate films and mists of colour' (Clark)[12] is legendary, but it is clear from the preceding comments that he is also to be admired for his clarity and precision of line – the primary descriptive tool in the artist's equipment. It was by means of line that he gathered the information out of which he created his landscape paintings. A few pencil strokes might be relied on to note the most evanescent effect of sunset light as late as the 1840s, when he made a quick sketch on the beach in the *Channel* sketchbook, which he was using at the very end of his active career.[13]

I have concentrated on Turner's use of line as a practical method of recording and conveying information; we have seen how it could be enlisted to make sense of complex subjects whether architectural or human, both at the stage of observation and at the point of synthesis into a final work of art. But there is a more general sense in which 'draughtsmanship' can refer to all aspects of the arrangement of a composition and the internal relationships of its component elements. It was probably this aspect of drawing, less pragmatic and more instinctive, that Stokes had in mind when he wrote that 'Turner was a phenomenal draughtsman in several genres, but particularly for choice and disposition of accent and blank space in a fairly controlled sea of detail.'[14] Turner's draughtsmanship works in abstract terms, on the two-dimensional space of the canvas or paper; it is validated by an overall mastery of means and purpose. 'Unity of treatment is matched by that of feeling: what is grasped from the subject is accorded with the projected strain of feeling that encompasses and adjusts each detail with another.'[15]

The unity that Turner achieves in each of his works is, as we have seen, very much the product of the careful analysis of complex subject matter and of a systematic preparation of materials for the synthesis by which all the diverse elements are welded together into an aesthetically satisfying whole.

It is in the drawings made on the spot, in the composition studies and in the colour beginnings that this elaborate and sophisticated process can be seen taking place. A pre-eminent fact about Turner's legacy to us in the contents of his studio is that so much of it is either of high merit in its own right as art or profoundly illuminating as to the processes whereby those works of art were created. The processes themselves – analytical, precise, subtle – are, in the end, the index of his mind: as an Edwardian biographer put it, 'the testimony of every man of insight, who ever conversed with Turner, is that they had met one who was something more than a great artist – a great intelligence.'[16]

Notes

Note that the place of publication of works cited is London, unless otherwise indicated.

1 INTRODUCTION: COULD TURNER DRAW?

1. Notably by Joyce Townsend and Peter Bower; see the Bibliography. Technical aspects of Turner's draughtsmanship are summarized below, Chapter 3.
2. A. J. Finberg, *Turner's Sketches and Drawings* (1910), reprinted with an Introduction by Lawrence Gowing, New York, 1968.
3. Clark (1969), p. 284.
4. Clark (1953), pp. 97 ff.
5. The progress of this twentieth-century critique has been summarized in Vaughan (1990).
6. Clark (1953), p. 104.
7. Ibid., p. 103. The picture, now called *Study for the Sack of a Great House*, is BJ 449. David Blayney Brown, in Rowell, Warrell and Brown (2002), has recently suggested that it might be an idea for a picture of 'The Sack of the Temple at Jerusalem', a putative pendant to Pilate washing his hands. Roger Fry, in his generally hostile assessment of Turner in *Reflections on British Painting* (1934), pointed out that the so-called *Interior at Petworth* was an unfinished work lacking in chromatic structure or formal cohesion; see Fry (1934), p. 135. For further comments on Fry's attitude to Turner see the Conclusion to this volume, Chapter 9.
8. Rothenstein and Butlin (1964), p. 45.
9. Clark (1953), p. 101.
10. Clark (1969), p. 284.
11. Stokes (1963), p. 67. The two pictures are BJ 359 and 364. The nine colour studies occur in a sketchbook, TB CCLXXXIII. Their place in the evolution of the paintings is discussed fully in Dorment (1986), pp. 396–405. See also note 14 below.
12. *Modern Painters*, in Ruskin (1903–19) (hereafter *Works*), vol. IV, p. 75.
13. Gage (1969), p. 194.
14. A recent account of Turner and the burning of the Houses of Parliament occurs in A. N. Wilson, *The Victorians* (2002), pp. 13, 14. Here practically everything concerning his working methods is misunderstood. According to Wilson, he 'stayed up all night doing innumerable pencil sketches'. No pencil drawings have been convincingly associated with the fire (though five have been tentatively identified as depicting it: TB CCLXXXIV, ff. 4–7, 9). Later, Wilson says, Turner made 'so many watercolour studies, based on immediate memory, that the leaves of his sketchbook stuck together.' Although most scholarly opinion agrees that the nine colour studies in TB CCLXXXIII show the Palace of Westminster on fire, they afford little topographical evidence to support this (otherwise reasonable) assumption. The blotting of one image onto the next page is probably a consequence of the Thames flood of January 1928, when the whole Bequest was immersed. (The popular notion that Turner made these colour studies on the spot – i.e. in the dark on a crowded boat – flies against both common sense and what we know of his methods.) See note 11 above.
15. The late finished pictures are of course often enough invoked as 'masterpieces' – as, for instance, in Schama (1995), p. 361, where *The Fighting Temeraire* and *Rain, Steam, and Speed* are discussed. But Schama tends to dismiss earlier work as hidebound: for him *England. Richmond Hill on the Prince Regent's Birthday* of 1819, for instance, 'never really escapes the oppressive stylization of its patriotic piety'. This is to treat Turner's 'middle period' with a condescension that no one would dream of according to the corresponding phase of Beethoven's output (the Eroica symphony, the Razoumovsky quartets and so on). It is interesting that Schama relies for his view of Turner on at least one long-established misunderstanding: he alludes to the painter's 'misgivings about the industrial future' (p. 363), a generalization promulgated by Ruskin but nowhere endorsed in Turner's writings or paintings, and fairly explicitly contradicted in *Rain, Steam, and Speed*, which

Ruskin refused to discuss. However, in his commentary on *Snowstorm: Hannibal and his Army crossing the Alps* (1812), Schama engages in an entirely post-modern analysis of the picture in its relation to contemporary events, as well as in an apt account of its antecedents in Salvator Rosa, John Robert Cozens and the tradition of the Sublime (p. 462).

16. Walter Shaw Sparrow, 'Turner's monochromes and early water-colours', in Holm, ed. (1903), p. MW ii.
17. A recent account of Turner's lectures is in Fredericksen (2004).
18. Constable to Maria Bicknell, 30 June 1813, quoted in Leslie (1951), p. 44. Constable's phrase is the starting-point for an important investigation of Turner's intellectual life and context; see Gage (1987).
19. So much so that when I recently mounted a large overview of Turner's life's work in Germany and Switzerland (2001–2002; see Wilton (2001b)), I was castigated by one critic for failing to draw out the links between Turner and modern art. My own view is that this no longer needs to be done, any more than Beethoven needs to be discussed as a precursor of atonalism. See the review by Matthias Frehner in the *Neue Zürcher Zeitung*, Weekend Review 2–3 February 2002. An English translation was published in *Turner Society News* **91** (August 2002), p. 3.
20. Annotation to Sir Martin Archer Shee's *Elements of Art*, quoted in Venning (1982–83), 2 (2), p. 44.
21. Venning (1982–83), 2 (1), p. 42.
22. British Library, Department of Manuscripts, Add. Mss 46151, C, f. 2.
23. Winckelmann had published an essay, 'Gedanken über die Nachahmung der griechischen Werke', in 1755, translated by Fuseli in 1765 as *Reflections on the Painting and Sculpture of the Greeks*. He followed the *Geschichte* with *Monumenti antichi inediti* (2 vols), in 1767. For a comprehensive discussion of Winckelmann and his influence see Alex Potts, *Flesh and the Ideal: Winckelmann and the Origins of Art History*, New Haven and London (1994).
24. Winckelmann in Fuseli's 1765 translation, p. 22 note (see n. 23, above).
25. See David Bindman, ed., *John Flaxman, R.A.*, exhibition catalogue, Royal Academy of Arts, 1979, pp. 86 ff.
26. Discourse VII, 1776, in Reynolds (1975), p. 138. The emphasis on Greek models was partly a fallacious position, since what Winckelmann considered pure Greek art was known in his day through later copies, often Roman and frequently inferior.
27. *Blake, Complete Writings with Variant Readings*, ed. Geoffrey Keynes, Oxford (1971), p. 585.
28. *Lectures on Painting*, vol. VIII (1810), reprinted in John Knowles, *Life and Writings of Henry Fuseli*, 3 vols. (1831).
29. Winckelmann in Fuseli's 1765 translation (see n. 23, above), p. 174.
30. George Cumberland, p. 33. For Cumberland and Neo-classicism see Robert Rosenblum, 'Toward the tabula rasa', in his *Transformations in Late Eighteenth-Century Art* (1967).
31. Discourse V, 1772, in Reynolds (1975), p. 84.
32. BJ 228; Turner Bequest. For a discussion of Turner's use of perspective in *Rome from the Vatican* see Davies (1992), pp. 85–91.
33. David Cox, *A Treatise on Landscape Painting and Effect in Water-Colours; from the first Rudiments to the finished Picture: with Examples in Outline, Effect, and Colouring*, 1841 (unpaginated).
34. 'Francis Fitzgerald, Esq.' (pseudonym of Charles Taylor), *Lecture on Landscape* (1786), pp. 197–8.
35. See for instance Finberg (1910), p. 21.
36. Clark (1953), p. 106.
37. Ruskin, *Lectures on Art delivered before the University of Oxford in Hilary Term 1870*, in Works, vol. XX, pp. 155–6. The *Liber Studiorum* plate (R 78), was not published in Turner's lifetime.
38. Clark (1953), p. 98.
39. Nathan Drake, 'Literary Hours', quoted in Wright (1824), p. 93.
40. See Finberg (1910), p. 2.
41. Ruskin, *The Elements of Drawing*, in Works, vol. XV, p. 17.
42. See Gage (1965).
43. See for example the *North-west view of Fonthill Abbey* exhibited by James Wyatt at the Royal Academy in 1798 (W 333); this is a drawing issued by the architect's studio with landscape added by Turner.

2 TURNER'S HISTORY OF DRAWING

1. William T. Whitley, *Art in England 1820–1837*, Cambridge (1930), pp. 276–80. Lawrence's collection included 'about a hundred and twenty drawings by Michael Angelo, two hundred by Raphael, a hundred and twenty by Rubens, eighty by Albert Durer, sixty by Nicolas Poussin, fifty by Titian, sixty by Vandyck, fifty by Leonardo da Vinci, a hundred by Claude . . .'. Lawrence directed in his will that it should be offered to the nation for £18,000, but there were no takers.
2. See Davies (1992) and also Fredericksen (2004).
3. Ottley's *Series of Plates engraved after the Paintings and Sculptures of the most eminent Masters of the Florentine School* (1826) was a milestone in the growth of the subject. For his lectures as Professor of Sculpture at the Academy (1810–26) Flaxman drew on a wide knowledge of pre-Renaissance sculpture.
4. The 'Historical Vignettes', along with the 'Fairfaxiana' drawings, all of which Turner executed for Walter Fawkes in about 1818, are in a private collection. They are reproduced in Hamilton (2003), pp. 170–72.

5. Turner's copy is TB XVIII-A. The subject is the lower half (legs and loins) of the lowest ascending male figure on the left-hand side of the composition.
6. See Brown and Turner (2001) (unpaginated).
7. Ruskin, who considered the Venetian school in the sixteenth century as the high point of painting, described the outline by which we identify discrete objects in reality as 'infinitely subtle – not even a line, but the place of a line, and that, also, made soft by texture' (*Lectures on Art*, in *Works*, vol. XX, p. 122)
8. TB LXX-A; it is reproduced in Brown and Turner (2001) as fig. 6.
9. Brown and Turner (2001) (unpaginated).
10. In a private collection; it is reproduced in Brown and Turner (2001) as fig. 5.
11. See White, Alexander and D'Oench 1983 passim and, for Baillie, p. 75.
12. See Gage (1972), p. 89, note 44; this book introduces a general appraisal of Turner's relationship to Rembrandt. See also Kitson (1988).
13. Turner's comment was recorded in Thornbury (1877), p. 8.
14. The two Van de Velde drawings are TB CCLXXX 17 and CXX h; the other Dutch drawings are in a private collection; see Brown and Turner (2001). Van de Velde's *The 'Hampton Court' from the Port Bow, in a Heavy Sea*, c. 1680, is reproduced there as fig. 7.
15. Seven of the Scott drawings are in the Turner Bequest, TB CCCLXIX A–G; the eighth is in a private collection. See *The Walpole Society*, **II** (1912–13), p. 128.
16. In a private collection. Two had been rejected from the Bequest by Turner's executors as being by a hand other than Turner's; the subject that remains in the Bequest, having been judged authentic by the executors, is a view of the Chapter House at Margam Abbey, Glamorgan, TB CCCLXX A. See *The Walpole Society*, **II** (1912–13), p. 128.
17. These were presented to the British Museum in 1824.
18. See Michael Kitson, *Claude Lorrain: Liber Veritatis*, catalogue of an exhibition at the British Museum, 1978.
19. Jonathan Richardson (1665–1745), portrait painter and writer, was Reynolds's most influential English precursor as theoretician of aesthetics. He published *An Essay on the Theory of Painting* in 1715 and, in 1719, *An Essay on the Whole Art of Criticism in Relation to Painting*.
20. Farington (1978–98, hereafter Farington, *Diary*), entry for 1 June 1806. See Brinsley Ford, 'The Dartmouth Collection of drawings of Richard Wilson', *Burlington Magazine*, **XC** (December 1948), p. 337.
21. William Gilpin, *Three Essays: On Picturesque Beauty; On Picturesque Travel; and On Sketching Landscape*, 2nd edn (1794), p. 6.
22. BJ 45, *Landscape with Windmill and Rainbow*; Turner Bequest.
23. See below, pp. 18, 14, and Hayes (1972), pls. 26–8, 30 and 32. Another work by Turner 'in the manner of Gainsborough' belonged to Turner's friend Henry Trimmer; see Turner (1980), p. 290.
24. See John Hayes, *The Drawings of Thomas Gainsborough*, 2 vols, New Haven and London (1971). Some drawings of Turner's early maturity reflect a more direct response to Gainsborough; one example is the distant view of Fonthill Abbey with the lake in the foreground and a team of oxen, in the Fonthill sketchbook, TB XLVII, f.46.
25. British Library Add. Mss 46151 A, f. 1.
26. See Brown and Turner (2001); an opening of the sketchbook is illustrated as fig.13; see also Venning 1982–83, 3 (1), p. 40. Ryley was severely disabled and it is possible that he had come under the care of Dr Monro, through whom the two artists might easily have met. Turner's interest in Ryley was first discussed in Gage (1969), pp. 60 and 238, note 29.

3 THE RUDIMENTS OF DRAUGHTSMANSHIP

1. Roget (1891), vol. I, p. 6.
2. The place of the amateur draughtsman and drawing-master in the seventeenth and eighteenth centuries is discussed in Sloan (2000). See also Bermingham (2000), Chapters 3 and 4.
3. Perhaps the most celebrated case of a great artist working as teacher and adapting his style to the needs of pupils is John Sell Cotman, many of whose monochrome and watercolour compositions were copied, often with deceptive skill, by his pupils.
4. Some of the portrait drawings sold in Lawrence's studio sale in 1831, for example, went for sums higher than those fetched by many oil paintings on the same day.
5. Rawlinson lists a total of 24 aquatint plates after Turner, R 812–832c.
6. The exceptions are the vignettes he made for Scott's *Minstrelsy of the Scottish Border*, where pen outlines are reproduced by means of simple etching.
7. The *View of Leeds*, 1823 (R 833).
8. See Finlay (1990), pp. 51 ff. I am grateful to Peter Bower for supplying many details of this account. Turner visited Borrowdale and drew the mine building there in 1797 (TB XXXV, f. 35).
9. Richard Redgrave, *A Descriptive Catalogue of the Historical Collection of Water-colour Paintings in the South Kensington Museum with an introductory notice* (1877), pp. 16, 17.
10. Bower (1990) and (1999) passim.
11. See Bower (1989) and (1990) and Townsend (1993), p. 18.
12. Letter to Christopher Anstey, 1767; quoted in Bower (1990), p. 33.
13. All quotes from Campbell (1757), p. 105. A copy of Campbell's book was owned by Turner.
14. Ibid., p. 106.

15. Ibid., p. 127.
16. The descriptions given in this paragraph are taken from editions of *Kent's Directory of the Names and Residences of the Merchants and Traders of London and Parts Adjacent*, various editions between 1785 and 1807.
17. A 'Mr Arrowsmith' is mentioned in two notes written by Turner on scraps of paper in the Bequest, TB XIII-H, XVII-R. These may refer, however, to a patron.
18. See Bermingham (2000), pp. 127 ff.
19. See Townsend (1998), p. 250.
20. BJ 340; Turner Bequest.
21. In the Indianapolis Museum of Art, Pantzer Collection; W 10.
22. TB I-B.
23. T II.
24. TB III-A.
25. TB II, ff. 9, 14. Radley Hall (now Radley School) is just outside Oxford.
26. See Robin Hamlyn, 'An early sketchbook of J. M. W. Turner in the Art Museum of Princeton University', *Record of the Art Museum of Princeton University*, **44** (2) (1985), pp. 2–23.
27. The drawings are in the *Bristol and Malmesbury* sketchbook, TB VI. See Wilton (1987), p. 28. The etching 'recipe' is on TB V–D verso.
28. Ruskin, *Works*, vol. VII, p 445, note.
29. TB XX, f. 17 recto. The identification by Ruskin of one of the drawings in the book (ff. 18 verso–19 recto) as a view of Marford Mill has been shown to be incorrect.
30. Tate Gallery Archive, A941.
31. Ruskin, *Lectures on Architecture and Painting*, in *Works*, vol. XII, pp. 124–5.
32. Hamerton (1895), p. 23.
33. Pp. 198–9.
34. The first was set up in Florence by Giorgio Vasari in 1563; a more influential successor was the Académie Française in Paris, founded by Colbert to regulate the French language. It was followed by other Parisian academies for the fine arts, music and science; these were imitated throughout Europe. See N. Pevsner, *Academies of Art, Past and Present* (1940).
35. Campbell (1757), p. 99.
36. From the Instrument of Foundation of the Academy, reprinted in Hutchison (1968), pp. 209–13.
37. TB X A, B. Finberg suggests that these drawings were done after the studies from the Antique; on the reverse of X A is a slight sketch that relates to the drawing of Henry VII's Chapel, Westminster, of c. 1790. The *écorché* study on X B is of inferior quality to that on X A, and is therefore perhaps earlier in date.
38. Finberg listed the drawings from the Antique as Section V in his *Inventory* (1909), the Life Class studies as Section XVIII. There are also a couple of anatomical studies in the Turner Bequest, which he lists as Section X. There are a few Academy studies by Turner in collections elsewhere.
39. TB XVIII B.
40. The drawing is in the Art Institute of Chicago.
41. Quoted in Venning (1982–83), **2** (2), p. 45, and **2** (1), p. 4.
42. TB XLIII B.
43. TB LXXXI, pp. 3, 9, 11–15, 17, 19, 23, 25. *Calais Pier* is in the National Gallery, London, BJ 48. The last of these studies was used in *The Fifth Plague of Egypt*, exhibited in 1800 (BJ 13); in the Indianapolis Museum of Art, Indiana.
44. See Davies (1992) and Fredericksen (2004).
45. The idea occurs more than once in Constable's writings; an early citation is in C. R. Leslie, *Memoirs of the Life of John Constable*, ed. Jonathan Mayne (1951), p. 323: 'Why ... may not landscape painting be considered as a branch of natural philosophy, of which the pictures are but the experiments?' See also R. B. Beckett, ed., 'John Constable's Discourses', *Suffolk Records Society*, vol. XIV, Ipswich (1970), p. 69.
46. Finberg (1910), p. 148.
47. Gage (1993a), p. 115. The memorandum occurs in TB CLXVII, f. 52 verso.
48. W 636–686. It is now agreed that this group of 51 includes a later, more elaborate subject, *Mainz and Kastell* (W 678), which differs in certain characteristics from the rest; it is nevertheless not a 'finished' drawing, like those Turner made from his Rhine studies in about 1820 (W 687–693). See Powell (1991).
49. Finberg (n.d. [1912]), pp. 9–10.
50. The *Isleworth* sketchbook is TB XC.
51. By Charles Martin, in the National Portrait Gallery archive. See Walker (1983), no. 34. Despite its wide dissemination as a classic image of Turner, this drawing is not convincing as a likeness, with its sentimentalized Pickwickian or Cheeryble aspect. But the pose, with a small, hard-covered book held against the stomach, is surely exact.
52. An example of Turner's use of a washline border on a sheet extracted from its sketchbook is TB XXVI, f. 29, a view of St David's Head from the south, taken from the *South Wales* sketchbook. See Wilton (1984a), p. 46. Despite a general move away from white or off-white 'museum' mounts for watercolours in recent decades, the appropriate use of washline borders is still not fully understood. Several of Turner's early topographical views should be classed as 'tinted drawings' and thus mounted, rather than being put into close gilt frames, treatment that came into its own with the more richly coloured works of 1797 onwards. See Chapter 6, below.

4 EARLY INFLUENCES

1. Thornbury (1862), vol. I, p. 47.
2. TB CXCV 156.
3. The tracing of Tom Tower is TB XIV A; that of Great Malvern porch is TB XIII D. The finished Malvern watercolour is W 49; it is in the Whitworth Art Gallery, University of Manchester.
4. The smaller sheet is TB XIV C; the larger is TB XXVII X.
5. Listed by Finberg among the late Venetian studies, TB CCCXVI 7; repr. in Stainton (1985) as no. 60.
6. The watercolour is W 700. The engraving is R 144.
7. The drawing is discussed in Warrell (2003b), pp. 49–50.
8. Quoted in Thornbury (1862), vol. II, p. 57.
9. Rooker's drawing is in the collection of the Royal Academy, London. Turner's two studies from it are TB XVII-Q, R. A case for Turner's special indebtedness to Rooker is made in Shanes (1997).
10. See Joppien (n.d.).
11. These seem to have been acquired by him at Thomas Monro's sale, 27 June 1833 (lot 110); they remain in the Turner Bequest, TB CCCLXXII 1–53; some are repr. in *The Walpole Society* (1912–13), pp. 128–9.
12. TB XXIII Q, R, V. These are discussed in Wilton (1984a), p. 39, nos 12–14.
13. Both works are in a private collection; they are illustrated in Lyles (1989), pp. 23, 24.
14. TB XXXIII a; BJ 19a.
15. TB XXIII T.
16. Farington, *Diary*, entry for 13 November 1817.
17. See W 40.
18. Farington, *Diary*, entry for 12 November 1798. For an account of the 'Monro School' see Wilton (1984b).
19. Rowlandson's *Vauxhall Gardens* and Dayes's *Buckingham House* are both in the Victoria and Albert Museum. They were issued as coloured aquatints by, respectively, Rowlandson himself and Francis Jukes.
20. TB IX A (W 27). The work was sent promptly to the Academy, where it appeared that same spring.
21. Gage (e.g. (1969), p. 26) even suggests that it was Monro who brought Turner to an appreciation of the Picturesque; but the idiom was so widespread and all-pervading that it is unlikely he had not encountered it earlier.
22. Farington, *Diary*, entry for 12 November 1798.
23. Stokes (1963), p. 60.
24. Pyne (1986) p. 19.
25. Alexander Cozens's *A New Method of assisting the Invention in drawing original Compositions of Landscape* was published in 1785–86. See Sloan (1986).
26. Leslie (1951), p. 82.
27. Richard Colt Hoare, *The History of Modern Wiltshire*, vol. I (1822), p. 82, quoted by Lindsay Stainton in Musée Cantonal des Beaux-Arts, Lausanne, (1985), p. 28.
28. See Andrew Wilton, 'William Pars and his work in Asia Minor', in Richard Chandler, *Travels in Asia Minor*, ed. Edith Clay (1971), pp. xxi–xxxvi.
29. Finberg (1910), p. 23. The drawing of Llandaff is in the Turner Bequest, XXVII A (W 143), and was exhibited at the Academy in 1796 (701).
30. *Cottage Interior by Firelight* is TB XVII I; repr. in Wilton (1979), p. 26, pl. 4; *Fishermen at Sea*, shown at the Academy in 1796, is BJ 1; *Trancept of Ewenny Priory, Glamorganshire* was exhibited in 1797 and is in the National Museum of Wales (W 227).
31. TB XXVIII R.
32. This important watercolour has not been published. It establishes that Girtin was evolving a sophisticated technical battery at about the time that Turner was first showing his paces as a painter of atmospheric watercolours. It is in the Abbot Hall Art Gallery, Kendal, on loan from Kendal Mayor's Parlour.
33. The two paintings are BJ 1 and 2.
34. When Finberg wrote his 1910 book, *Fishermen at Sea* had not been rediscovered, and he assumed from the RA catalogue entry that it was a watercolour. The *Millbank* study was then indeed Turner's 'first exhibited oil painting'.
35. TB XXXVII, pp. 104–105.

5 A MATURE SHORTHAND

1. J. Ruskin, *Catalogue of the Sketches and Drawings by J. M. W. Turner. R.A., exhibited in Marlborough House in the Year 1857–8, accompanied with Illustrative Notes*, in *Works*, vol. XIII, p. 260.
2. TB XXI, XXII.
3. Ruskin, *Works*, vol. XIII, p. 253.
4. Quoted in Arthur T. Bolton, *The Portrait of Sir John Soane, R.A.* (1927), pp. 284–5.
5. Quoted in Venning (1982–83), 2 (1), p. 38.
6. Pyne (1986), p. 19.
7. Finberg (1910), p. 34.
8. Hill (1996), p. 27.

9. Farington, *Diary*, entry for 6 February 1802.
10. W. H. Pyne, in *The Somerset House Gazette*, quoting the opinion of James Northcote, in Hardie (1966), vol. I, p. 150.
11. TB XXXVII; see Wilton (1988) and Bower (1990), p. 54.
12. W 138, 194 and 141.
13. W 227, 197. Another version of the Ely interior also appeared in the 1797 exhibition (see W 195).
14. TB XXXIII and XXX. See Bower (1990), p. 52.
15. TB XXXVIII.
16. Stokes (1963), p. 59.
17. Turner took some of these folio sheets with him from England; they were of white paper which he prepared with a grey wash. Others he bought in France during the tour; see Bower (1990), pp. 86–8.
18. Ruskin, *Works*, vol. XIII, pp. 259–60.
19. Townsend (1993), p. 27.
20. Ruskin, *Notes on Pictures* in *Works*, vol. XIII, p. 369.
21. An admittedly unlikely analogy might be drawn with Peter Schaffer's play *Black Comedy* (1965), which takes place during an electrical blackout. The convention is established that total darkness equals light, and when the electricity fails the stage is flooded with light, so that the action can be seen by the audience.
22. Butlin, Wilton and Gage (1974), p. 21.
23. Add. Mss 46151 f. 4, cited in Venning (1982–83), **2** (1), p. 38. Turner's view of 'invention' even helps to explain his indefatigable sketching.
24. Quoted in Ziff (1963), p. 133.
25. A pencil study of St Paul's from the Thames, in which riverside houses and shipping receive more attention than the cathedral itself, is TB XXIIT. A drawing of the Tower of London from the river, also in pencil, was apparently done in connection with a commission for a series of views engraved in *The Lady's Pocket Magazine* and related publications in the mid-1790s. See Wilton (2001a), pp. 29–32. Both drawings probably date from 1794.
26. See George (1984).
27. The various journeys undertaken in connection with the *Rivers of Europe* project are discussed in detail in Powell (1991) and Warrell (1997) and (1999).
28. For example the *Hamburg and Copenhagen* sketchbook, TB CCCV, probably bought in Hamburg during a tour of Germany in 1835; see Bower (1999), pp. 60–61. According to Bower, three other sketchbooks in use on this tour were also purchased in Europe, and are 'all of continental origin'. They contain paper manufactured in Holland, France and Germany.
29. Most famously in 'Turnerian Topography', *Modern Painters*, in *Works*, vol. VI, pp. 27–47.
30. E. H. Gombrich, *Art and Illusion: A Study in the Psychology of Pictorial Representation* (1960), esp. Chapter VIII.
31. William Gilpin, *Observations relative chiefly to Picturesque Beauty, made in the year 1776, on several Parts of Great Britain, particularly the High-Lands of Scotland*, 2 vols (1789), vol. 1, pp. 146–8.
32. Venning (1982–83), **2** (2), p. 41.
33. Thornbury (1862), vol. II, pp. 119, 121.
34. Quoted in Venning (1982–83), **2** (1), p. 78.
35. TB LVI, ff. 138 verso–139 recto. Gilpin's various books on landscape appreciation were influential in the late eighteenth century, and Turner certainly knew them; a youthful copy by him of a plate from Gilpin's *Northern Tour* (1789), showing Dove Dale in Derbyshire, was recorded by Finberg in the Turner Bequest (TB I H), but it has disappeared, possibly a victim of the Thames flood of 1928.
36. TB CCXIV.
37. The drawings are well reproduced in Bachrach (n.d. [1974], pp. 62–9, with many other pages of the book, and with notes on all the structures shown.
38. Redding (1858), vol. I, p. 200.
39. Annotation to Opie's *Lectures on Art*, transcribed in Venning (1982–83), **2** (1), p. 38.
40. C. Powell, 'A Visionary but no Spy!', *Turner Society News*, **88** (August 2001), p. 10.
41. Reynolds described Gainsborough's procedure in his discourse honouring his recently deceased rival in 1788; see Reynolds (1975), p. 250.
42. See Gage (1965).
43. The sketchbook, TB XC, was in use around 1805. Sequences of drawings alternating in the manner described occur in several places throughout the book.
44. TB LXXXI, pp. 54, 64–65, 66–67 etc. The *Bridgewater Sea-piece* is BJ 14, in a private collection.
45. TB CCLX 7, 8, 10 and CCXXVII(a) 15. See Warrell 2003, pp. 128 ff.
46. *Dido directing the Equipment of the fleet, or the Morning of the Carthaginian Empire* is BJ 241; Turner Bequest.
47. Brown (1998), p. 26, The Grenoble Sketchbook, TB LXXXIV.
48. Two of these drawings, in a private collection, are in pencil on thin card stamped 'Turnbull's Superfine London Board', and have retained an explanatory note written in 1919: they were given to the recipient 'some 85 or 90 years ago, when she was on a visit to East Cowes Castle, Isle of Wight . . .'.

6 LINE AND COLOUR

1. The leading scholar on this important aspect of Turner's work is John Gage; see especially his *Colour in Turner* (Gage 1969).
2. TB CXXI G, XLVIII 5. See Harrison (2000), pp. 18, 19, pls. 10, 11.
3. See Shanes (1997a), where the function of the 'colour beginning' is discussed at length. Townsend (1993, p. 26, fig. 18, and p. 27) implies that drawings in 'roll' books may be 'colour beginnings', but the example she uses does not conform to the standard definition.
4. TB LXX c, d, e. See Wilton (1984a), nos. 88–9.
5. TB LXX X, Y. See Wilton (1984a), nos. 90–91.
6. TB CCCLXIV 196.
7. In particular the series listed by Finberg as TB LX(a). See Wilton (1984a), pp. 63–6.
8. TB LXX O.
9. Farington, *Diary*, entry for 21 July 1799.
10. Ibid., entry for 16 November 1799.
11. Horsley (1903), p. 248.
12. There are parallels in contemporary portrait drawings by, for example, John Downman, who touched the backs of faces with red chalk that would 'glow' through the thin paper to suggest the flush of healthy flesh. See Butlin, Joll and Wilton (1983), pp. 159–61, and Christine MacKay, 'Turner's "Llandeilo Bridge and Dynevor Castle"', *Apollo* (June 1998), pp. 383–5.
13. *Grenoble Bridge*, signed, 1824, Baltimore Museum of Art (W 404). The related studies are TB CCLXIII 346, 367, 368, repr. in Centre Culturel du Marais, Paris (1981), pp. 531–3; cat nos. 165–7, p. 536. The finished watercolour is repr. on p. 535; see text on pp. 534, 536.
14. The drawing, in pencil with black and white chalks on grey paper, is in the so-called *Grenoble* sketchbook, TB LXXIV, p. 14.
15. Where it was known as Schweinfurt green; see Harley (1970), pp. 76–7.
16. See Miklos Rajnai, ed., *John Sell Cotman 1782–1842* (1982).
17. Burke (1757), p. 64.
18. By John Gage (see Gage (1993b), p. 6), See also Chumbley and Warrell (1988).
19. The title was given as *Cathedral Church at Lincoln*. It is now in the British Museum, Henderson Bequest, W 124.
20. He applied the principle to his oil paintings as well; see Townsend (1993), p. 17.
21. Notes by William Leighton Leitch, in 'M. H.' (Marcus Huish?) (1985), p. 26.
22. Gowing (1966), p. 53.
23. W 499. The whole passage is quoted in Wilton (1987), p. 114.
24. Typescript of Edith Mary Fawkes, in the National Gallery Library, London.
25. See Finberg (n.d. [1912]), p. 17.
26. Horsley (1903), p. 248.
27. Ibid., pp. 240–41.
28. Ruskin, *Works*, vol. XIII, p. 432.
29. See Rowell, Warrell and Brown (2002).
30. Though he did make one for a member of Egremont's family, by way of apology for an accident. See Rowell, Warrell and Blayney Brown (2002), p. 103.
31. R 751. The picture is BJ 54; Turner Bequest.
32. W 507; in a private collection.
33. R 7, 22, 29, 32, 47.
34. Forrester (1996), p. 32.
35. See Finberg (1929), p. xv: 'The "white" picture of modern art, with all that it implies of naturalism, atmosphere and vivacity ... was at cross-purposes with the capacities of mezzotint.'
36. The only subject of his to be lithographed in his lifetime was a view of Leeds of 1823 (R 833). The original watercolour is W 544 (Yale Center for British Art, New Haven).
37. Rawlinson (1906), p. 229. Sir Francis Seymour Haden pointed out to Rawlinson that the outlines that Turner himself had etched were most likely bitten by the engravers, who had their individual styles of doing so.
38. Rawlinson (1906), p. v.
39. R 45.
40. For a detailed study of these matters, see Forrester (1996).
41. *Shields Lighthouse*, R 801. The watercolour on which the plate is based is W 771.
42. The relevant plates are R 791–798: of these some are undated, and five reproduce works of the period before 1820.
43. The drawings, many now untraced, are W 87–118; the engravings from them are R 1–31.
44. BJ 374, 375.
45. The two *Aeneas and the Sibyl* subjects are BJ 34 and 226 (Turner Bequest and Yale Center for British Art, New Haven).
46. See Warrell (1995), pp. 12 ff. Turner's initial proposal was to make as many as twenty views derived from his tour to Switzerland in 1841; in the end only ten appeared in 1842, but another five in 1843 and six more in 1844. Further subjects appeared later, and were also presumably intended to make up sets, which were never completed. See also W 1523–1569.
47. *Picturesque Views of the Southern Coast of England* appeared between 1814 and 1826 (W 445–484). For a detailed account of the commission and analysis of the subject matter of the works, see Shanes (1981).

48. Kenneth Clark, disapproving as he did of the highly wrought Turner, dismissed the series as exhibiting 'Swinburnian redundancy' (1953, p. 102).
49. Stokes (1963), p. 62.
50. W 455.
51. *Plymouth Dock, from Mount Edgecumbe*, W 456; *Plymouth , with Mount Batten*, W 457.
52. R 98; and see Finberg (1929), p. 22.
53. *Tintagel Castle, Cornwall*, W 463; *St Mawes, Cornwall*, W 473.
54. W 736. See 'Turner's colour and optics', in Finley (1973), pp. 386 ff.
55. W 741.
56. W 733, 739.
57. W 745.
58. W 544.
59. W 732.
60. Ruskin, *Praeterita*, in *Works*, vol. XXXV, p. 79.
61. 'Translation' is Turner's own term: see his draft lecture, BL Add. MS 46151, f. 16 verso, transcribed in Gage (1969), p. 196.
62. Roget and Pye (1879), p. 8; the quotation is from the third edition of *Modern Painters*, vol. I, p. 169.
63. Draft lecture, British Library Add. Mss 46151, f. 17 verso, transcribed in Gage (1969), p. 197.

7 DRAWING AND PAINTING

1. BJ 398; Turner Bequest.
2. In Ruskin, *Works*, vol. VII, p. 445, note.
3. Gowing (1966), pp. 47–8.
4. BJ 409; Turner Bequest, now in the National Gallery, London. See for instance Gage (1972).
5. See Ziff (1963), p. 143, and Wilton (1986b), pp. 403–27.
6. Clark (1953), pp. 101–102.
7. BJ 365, in a private collection, Buenos Aires. The contemporary criticisms and Ruskin's response are discussed in Finberg (1961), pp. 363–4.
8. For instance in R. Paulson, *Book and Painting: Shakespeare, Milton and the Bible*, Knoxville, Tennessee, 1982.
9. In, say, BJ 507, 708.
10. BJ 362; Metropolitan Museum of Art, New York.
11. BJ 396; Tate Gallery, Vernon Bequest.
12. BJ 349; Tate Gallery, Vernon Bequest.
13. BJ 516; Turner Bequest.
14. The oil painting has been identified tentatively as showing the Lake of Lucerne at Brunnen; Warrell (2003a, p. 168) suggests a connection with *The Departure of the Fleet*, one of the final group of Carthage subjects exhibited in 1850 (BJ 432; Turner Bequest), but this is at odds with the clear indications in the picture of a fortified town like those on the Rhine. The 'boat' of the present title is not apparent.
15. W 666; in a private collection. The pencil sketch is TB CLX, f. 83 recto. See Powell (1991), pp. 99–100.
16. The study is BJ 285, in the Turner Bequest. The finished canvas is BJ 290; Tate Gallery, in the Petworth House Collection.
17. TB CCCLXIV 278; repr. in Warrell (1995), p. 123. Studies making use of coloured chalks are TB CCCXXXVII 28, CCCLXIV 223.
18. TB CCCLXIV 362; repr. in Warrell (1995), p. 120.
19. Ruskin, *Works*, vol. XXIII, p. 217.
20. Stokes (1963), p. 74. The lines come from Turner's poem 'The Origin of Vermilion'; see Wilton and Turner (1990), pp. 30–35, 149.
21. Burke's ideas were taken up in the context of a more complex epistemological and moral philosophy by Immanuel Kant, first in his early *Observations on the Sentiment of the Beautiful and the Sublime*, 1764, and more fully in *The Critique of Judgement*, of 1790. The latter was to exert great influence over philosophers later in the nineteenth century, but an English translation did not exist in Turner's day and it cannot have had any direct bearing on his thinking.
22. See Warrell (2003c). Warrell contends that the story of Ruskin and R. N. Wornum, Keeper of the National Gallery, burning the erotica is probably untrue. He assembles and illustrates all the known erotic subjects in the Turner Bequest, and they amount to a considerable list.

8 TURNER'S HUMANITY

1. Many of the ideas put forward in this chapter were outlined in my article 'Sublime or ridiculous? Turner and the problem of the historical figure', *New Literary History*, **XVI** (2) (Winter, 1985), pp. 343–76. A more general interpretation of Turner's use of the human figure is to be found in Shanes (1990).
2. Stokes (1963), p. 60.
3. Clark (1953), p. 106.
4. Ruskin, *Works*, Vol. III, p. 325.

5. H. Quilter, *Sententiae Artis: First Principles of Art for Painters and Picture Lovers*, 1886, pp. 152–3.

6. Stokes (1963), p. 69.

7. TB LIX, LXXVIII.

8. The *Cows* sketchbook, TB LXII.

9. His awareness of such problems is apparent in the verses he wrote to accompany a projected picture concerned with 'The Amateur Artist' (perhaps intended as a pendant to *The Garreteer's Petition*, exhibited in 1809 (BJ 100): 'Pleas[d] with his work he views it o'er and oer / And finds fresh Beauties never seen before . . .' (inscription on the composition study, TB CXXI B).

10. Samuel Palmer, letter to Hannah Palmer, 1856, quoted in Raymond Lister, ed., *The Letters of Samuel Palmer*, 2 vols., Oxford (1974), vol. I, p. 516.

11. *Louth, Lincolnshire* was executed for the *Picturesque Beauties of England and Wales*, c. 1827; W 809. Ruskin's comments are in his *Notes on His Drawings by the late J. M. W. Turner, R.A.* (1878), *Works*, XIII, p. 438.

12. W 11; National Portrait Gallery, London.

13. BJ 25. The coat and neckerchief he shows himself wearing are apparently the same as those in George Dance's chalk portrait of him in profile; it is dated March 1800. He had been elected Associate of the Academy on the 4th of the preceding November. An ostensibly earlier portrait, in the Indianapolis Museum of Art (BJ 20), has a respectable provenance going back to Ruskin, but, if it is an authentic work by Turner, must have been heavily retouched: it seems to be a coarsely sentimentalized version of the watercolour miniature in the National Portrait Gallery (see note 12 above).

14. See Turner's letter to James Holworthy postmarked 21 November 1817 (Turner (1980), letter 70): 'Barry's words are always ringing in my ears: *Get home and light your lamp.*' As Gage points out, Turner probably heard Barry say this in the course of his 1793 lecture to the Academy Schools ('On Colouring'), in which he delivered an encomium on the recently deceased Reynolds.

15. In the Guildhall Art Gallery, London.

16. It originally hung on the West Wall but in 1815 was moved to a less important position on the East Wall.

17. Géricault's great picture, which appeared at the Salon of 1819, was shown in London at the Egyptian Hall, Piccadilly, June–December 1820.

18. BJ 460; Turner Bequest. For a recent interpretation of the picture, which may date from the early to mid-1830s, see Powell (1993), esp. pp. 14–15. On the basis of Powell's work the painting has now been renamed *The Female Convict Ship: Women and Children abandoned in a Gale*.

19. TB XX ff. 36–37, 41–42. Further studies of this type occur in the *Dinevor Castle* sketchbook of about 1798. They have been supposed to relate to a planned picture of Hannibal and his army – a subject that was not to be realized in fact for over a decade; see TB XL, pp. 6a–7; 13; 26a–27, etc. These drawings are accompanied in the sketchbook by a transcription of the lost painting exhibited by John Robert Cozens in 1776 of *Hannibal and his Army surveying the Fertile Plains of Italy*. See Matteson (1980) and Sloan (1986), pp. 110–111.

20. *Shipwreck*, 1805, is BJ 54; Turner Bequest. *Wreck of a Transport Ship*, unexhibited, c. 1810, is BJ 210; now in the Fundaçao Calouste Gulbenkian, Lisbon.

21. BJ 55; Turner Bequest.

22. TB LXXXI, pp. 120–21.

23. TB XVII L, repr. in Wilton (1979), p. 26, pl. 4.

24. BJ 68; Turner Bequest.

25. BJ 81; in a private collection. Turner painted the picture for Richard Payne Knight as a pendant to a seventeenth-century Flemish work in his collection, *The Alchemist's Laboratory*, now attributed to Gerard Thomas. The animal life included by Turner alludes to the contents of the alchemist's room, but clearly also reflects in joking ways on the status and practice of the modern dentist. See Bishop, Gelbier and King (2004).

26. See Wilton (1989) and (1990). Although published some years ago these ideas have rarely been picked up by other Turnerians, and are ignored in *The Oxford Companion to J. M. W. Turner*, Oxford, 2001.

27. G. Jones, 'Recollections of J. M. W. Turner', reprinted in Turner (1980), p. 5.

28. BJ 346; Turner Bequest. Turner exhibited the picture without a title, but with a quotation from Daniel 3, 26: 'Then Nebuchadnezzar came near to the mouth of the burning fiery furnace, and said, Shadrach, Meshach, and Abednego come forth of the midst of the fire.'

29. The sequence occurs in the *Colour Studies (1)* sketchbook, TB CCXCI (b). All are reproduced in Warrell (2003c), pp. 28–39.

30. Jones, 'Recollections of J. M. W. Turner', in Turner (1980), pp. 1, 2.

31. At least one of the drawings, on page 45 verso of the *Colour Studies* book, strongly suggests that Turner was in a position to draw couples enjoying sexual intercourse, as opposed to inventing such scenes. But the context may be a brothel rather than a country house.

32. BJ 228; Turner Bequest.

33. BJ 230; Turner Bequest.

34. BJ 229; in a private collection, USA.

35. *Harbour of Dieppe*, 1825, is BJ 231; *Cologne*, 1826, is BJ 232; both are in the Frick Collection, New York. *Dort or Dordrecht: the Dort Packet-boat from Rotterdam becalmed* is BJ 137; it is in the Yale Center for British Art, New Haven.

36. See David Blayney Brown, *Augustus Wall Callcott*, exhibition catalogue, Tate Gallery, London, 1981.

37. BJ 238; Fogg Art Museum, Harvard.

38. The letter is in Turner (1980), no. 162. It was first published by Finberg (1961, p. 322).
39. BJ 332; Turner Bequest.
40. BJ 455, 456; both Turner Bequest.
41. *Dinner in a Great Room*, BJ 445; *Figures in a Building*, BJ 446; and *A Vaulted Hall*, BJ 450: all Turner Bequest.
42. BJ 447; Turner Bequest.
43. See Wilton (1990).
44. *The Sacking of Basing House*, 1836, and *The Pillaging of a Jew's House in the Reign of Richard I*, 1839; both in the Tate Gallery.
45. BJ 338, 340; both Turner Bequest.
46. BJ 448; Turner Bequest. See Townsend (1989).
47. See Whittingham (1985), p. 19. The hairstyle was fashionable in the early decades of the nineteenth century; compare the oil study attributed by Graham Reynolds to Constable, and dated by him to c. 1806, in a private collection; see Reynolds (1996), 6.84, showing a young woman seen from behind. The attribution is in some respects puzzling, and the little picture may not be quite as early as Reynolds suggests – the sitter apparently wears large white balloon sleeves, conforming to the style of about 1830 – but it illustrates the fashion admirably.
48. BJ 333; in the Turner Bequest.
49. The model may have been Van Dyck's *Anne Cavendish, Lady Rich* of 1635–37. My reasons for dating the *Lady in Van Dyck Costume* earlier than *Jessica*, and much earlier than the date sometime in the early 1830s assigned it by Butlin and Joll, are based on the character of its palette. The *Lady* has much in common with the iridescent skies of Turner's oil studies at the Cowes Regatta, especially *Shipping off East Cowes* headland, BJ 267; Turner Bequest.
50. Compare the gouache study of a woman, presumably made from life at Petworth, TB CCXLIV 39.
51. *Morning Chronicle*, 3 May 1830, quoted in Butlin and Joll (1984). For the Rembrandt connection see Kitson (1988), pp. 12–14.
52. In the Tate Gallery; the similarity with *Jessica* was pointed out by Ian Warrell (personal communication).
53. The painting is in the National Museum of Wales. The mezzotint is by John Inigo Greenwood (1727–92) and was published in Amsterdam by P. Fouquet c. 1761.
54. *The Longest Journey*, 1907, Chapter 7.
55. *Calais Sands, Low Water, Poissards collecting Bait*, BJ 334; in the Bury Art Gallery.
56. W 817. The drawing is in the Usher Art Gallery, Lincoln.
57. Mario Praz, *Unromantic Spain*, London and New York (1929), p.37. Goya's *Nude Maja* is in the Museo del Prado, Madrid.
58. N. Pevsner, 'The Adoration of the Kings,' radio talk 1948, reprinted in Stephen Games, ed., *Pevsner on Art and Architecture* (2002), p. 21.
59. The lines from Byron's *Childe Harold's Pilgrimage*, which Turner quoted in the catalogue entry, conclude: 'The thunder clouds close o'er it, which when rent, / The earth is covered thick with other clay / Which her own clay shall cover, heaped and pent, / Rider and horse, friend, foe, in one red burial blent!'
60. Clark (1953), p. 106.
61. Turner seems to have intended it to be framed not as a square but as 'an irregular octagon' (see Butlin and Joll (1984), no. 382).
62. Turner's other 'fairy' subjects are *The Fountain of Indolence*, 1834 (BJ 254; in the Beaverbrook Art Gallery, Fredericton, New Brunswick), and *Queen Mab's Cave*, 1846 (BJ 420; Turner Bequest).
63. BJ 405; Turner Bequest.
64. *Mercury and Argus* is BJ 367; in the National Gallery of Canada, Ottawa. *Apollo and Daphne* is BJ 369; Turner Bequest. Kathleen Nicholson (1990, pp. 181–8) links *Mercury and Argus* and *Bacchus and Ariadne* as treatments of stories from Ovid, suggesting that the latter is possibly a 'self-deprecating' essay that deliberately shows Titian as the finer artist. This is to imply that Turner's intention was satirical, a dangerous gambit for anyone seeking to explain the less successful late pictures.
65. See Powell (1995), p. 70.
66. Turner several times painted subjects that he hoped would appeal to the royal family. *England: Richmond Hill on the Prince Regent's Birthday* of 1819 was an obvious bid for patronage. Gage (1987, p. 179) has suggested that the long series of marine subjects that Turner produced in the 1830s was a deliberate bid for the interest of William IV, the 'sailor king'. When Prince Albert came from Coburg to marry Queen Victoria in 1840, Turner was prompted to paint two pictures that referred, one directly, one obliquely, to the Prince and his interests. A view of his German home, Schloss Rosenau, was shown at the Academy in 1841 (BJ 392), and the following year one of his boldest seascapes, *Snow Storm – Steam Boat off a Harbour's Mouth* (BJ 398), included in its title an allusion to the ship, the *Ariel*, in which Albert had arrived in England two years earlier. This was a work that was almost wilfully calculated not to appeal to the Prince, but Turner must have been conscious that it represented his own work at its most inspired. A third picture, *Slavers throwing Overboard the Dead and Dying* (BJ 385), was probably painted too soon to be directly influenced by the Prince; it nevertheless acquired vivid relevance when the Consort presided over a meeting of the Society for the Abolition of Slavery at about the time it was on display at the Academy's exhibition in the summer of 1840. Gage points out (ibid.) that *Light and Colour* includes an allusion to 'Goethe's Theory' of colours, which seems to be a gratuitous compliment to a famous German. He also suggests that a later 'square' picture, *Undine giving the Ring to Masaniello, Fisherman of Naples* (1846; BJ 424) makes deliberate use of the German fairytale of Undine. These may have been less

attempts to attract Albert's attention than, more generally, ways of including himself in the current fashion for German culture.

67. *Spectator*, 13 May 1843, quoted in Butlin and Joll (1984), no. 401.
68. BJ 440; Turner Bequest.
69. Powell (1995), pp. 201–202.
70. The colour studies are in the *Heidelberg* roll sketchbook, TB CCCLII. See Powell (1995), pp. 209–213.
71. W 1376, 1377, 1554.
72. See Powell (1995), pp. 201–202.
73. BJ 416, 417; 421, 422. The former pair had references (without actual quotations) to Turner's 'MS poem' *Fallacies of Hope*; the inference that these scenes of ephemeral pleasure are to be read in a simply pessimistic sense is, however, hard to sustain. See Wilton and Turner (1990) and Lindsay (1966).
74. See Warrell (1995), pp. 12–15 and 57–83. The two Zürich views are W 1533 and 1548.
75. Beethoven, Symphony no. 9 in D minor, op. 125, last movement.

9 CONCLUSION

1. See p. 66 above.
2. Hamerton (1895), p. 46.
3. *Modern Painters*, in *Works*, vol. V, p. 173.
4. Ibid., pp. 173–4.
5. Ruskin, *Works*, vol. XIII, p. 242.
6. Fry (1934), pp. 124–6.
7. Fry (1934), pp. 128–9. Fry's account of Turner in his *Reflections on British Painting* is hardly more damning than most of the other painters he discusses. His responses were based in part on misleading evidence: one of the pictures he analysed, an oil painting of *The Battle of Fort Rock*, is not by Turner and is probably a crude fake. But Fry does point out that it was not Turner who anticipated the Impressionists, but Constable.
8. *Modern Painters*, in *Works*, vol. III, p. 234. In the same paragraph Ruskin mentions some watercolours that he considers show 'coarseness and conventionality'. But this is not a criticism of Turner's drawing as such. The whole passage betrays a certain haziness over the chronology of Turner's topographical views. An example of Ruskin's enthusiasm for the young Turner's precision and delicacy is his commendation of a little watercolour study of a sow and piglets in the *Studies near Brighton* sketchbook (TB XXX, f. 93): 'wonderful, quite beyond telling . . . examine it for a quarter of an hour through a magnifying glass and you will see something of what it is'.
9. Monkhouse (1879), p. 27.
10. Stokes (1963), p. 59.
11. Ibid., p. 58.
12. Clark (1953), p. 107.
13. See Wilton (1986a), p. 12, ill. 2.
14. Stokes (1963), p. 60.
15. Ibid., p. 58.
16. Chignell (1902), p. 45.

Bibliography

Note: The place of publication is London unless otherwise indicated.

Bachrach, A. G. H. (n.d. [1974]), *Turner and Rotterdam 1817 – 1825 – 1841*.

Barnard, George (1858), *The Theory and Practice of Landscape Painting in Watercolours*.

Bermingham, Ann (2000), *Learning to Draw: Studies in the Cultural History of a Polite and Useful Art*, New Haven and London.

Bishop, M., S. Gelbier and J. King (2004), 'J. M. W. Turner's painting "The unpaid bill, or the dentist reproving his son's prodigality"', *British Dental Journal*, **197**, (12) (December 25).

Bower, Peter (1989), 'The fugitive Mr Turner', *Turner Society News* **53** (October), p. 5.

—— (1990), *Turner's Papers: A Study of the Manufacture, Selection and Use of his Drawing Papers 1787–1820*, exhibition catalogue, Tate Gallery.

—— (1999), *Turner's Later Papers: A Study of the Manufacture, Selection and Use of his Drawing Papers 1820–1851*, exhibition catalogue, Tate Gallery.

Brown, David Blayney (1998), *Turner in the Alps*, catalogue of an exhibition in the Clore Gallery and the Fondation Pierre Gianadda, Martigny.

—— and Rosalind Mallord Turner (2001), *Turner's Gallery, House and Library*, exhibition leaflet, Tate Gallery.

Burke, Edmund (1757), *An Enquiry into the Origin of our Ideas of the Sublime and Beautiful*.

Butlin, Martin, and Evelyn Joll (1984), *The Paintings of J. M. W. Turner*, 2nd edn, 2 vols (first publ. 1977) (catalogue referred to as 'BJ').

Butlin, Martin, Andrew Wilton and John Gage (1974), *Turner 1775–1851*, bicentenary exhibition catalogue, Royal Academy.

Butlin, Martin, Evelyn Joll and Andrew Wilton (1983), *J. M. W. Turner*, exhibition catalogue (with contributions by John Gage and Jerrold Ziff), Grand Palais, Paris.

Campbell, R. (1757), *The London Tradesman, being an Historical Account of All the Trades, Professions, Arts, both Liberal and Mechanic, now practised in the Cities of London and Westminster, calculated for the Instruction of Youth in their Choice of Business*.

Centre Culturel du Marais, Paris (1981), *Turner en France*, exhibition catalogue.

Chignell, Robert (1902), *J. M. W. Turner, R.A.*

Chumbley, Ann and Ian Warrell (1988), *Turner and Architecture*, exhibition catalogue, Tate Gallery.

Clark, Kenneth (1953), *Landscape into Art*.

—— *Civilisation* (1969).

Clark, Paul (2001), 'J. M. W. Turner's (1775–1851) Watercolour Materials, Ideas and Techniques' unpublished PhD thesis, University of Durham.

Davies, Maurice (1992), *Turner as Professor: The Artist and Linear Perspective*, exhibition catalogue, Tate Gallery.

Dorment, Richard (1986), *British Painting in the Philadelphia Museum of Art: From the Seventeenth through the Nineteenth Century*, Philadelphia and London.

Farington, Joseph (1978–98) *The Diary of Joseph Farington 1793–1821*, ed. Kenneth Garlick, Angus Mackintyre and Kathryn Cave, 16 vols, with index by Evelyn Newby.

Finberg, A. J. (1909), *A Complete Inventory of the Drawings in the Turner Bequest: with which are included the twenty-three drawings bequeathed by Mr Henry Vaughan. Arranged chronologically*, 2 vols. (catalogue referred to as 'TB').

—— (1910), *Turner's Sketches and Drawings*. [This has also been reprinted with an Introduction by Lawrence Gowing, New York: 1968].

—— (1912), *Turner's Water-Colours at Farnley Hall*.

—— (1929), *An Introduction to Turner's Southern Coast with a Catalogue of the Engravings in which all the known working proofs are arranged and described for the first time, and a full transcript is made of Turner's marginal notes and instructions to the engravers*.

—— (1961), *The Life of J. M. W. Turner, R.A.*, 2nd edn, revised and with a Supplement by Hilda F. Finberg, Oxford (first publ. 1939).

Finlay, Michael (1990), *Western Writing Implements*, Carlisle.

Finley, Gerald (1973), 'Two Turner studies: a "new route" in 1822; and Turner's colour and optics', *Journal of the Warburg and Courtauld Institutes*, **XXXVI**, pp. 395–90.

Forrester, Gillian (1996), *The Liber Studiorum, Turner's 'Drawing Book'*, exhibition catalogue, Tate Gallery.

Fredericksen, Andrea (2004), *Vanishing Point: The Perspective Drawings of J. M. W. Turner*, Tate Gallery.

Fry, Roger (1934), *Reflections on British Painting*.

Gage, John (1965), 'Turner and the Picturesque', *Burlington Magazine*, **CVII** (January), pp. 16–26; (February), pp. 75–81.

—— (1969), *Colour in Turner: Poetry and Truth*.

—— (1972) *Rain, Steam, and Speed*.

—— (1987), *J. M. W. Turner: A Wonderful Range of Mind*, New Haven and London.

—— (1993a), *Colour and Culture*.

—— (1993b), 'Turner: the architecture of fancy', *Turner Society News* **64** (August), pp. 5–8.

George, Hardy (1984), 'Turner in Europe in 1833', *Turner Studies*, 4: 1, pp. 2–21.

Gowing, Lawrence (1966), *Turner: Imagination and Reality*, exhibition catalogue, Museum of Modern Art, New York.

Hamerton, P. G. (1895), *The Life of J. M. W. Turner, R.A.*, new edn (first publ. 1879).

Hamilton, James (2003), *Turner's Britain*, London and New York.

Hardie, Martin (1966) *Water-colour Painting in Britain*, ed. Dudley Snelgrove with Jonathan Mayne and Basil Taylor, 3 vols.

Harley, R. D. (1970), *Artists' Pigments c. 1600–1835*.

Harrison, Colin (2000), *Turner's Oxford*, exhibition catalogue, Ashmolean Museum, Oxford.

Hayes, John (1972), *Gainsborough as Printmaker*, New Haven and London.

Hill, David (1996), *Turner in the North, A tour through Derbyshire, Yorkshire, Durham, Northumberland, the Scottish Borders, the Lake District, Lancashire and Lincolnshire in the Year 1797*, New Haven and London.

Holm, Charles, ed. (1903), *The Genius of J. M. W. Turner R.A.*, The Studio.

Horsley, John Callcott, RA (1903), *Recollections of a Royal Academician*, ed. Mrs Edmund Helps.

Hutchison, Sidney C. (1968), *The History of the Royal Academy 1768–1968*.

Joll, Evelyn, Martin Butlin and Luke Herrmann, eds (2001), *The Oxford Companion to J. M. W. Turner*, Oxford.

Joppien, Rudiger (n.d.), *Philippe Jacques de Loutherbourg, R.A., 1740–1812*, exhibition catalogue, Kenwood House.

Kitson, Michael (1988), 'Turner and Rembrandt', *Turner Studies* **8**: 1, pp. 2–19.

Leslie, Charles Robert (1951), *Memoirs of the Life of John Constable composed chiefly of his Letters*, ed. Jonathan Mayne (first publ. 1843, 2nd edn 1845).

Lindsay, Jack (1966), *The Sunset Ship: The Poems of J. M. W. Turner*, Lowestoft.

Lloyd, Mary (1984), *Sunny Memories*, first publ. 1880, reprinted in *Turner Studies* **4** (1), pp. 22–3.

Lyles, Anne (1989), *Young Turner: Early Work to 1800*, exhibition catalogue, Tate Gallery.

—— and Diane Perkins, (1989), *Colour into Line: Turner and the Art of Engraving*, exhibition catalogue, Tate Gallery.

'M. H.' (Marcus Huish?) (1985), 'The early history of Turner's Yorkshire drawings', first publ. in *The Athenaeum*, 8 September 1894, pp. 326–7, reprinted in *Turner Studies*, **5** (2), pp. 24–7.

Mattheson, Lynn R. (1980), 'The poetics and politics of Alpine passage: Turner's *Snowstorm: Hannibal and his Army crossing the Alps*', *Art Bulletin* **LXVII** (3), pp. 385–98.

Monkhouse, Cosmo (1879), *Joseph Mallord William Turner Royal Academician*.

Morrell, Mary Tussey (1994), 'Turner's working methods in his 1817 series of fifty-one Rhenish drawings', unpublished PhD thesis (completed 1993).

Musée Cantonal des Beaux-Arts, Lausanne (1985), *Images of the Grand Tour: Louis Ducros 1748–1810*, exhibition catalogue, Lausanne and Kenwood House, London.

Nicholson, Kathleen (1990), *Turner's Classical Landscapes: Myth and Meaning*, Princeton.

Pole, L. W. (1994), 'Turner's watercolour technique: a new interpretation', *Turner Society News* (August), p. 6.

Powell, Cecilia (1991), *Turner's Rivers of Europe: The Rhine, Meuse and Mosel*, exhibition catalogue, Tate Gallery.

—— (1993), 'Turner's women: the painted veil', *Turner Society News*, **63** (March), pp. 12–15.

—— (1995), *Turner in Germany*, exhibition catalogue, Tate Gallery.

Pyne, William Henry (1986), 'J. M. W. Turner, R.A.', *Arnold's Magazine of the Fine Arts* (August 1833), reprinted in Jerrold Ziff, 'William Henry Pyne's "J. M. W. Turner, R.A.": a neglected critic and essay remembered', *Turner Studies* **6** (1), pp. 18–25.

Rawlinson, W. G. (1906), *Turner's Liber Studiorum: A Description and Catalogue*, 2nd edn (first publ. 1878) (catalogue referred to as 'R').

—— (1913) *The Engraved Work of J. M. W. Turner, R.A.* 2 vols (catalogue also referred to as 'R').

Redding, Cyrus (1858), *Fifty Years' Recollections, Literary and Personal*, 2 vols.

Reynolds, Graham (1996), *The Early Paintings and Drawings of John Constable*, 2 vols, New Haven and London.

Reynolds, Sir Joshua (1975), *Discourses on Art*, ed. Robert R. Wark, New Haven and London (first definitive edn 1797).

Rothenstein, John and Martin Butlin (1964), *Turner*.

Roget, John Lewis (1891), *A History of the 'Old Water-Colour' Society, now the Royal Society of Painters in Water Colors*, 2 vols.

—— and J. Pye (1879), *Notes and Memoranda respecting the Liber Studiorum of J. M. W. Turner*.

Rowell, Christopher, Ian Warrell and David Blayney Brown (2002), *Turner at Petworth*.

Ruskin, John (1903–12), *The Works of John Ruskin* (Library Edition), ed. Sir E. T. Cooke and Alexander Wedderburn, 39 vols.

Schama, Simon (1995), *Landscape and Memory*.

Shanes, Eric (1981), *Turner's Rivers, Harbours and Coasts*.

—— (1990), *Turner's Human Landscape*.

—— (1997a), *Turner's Watercolour Explorations 1810–1842*, exhibition catalogue, Tate Gallery.

—— (1997b), 'Turner and the "scale practice" in British Watercolour art', *Apollo Magazine* (November), pp. 45–51, 69.

Sloan, Kim (1986), *Alexander and John Robert Cozens: The Poetry of Landscape*, New Haven and London.

—— (2000), *'A Noble Art': Amateur Artists and Drawing Masters c.1600–1800*, exhibition catalogue, British Museum.

Stainton, Lindsay (1985), *Turner's Venice*.

Stokes, Adrian (1963), 'The art of Turner', in his *Painting and the Inner World*, pp. 49–84.

Thornbury, Walter (1862), *The Life of J. M. W. Turner R.A.*, 2 vols [This was later published in a rev. edn as *Life and Correspondence of J. M. W. Turner R.A.*, 1877.]

Townsend, Joyce H. (1989), 'Picture Note 1, *Two Women with a Letter*', *Turner Studies* **9** (2), p. 13.

—— (1990), 'Turner's painting materials: a preliminary discussion', *Turner Studies* **10** (1), pp. 22–3.

—— (1993), *Turner's Painting Techniques*, exhibition catalogue, Tate Gallery.

—— (1998), 'The materials of J. M. W. Turner: pigments', *Studies in Conservation* **38**, pp. 231–54.

Turner, J. M. W. (1980) *Collected Correspondence*, ed. John Gage, Oxford.

Vaughan, William (1990), 'Hanging fragments: the case of Turner's oeuvre', in Victoria Todd, ed., *Appearance, Opinion, Change: Evaluating the Look of Paintings*, United Kingdom Institute for Conservation, pp. 85–91.

Venning, Barry (1982–83), 'Turner's annotated books: Opie's "Lectures on Painting" and Shee's "Elements of Art"', *Turner Studies* **2** (1) 1982, pp. 36–46; **2** (2), pp. 40–49; and **3** (1) 1983, pp. 33–44.

Walker, R. J. B. (1983), 'The portraits of J. M. W. Turner: a checklist', *Turner Studies* **3** (1), pp. 28–9.

Warrell, Ian (1995), *Through Switzerland with Turner: Ruskin's first Selection from the Turner Bequest*, exhibition catalogue, Clore Gallery.

—— (1997), *Turner on the Loire*, exhibition catalogue, Tate Gallery.

—— (1999), *Turner on the Seine*, exhibition catalogue, Tate Gallery.

—— (2003a), *Turner et le Lorrain*, catalogue of an exhibition (first shown at the Tate Gallery, 2000), Musée des Beaux-Arts de Nancy.

—— (2003b), *Turner and Venice*, exhibition catalogue with contributions by David Laven and Cecilia Powell, Tate Britain, London.

—— (2003c), 'Exploring the "dark side", Ruskin and the problem of Turner's Erotica', *The British Art Journal* **IV** (1), pp. 5–46.

White, Christopher, David Alexander and Ellen D'Oench, eds (1983), *Rembrandt in Eighteenth Century England*, exhibition catalogue, Yale Center for British Art, New Haven.

Whittingham, Selby (1985), 'What You Will; or some notes regarding the influence of Watteau on Turner and other British artists', *Turner Studies* **5** (1), pp. 2–24.

Wilkinson, Gerald (1972), *Turner's Early Sketchbooks: Drawings in England, Wales and Scotland from 1789 to 1802*.

—— (1974), *The Sketches of Turner, R.A., 1802–20*.

Wilton, Andrew (1979), *The Life and Work of J. M. W. Turner* (including catalogue of watercolours, referred to as 'w')

—— (1984a), *Turner in Wales*, exhibition catalogue, Llandudno and Swansea.

—— (1984b), 'The "Monro School" question: some answers', *Turner Studies* **4** (2), pp. 8–23.

—— (1985), 'Sublime or ridiculous? Turner and the problem of the historical figure', *New Literary History*, **XVI** (2) (Winter), pp. 343–76.

—— (1986a), 'A rediscovered Turner sketchbook', *Turner Studies* **6** (2), pp. 9–23.

—— (1986b), 'Turner at Bonneville', in *Essays in Honor of Paul Mellon*, Washington, D.C., pp. 403–427.

—— (1987), *Turner in his Time*.

—— (1988), *J. M. W. Turner: The 'Wilson' Sketchbook*.

—— (1989), 'The Keepsake Convention: "Jessica" and some related pictures', *Turner Studies* **9** (2), pp. 14–33.

—— (1990) 'Picture note', *Turner Studies* **10** (2), pp. 55–9.

—— (2001a), *Turner, Girtin and Bonington: A New York Private Collection, Paintings, Watercolours and Drawings*, New York, privately printed.

—— (2001b), *William Turner, Licht und Farbe*, exhibition catalogue, Folkwang Museum, Essen and Kunsthaus, Zürich.

—— and Rosalind Mallord Turner (1990), *Painting and Poetry: Turner's Verse Book and his Work of 1804–1812*, exhibition catalogue, Tate Gallery.

Wright, Thomas (1824), *Some Account of the Life of Richard Wilson, Esq', R.A.*

Ziff, Jerrold (1963), '"Backgrounds, introduction of architecture and landscape": a lecture by J.M.W. Turner', *Journal of the Warburg and Courtauld Institutes* **26**, pp. 124–47.

Index

Note: Works of art, in oil or watercolour, are listed under title, in italics. They are by Turner unless otherwise stated. Turner's sketchbooks, however, are listed under 'sketchbooks'.